EXPLORING
AVEBURY

THE ESSENTIAL GUIDE

First published 2016
Reprinted 2016, 2017, 2018, 2020

The History Press
97 St George's Place,
Cheltenham, Gloucestershire, GL50 3QB
www.thehistorypress.co.uk

British Library Cataloguing in Publication Data.
A catalogue record for this book is available from the British Library.

ISBN 978 0 7509 6766 2

Typesetting and origination by The History Press
Printed in Turkey

EXPLORING
AVEBURY

THE ESSENTIAL GUIDE

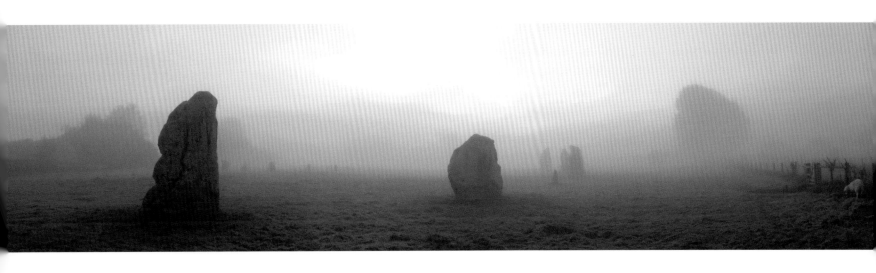

STEVE MARSHALL

The History Press

ACKNOWLEDGEMENTS

I am extremely grateful to the many people who generously gave their time, energy and expertise in helping me to research and write this book. Special thanks are due to Brian Edwards and David Field, who patiently read through countless early versions of my text that were all far too long; with their guidance I eventually came to understand that less is more. Thanks to Abby George for cartography and graphics, Martin Smith for CGI, Mike Robinson and Philippe Ullens for their photographs, Kim Kalina for editing the final text and Mike Parker Pearson for his expert review and comments.

The balloon photography was made possible by a grant from the Dr Terence Meaden Research Fund, and Garmin UK supplied GPS equipment. Thanks to Ros Cleal, Mark Gillings, Josh Pollard and the many others who gave me advice, information and practical help: Stephen Allan, Charlie Arnold, ASAHRG, the Avebury Society, Martyn Barber, Steve Boreham, Gill Campbell, George Currie, Andrew David, Kate Fielden, Darren Francis, Anne Furniss, Jamie George, Kenny Gloster, Frances Howard-Gordon, Marina Graham, Jim Gunter, David Haycock, Judi Holliday, Alice Isaacsen, Rob Ixer, Jurgen Krönig, Jim Leary, John Martineau, John Neal, Ian Oliver, Victor Reijs, Bob Trubshaw and Simon Wyatt.

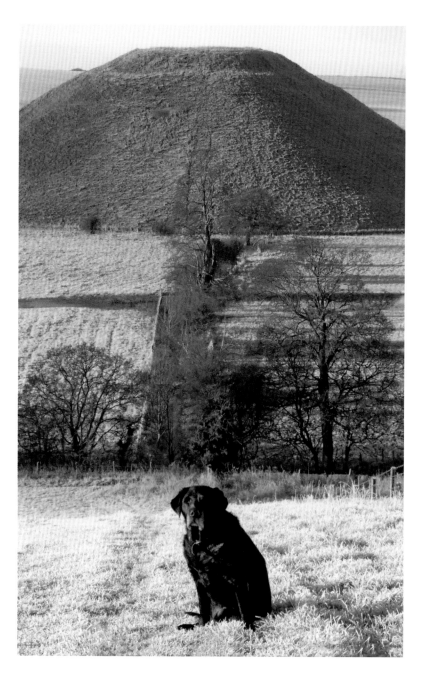

Dedicated to my research assistant Betty (2000–2013)
who accompanied me across hundreds of miles of Wiltshire countryside
throughout the writing of this book.

CONTENTS

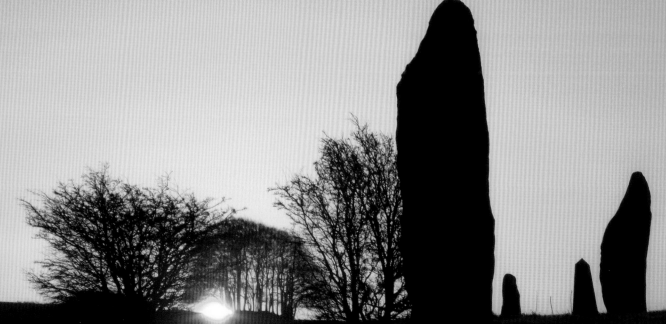

TIMELINE


Mesolithic		**8300 BC**	
	Stonehenge postholes: 8500-7000 BC		8500-7000 BC: Possible Avebury posthole?
	Occupation of Blick Mead springs, near Stonehenge: 7550-4700 BC		
Neolithic		**4000 BC**	
			3680-3650 BC: Windmill Hill enclosure
			3670-3635 BC: West Kennet long barrow
			3300 BC: West Kennet Palisaded Enclosures
	Stonehenge earthwork: 3000-2620 BC		3000-2700 BC: Avebury primary earthwork
	Great Pyramid, Egypt: 2560 BC		
	Stonehenge stones raised: 2620-2480 BC		2630-2460 BC: Avebury bank & ditch
			2600-2000 BC: Avebury stones erected
			2600-2300 BC: Avebury Avenues
Bronze Age		**2500 BC**	Around 2500 BC: The Sanctuary
			2450-2360 BC: Silbury Hill
			2500-2000 BC: West Kennett settlement
			Note: The period 2500-2200 BC is sometimes referred to as the *Chalcolithic* ('Copper Age'). The Beaker people and metallurgy arrived in Britain at that time.
	Petra, Jordan: 1200 BC		
Iron Age		**800 BC**	
	Parthenon, Greece: 447-432 BC		
	Great Wall of China: 400-200 BC		
Roman		**43 AD**	
	Colosseum, Italy: 70-80 AD		Roman town near Silbury
Anglo-Saxon		**450 AD**	
	Fall of Roman Empire: 476 AD		
	Chichén Itzá, Mexico: 600-900 AD		Origins of Avebury village
	Angkor Wat, Cambodia: 800-1200 AD		
Norman		**1066 AD**	
	Domesday Book: 1086 AD		Origins of Avebury Church
Medieval		**1154 AD**	
	Magna Carta: 1215 AD		Some Avebury stones buried
Modern		**1400 AD**	
	Machu Picchu, Peru: 1400 AD		
			1700s: Some Avebury stones destroyed
		Present	1930s: Avebury restored

SOME AVEBURY ARCHAEOLOGISTS PAST & PRESENT

What we know today about Avebury is the result of centuries of work by many individuals, too numerous to list. However, there are several prominent names that recur throughout this book. In chronological order:

John Aubrey (1626–1697)

Credited with the 'discovery' of Avebury whilst out hunting in 1649; his interest prompted a visit from King Charles II, bringing Avebury to wider attention. Aubrey made notes and drew maps of the henge and Avenue when they were still almost intact.

William Stukeley (1687–1765)

An enthusiastic antiquarian, Stukeley visited Avebury several times in the early 1720s. His detailed sketches, made in the field, have proved invaluable to modern researchers. Stukeley's book *Abury, a Temple of the British Druids* was published in 1743.

Reverend A.C. Smith (1822–1898)

Was Rector of Yatesbury, a tiny village close to Avebury. Smith and his wife spent thirty years touring the area on horseback, recording all of its ancient monuments and earthworks onto an enormous hand-drawn map. Smith's book *Guide to the British and Roman Antiquities of the North Wiltshire Downs in a Hundred Square Miles Round Abury* was published in 1884.

Maud Cunnington (1869–1951)

Excavated many important sites in the 1920s and '30s; these included Woodhenge and the Sanctuary, which she bought and donated to the nation. The concrete markers that exist today were installed at her suggestion.

Alexander Keiller (1889–1955)

Used his considerable private fortune to finance archaeological work, with the excavation of Windmill Hill in the 1920s and the restoration of Avebury in the '30s. Keiller made detailed site notes daily, but ill-health prevented him from publishing them. Keiller's widow eventually commissioned a full report from Isobel Smith (1912–2005), curator of the Alexander Keiller Museum in Avebury, published in 1965.

Stuart Piggott (1910–1996)

Worked for Keiller in the 1930s. He went on to excavate many high-profile sites, including Stonehenge and Wayland's Smithy and was responsible for the 1956 restoration of the West Kennet long barrow. Piggott often worked with Richard Atkinson (1920–1994), best known for directing the 1968 excavations into Silbury, as televised by the BBC.

Mark Gillings and Joshua Pollard

Have led many recent Avebury excavations, including the 1997–2003 Longstones Project that confirmed the existence of the Beckhampton Avenue. They have written extensively on Avebury and are directors of Between the Monuments, a joint-universities research programme.

INTRODUCTION

You may have bought this book because you have visited Avebury for the first time, or because you plan to visit in the future. Or perhaps, like me, you are one of the many who fell in love with Avebury and return time and time again. For me, one of the pleasures of roaming Avebury is meeting people who want to share their personal stories. I have met Avebury-loving families — couples who visited in their youth, then married and returned to reaffirm their marriage vows among the stones. They bring their children to Avebury, then their grand-children, who will probably do the same one day. Some are there to remember lost loved ones. An elderly gent, sitting quietly on the grass between two stones, told me he was there for his late wife and daughter, who had shared a birthday. Each had a favourite Avebury stone: they were the ones either side of him.

Everyone has their own Avebury, unique to them. To a surprising number of visitors Avebury is all about *energy*, a mysterious force that they feel in the stones. The Dalai Lama, so I have been told, declared on his visit that Avebury is 'the most sacred place in Britain'. Many visitors of diverse faiths share that view and liken Avebury to an open-air cathedral. Whatever Avebury means to you, I hope this book will add to your enjoyment and understanding of this beautiful and fascinating place.

The book focuses on an area just 10 miles square, with Avebury at its centre. The Avebury landscape is filled with monuments from many different periods, but only the major monuments of the Neolithic and Early Bronze Age are featured (*see timeline, page 6*). If you would like to know more, then visit the *Exploring Avebury* website: www.exploringavebury.com. There you will find detailed information about Avebury, with maps, photographs, links and more.

Measures, Maps and Names

The metre is the chief measure used throughout this book. For longer distances I have used the mile. Few Britons can visualise kilometres, for despite Britain's met-rication in 1971 all of the country's road signs are still in miles. Similarly, I have used the acre rather than the hectare, and the ton rather than the metric tonne. When referring to pre-metric archaeological reports the original measures have been used.

The maps use only Ordnance Survey data that is copyright-free, such as contour lines, which have been shaded to indicate altitude in 5m steps, with dark for low ground and light for high ground. The positions of roads and buildings are approximate and are for reference only: they should not be used in place of a proper road map.

There are two spellings of *Kennet*. One *t* is used for naming the river and associated archaeological sites, two *t*s for the villages of *East* and *West Kennett*. This came about in the 1970s, long after the various sites had been named, when the two villages decided to re-adopt their old spellings. Avebury, until the early twentieth century, was known as *Abury*.

EXPLORING AVEBURY

Avebury lies about 90 miles west of London, between Calne and Marlborough in the county of Wiltshire. Less than 20 miles to the south is Stonehenge. Close to the A4 road and not far from the M4 motorway, Avebury is easily reached by car and has ample parking for visitors. Buses to Avebury run hourly from Swindon, which is well served by trains from London and Bristol.

However you arrive, the Avebury Complex is best explored on foot. Moving slowly through the landscape as the Avebury people did 6,000 years ago, we can better appreciate the vast scale of Neolithic construction and gain some sense of how monuments and nature interact in a ritual landscape. To the many visitors who form a personal, often spiritual connection to Avebury, this is also a sacred landscape. Despite today's traffic and aeroplanes, peace and solitude can still be found throughout much of the Avebury area, often with no-one else in sight and the silence broken only by skylark song.

Avebury is best known as the world's largest stone circle: a quarter of a mile across, it partly encompasses a village. However, the stone circle is just one element of the Avebury Complex. Scattered across the ritual landscape surrounding Avebury is a wealth of prehistoric monuments, spanning many thousands of years in their construction (*see timeline, page 6*).

Avebury was awarded World Heritage Site status by UNESCO in 1986, in a joint application for 'Stonehenge, Avebury and Associated Sites', which uniquely included not just the megalithic monuments, but a large area of countryside around them. The two sites are listed as 'monuments and their landscape setting'. Destruction, wilful damage and digging of the monuments are illegal, as is the use of metal detectors. As ritual landscapes, the space between the monuments is considered as important as the monuments themselves.

There is an excellent network of public footpaths around Avebury, and wide expanses of open access land, so major roads can largely be avoided. Public rights of way are shown clearly on Ordnance Survey (OS) maps, which are widely available. Please take great care when you do encounter the roads, particularly if you are not used to traffic driving on the left. The A4 road can be dangerous to walk along or cross, as many drivers ignore the 60mph speed limit.

English Heritage's map of the entire World Heritage Site (WHS), with Stonehenge and Avebury on separate sides of the sheet, is highly recommended. At the very large scale of 1:10,000 (6 inches to the mile) it is by far the best aid to navigating the landscape. The map can be found on sale in Avebury's shops.

The most useful OS map for Avebury is the *Explorer Map 157 Marlborough & Savernake Forest, Avebury & Devizes*. At a scale of 1:25,000 (2½ inches to the mile) it shows all of the area around Avebury in considerable detail. OS also produces

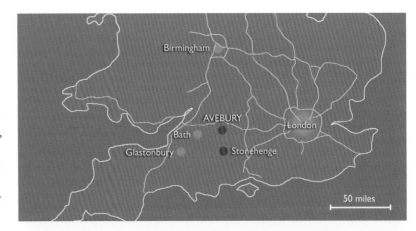

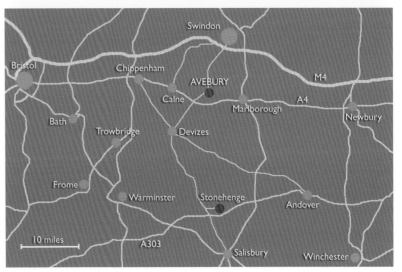

the *Landranger Map 173 Swindon & Devizes, Marlborough & Trowbridge*, but at the smaller scale of 1:50,000 (1¼ inches to the mile) it is less suited to walkers.

GPS is useful too, but do not rely on just a mobile phone for navigation — coverage is patchy and the signal can be poor across much of the WHS, including Avebury village.

The *Exploring Avebury* website has lots more information on mapping, including a guide to using OS maps, GPS and Google Earth.

Not far from Avebury there are several small market towns that are well worth visiting. Marlborough and Devizes are particularly interesting and attractive. Both still have a traditional weekly market; Devizes also has the superb Wiltshire Museum, home to one of the finest Bronze Age collections in Britain, which includes gold from the burials near Stonehenge.

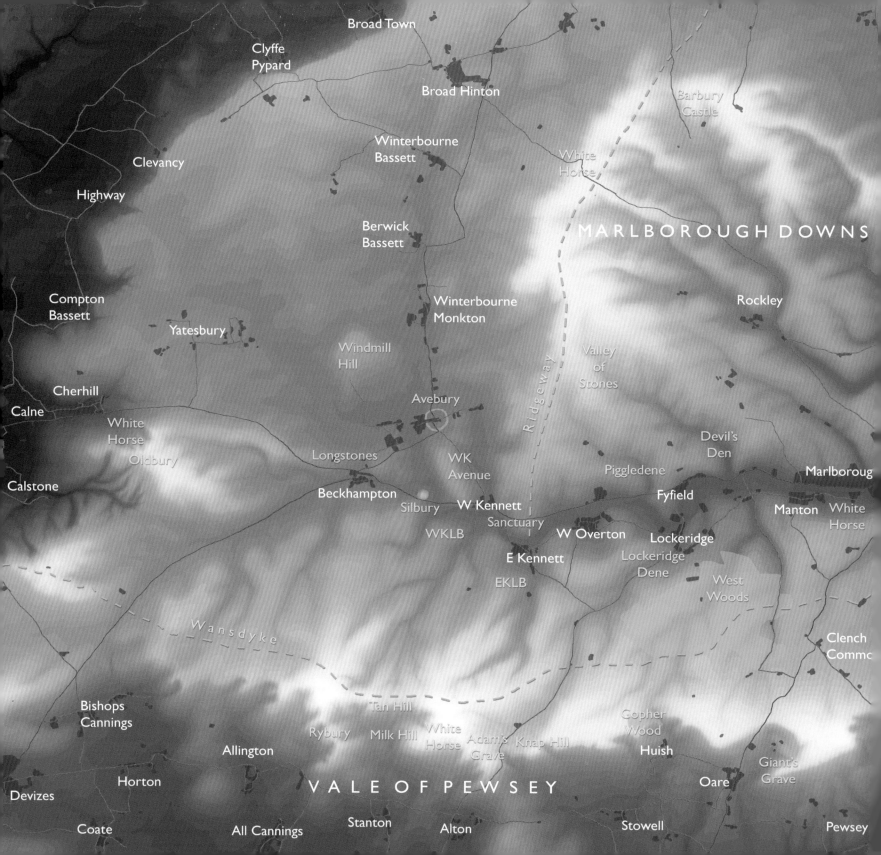

THE AVEBURY COMPLEX: INTRODUCING THE MONUMENTS

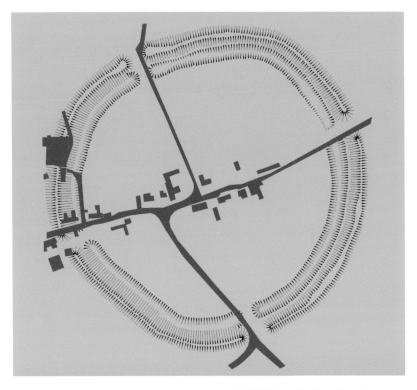

Avebury Henge (left)

Roads divide Avebury's circular earthwork into four quadrants (*left*). Most visitors enter Avebury from the National Trust visitors' car park, sited to the south-west of Avebury; it is a short walk from there to the High Street. Turning right onto the High Street leads eastwards, towards the centre of the henge and the Red Lion pub. On the south side of the High Street are the Henge Shop and the Avebury Community Shop. On the north side of the High Street is a path leading to Avebury Manor, the National Trust museum, cafe and shop. Also on the High Street there are public toilets.

West Kennet Avenue (below)

From Avebury's southern entrance a double row of standing stones runs south alongside the B4003 road to the village of West Kennett. Partially restored by Keiller in the 1930s, the Avenue is fenced and sometimes grazed by cows or sheep. It may be accessed from the south-east quadrant of the Avebury Henge. Alternatively, at the far southern end of the restored section of avenue there is limited roadside parking. Also at the southern end is a gate leading into an empty field beyond. Turn right here and climb up Waden Hill: at the top is a stunning view of Silbury Hill, the West Kennet long barrow and more.

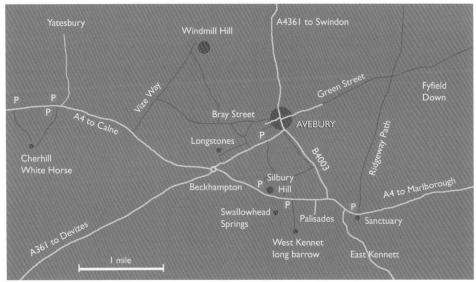

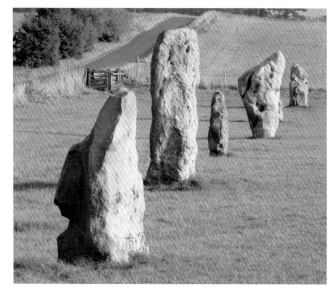

The Longstones

Avebury once had an avenue leading from its western entrance, but only two of its stones can be seen today. Known as the Longstones, or Adam and Eve, they are sited in an accessible field not far from the Beckhampton roundabout.

The Sanctuary

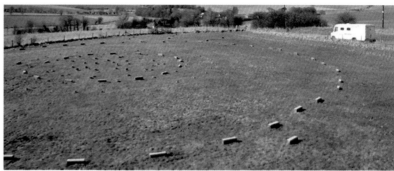

Sited on top of Overton Hill, the Sanctuary has nearby parking places north and south of the A4 road, which can be dangerous to cross at that point. The Sanctuary is in a small, fenced-off field on the south side of the road. Nothing remains of the former timber and stone circles, but coloured concrete markers indicate where they once were. There is a fine view of Silbury from the site; the West Kennet Avenue may also be seen, as can the East and West Kennet long barrows. From East Kennett village a public footpath leads up to the Sanctuary; it may also be approached from the north by the Ridgeway.

West Kennet Palisaded Enclosures

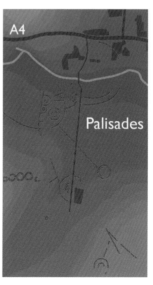

Silbury Hill

There is a dedicated car park on the A4 road next to Silbury, but the most satisfying way to approach the hill is by walking there from Avebury. From the National Trust's Avebury car park entrance there is a good circular walk around the hill. No-one walking around Silbury can fail to notice its ugly vertical scars, which are made, and worsened, by every individual who ignores the signs and climbs the mound. Please – do not climb Silbury. There is a better view of the Avebury area from the top of Waden Hill, just a short distance away, with easy access.

Two huge timber enclosures, radial lines and other features once ranged across a vast area south of the A4 at West Kennett. The enclosures were made from a continuous wall of 2,000 mature oak tree trunks that was probably up to 5m high. Today there is nothing to be seen, although traces sometimes appear as cropmarks on aerial photographs. Walking the area where the Palisades once were is the only way to truly appreciate their vast scale. In the centre of the Palisades area is Gunsight Lane, a tiny road running south from the A4. If driving, the turn is safest when approached from the east. Another option is to walk into the area from the footpath leading to the West Kennet long barrow. Turning east after crossing the River Kennet, a footpath leads to Gunsight Lane.

Windmill Hill

The earliest occupied site of the Avebury Complex, Windmill Hill is a beautiful place that sees few visitors, largely because it can only be reached on foot. The hill is not steep or particularly high but the views from the top are superb and several of the Avebury monuments are visible. The earthworks on the hill – three concentric banks and ditches – are not so easy to make out, but odd traces can be seen, especially on the north-east side. Numerous round barrows were added in the Bronze Age, after the original enclosures had been disused for many centuries.

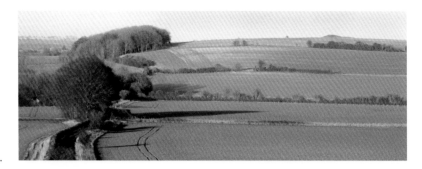

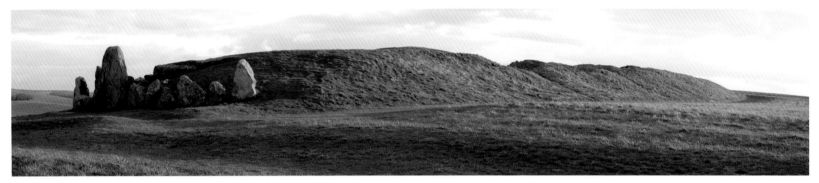

West Kennet Long Barrow

The stone chambers of this 6,000-year-old monument are open and accessible. Sited on a low hill, the long barrow can only by reached by a footpath running south from the A4 road, about 500m east of Silbury. Walking there from the Silbury car park is easy; there is also limited parking on the south side of the A4, just where the signposted path begins. The path crosses the River Kennet by a bridge. A short way to the west of the bridge are the Swallowhead Springs, which can be reached by crossing the field and using stepping stones to cross the River Kennet.

White Horses

Wiltshire has eight hill figures of giant horses, made by cutting through the turf to reveal the chalk beneath. Positioned on steep hillsides, they may be seen from several miles away. The famous *Uffington White Horse* in Oxfordshire is about 3,000 years old, but all of Wiltshire's horses are relatively modern, dating mostly from around AD 1800. Close to Avebury there are several horses, of which Cherhill is the most impressive. It may be viewed from the A4 road just east of Cherhill village. Above the horse is the Iron Age Oldbury Hill Fort and a nineteenth-century obelisk.

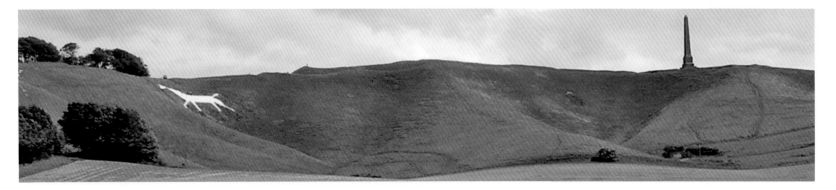

AVEBURY'S LANDSCAPE

Beneath the Avebury turf is a layer of chalk up to 210m thick. It is chalk that gives the Avebury area its characteristic landscape of gently rolling hills and dry valleys. A very pure form of limestone, chalk is made from fine particles of calcium carbonate compressed into rock. Flint – a hard, brittle form of silicon dioxide – is often found inside cavities in the chalk.

Sarsen Drifts

Several of the monuments, such as the Avebury Henge and the West Kennet long barrow, feature sarsen stone – an extremely hard form of sandstone – in their construction. Not unique to Wiltshire, sarsen is found in many parts of southern England, in a line that broadly extends from Dorset in the west to Kent in the east; also in parts of Oxfordshire, Buckinghamshire and Somerset. The greatest concentration is on Fyfield Down, a couple of miles north-east of Avebury. Sarsen occurs naturally in 'drifts', where many lumps or slabs of the stone are found scattered over a wide area, typically in the bottom of valleys. Although a great quantity has been removed in recent centuries for use as building stone, there are still several places where spectacular sarsen drifts can still be seen. All are now protected.

The map (*right*) shows just how much sarsen was removed from the Avebury area in the late nineteenth and early twentieth century. Areas in yellow are dense drifts of sarsen as recorded by A.C. Smith in 1885; orange areas are the drifts that survive today. Thousands more stones may still be found scattered across the landscape, but they are too widely spaced to be considered drifts.

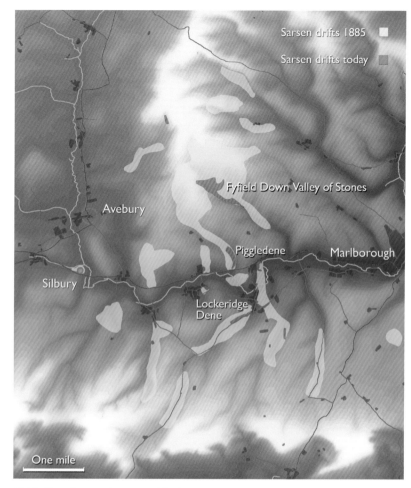

Sarsen drifts 1885
Sarsen drifts today

Fyfield Down Valley of Stones

Avebury

Piggledene Marlborough

Silbury

Lockeridge
Dene

One mile

Distribution of sarsen stone around Avebury.

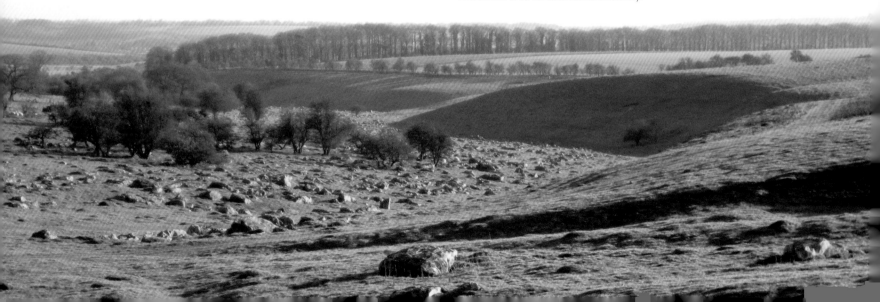

The Valley of Stones, Fyfield Down

An estimated 20,000 sarsens survive in the Valley of Stones (*below*) despite an intense period of commercial stone-extraction at the start of the twentieth century. All except a handful are quite small, and none resemble the sarsens of Avebury or Stonehenge. Most of the Fyfield stones are covered in lichen, with one rare species that grows only on sarsen stone (overleaf).

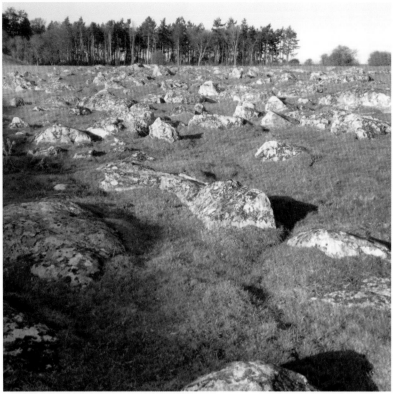

Lichen-covered sarsens of Fyfield Down.

Lockeridge Dene (*below*) is partially visible from the road through Lockeridge village. Walk further south-west though, beyond the trees, and a far more impressive area of stones is hidden from the road. Many Lockeridge stones have unusual and characteristic rootholes.

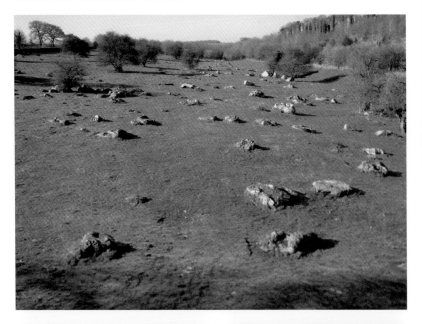

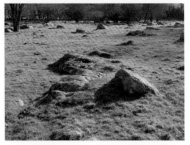

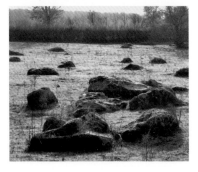

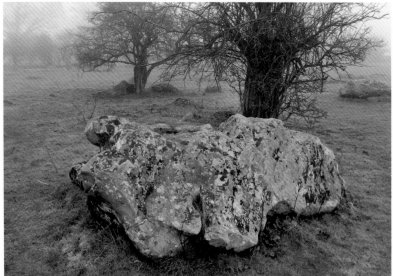

Piggledene (*above and overleaf*) is a beautiful little valley, most readily accessed from a particularly bad section of the A4 road where parking is impossible. It is best reached by parking at Fyfield, from where there is a pavement running beside the road to Piggledene. Public footpaths connect Piggledene to the Valley of Stones, only a mile or so away to the north.

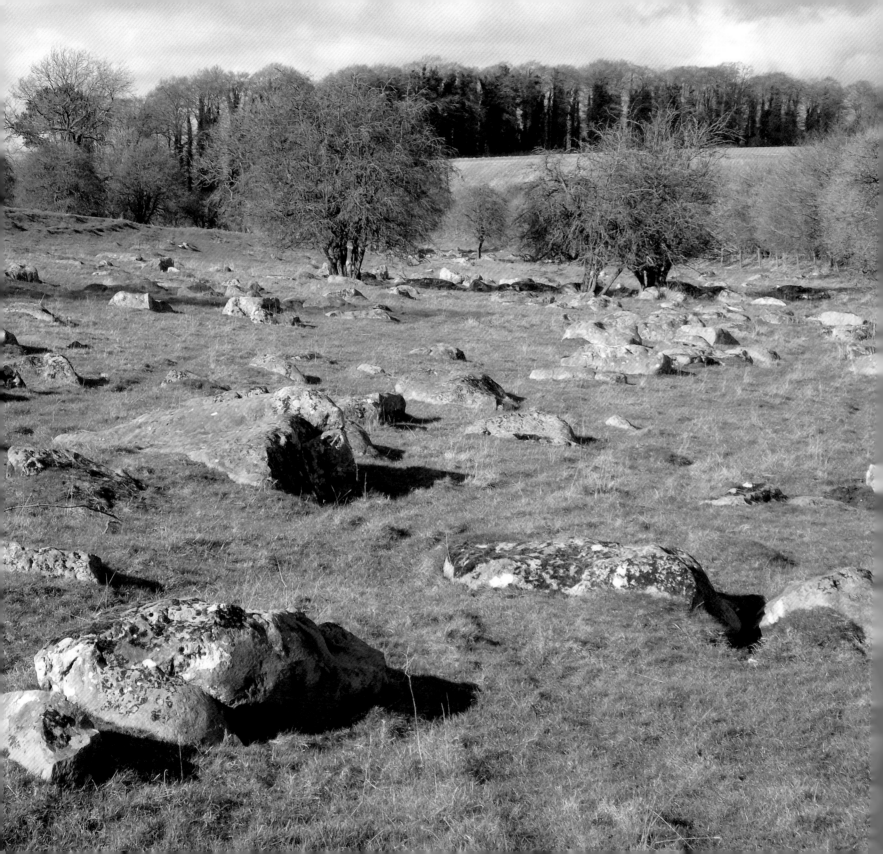

How was Sarsen Stone Formed?

Sarsen is a *silcrete* – a form of sandstone that has been solidified, not under pressure, but by the absorption of dissolved silica. The source of the silica is not certain, though it may have come from rotting vegetation or marine life. Avebury's sarsens appear to be a type of silcrete that generally forms in river valleys, the sand absorbing dissolved silica from below by capillary action.

Around 40 million years ago, when the sarsens were formed, the Avebury landscape was probably a low-lying tropical wetland very like the Everglades of Florida today. Some sarsen stones have holes, made by the roots of plants and trees growing through the layer of sand before or during its silicification. Although there are many holes that strongly resemble animal burrows, no animal fossils have been found in sarsen stone. There are, however, clear indications that certain holes were made by coniferous trees.

Rare pieces of petrified wood found in sarsen stone closely resemble the swamp cypress, a species of deciduous conifer common today in the Everglades, which often grows alongside mangrove species, reeds and grasses.

There is a unique fragment of petrified wood in a sarsen stone close to Avebury – a piece of twig some 40mm long by 15mm in diameter. In its cross section, tiny holes can be seen: they are *resin pores*, indicating that the wood is coniferous. Compare pictures of the fossil with a piece of twig of the same size found beneath one of Lacock's swamp cypresses.

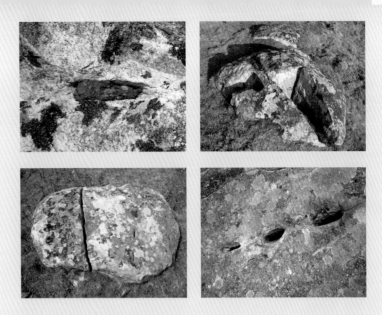

Sarsen stone is extremely hard and notoriously difficult to work with. Amongst all the drifts that exist today, occasional abandoned split stones may be found, sometimes with iron wedges still imbedded in them.

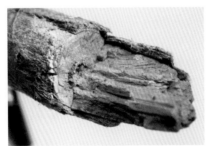
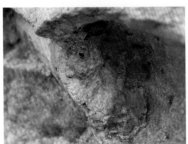
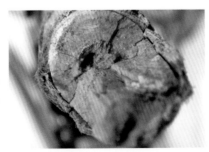

Fossilised wood in sarsen stone.

Swamp Cypress twig from Lacock Abbey.

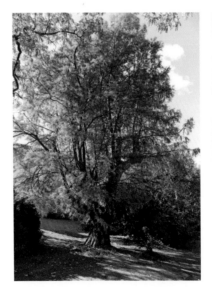

Swamp cypress can be found in parkland collections all around Britain. Just 15 miles west of Avebury, in the grounds of Lacock Abbey, two large specimens may be seen (*above*). Both were planted in the 1830s by William Henry Fox Talbot, the inventor of photography. Lacock is well worth visiting; the abbey has beautiful grounds and a fine museum.

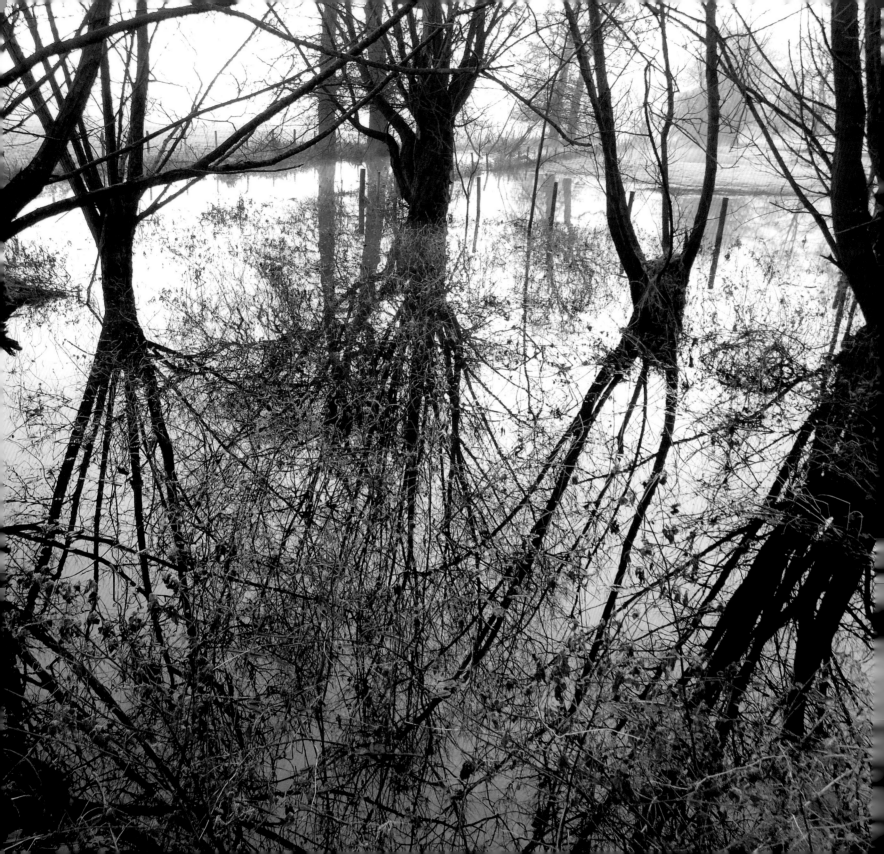

AVEBURY'S WATERSCAPE

Water is vital to life. For any settlement of people a reliable supply of clean drinking water is essential; a farming community must also have water to sustain crops and livestock. But to the Avebury people, water seems also to have had ritual or religious importance, since so many of their monuments were sited near rivers and springs.

Comparing Avebury to other henge monuments in Britain reveals that a strikingly common factor is their proximity to moving water, and particularly to a confluence of rivers – often where one river flowing south joins with another flowing east. This may be coincidence; it may also be that south-west Britain's natural eastward tilt produces a general movement of water in that direction. Yet there are many prehistoric sites in other parts of Britain that also indicate a preference for east and south. The reason for this may be in the sky.

The sun and moon both rise in the east, reach their highest points in the southern sky and set in the west. This phenomenon has been explained in folklore as the sun, moon or both, 'dying' in the west, passing through an 'underworld' to the north and being 'reborn' in the east. North is associated in many cultures with darkness and death. Long barrows, the earliest of Neolithic burial monuments, are usually aligned with an entrance that faces the sunrise, suggesting a belief in reincarnation.

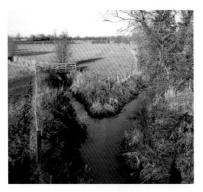
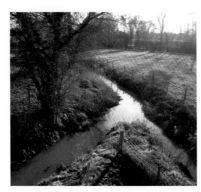

Confluence of the Oslip and the Winterbourne, just west of the Avebury Henge.

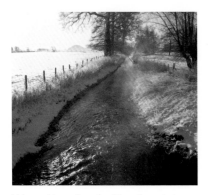

Warmed by springs, the River Kennet steams as it flows by Avebury and Marlborough.

OPPOSITE: Flooded willows in Avebury. To some traditional cultures the Otherworld is a mirror image of the material world; water is a conduit between worlds. Hence, when we see reflections in water we are glimpsing the Otherworld. Was this how the Avebury people regarded water? At Blick Mead, a recently discovered Mesolithic site in Amesbury, close to Stonehenge, it appears that 'votive offerings' were being deposited in springs from as early as 7550 BC. This practice continued throughout Britain for millennia. Numerous valuable offerings have been found in the River Thames, which was apparently regarded as a sacred river in the Iron Age (800 BC–AD 100) and may always have been sacred. Springwater rising in the Avebury area flows east into the Thames and was possibly thought to be its true source in prehistory.

Where Does the Water Come From?

The Avebury landscape is made of chalk, which is naturally permeable to water. Rainwater seeps down through the chalk until it reaches a bottom layer of impermeable rock or clay and forms an *aquifer* or saturated layer. Britain's underground reserves of groundwater are colossal, providing around a third of the drinking water used in England and Wales. Exceptionally pure after being filtered though chalk, the water needs minimal treatment.

Aquifers are peculiar things; the popular belief that they are underground lakes is wrong – they more resemble dense sponges. Seasonal variations in rainfall are mirrored by the fluctuating level of water stored below ground, known as the *water table*. As winter rains seep into the chalk the water table rises; when that water reaches ground level it may flow out as a spring. But in the summer, when less rain falls, the water table will drop again and the spring will eventually dry up until winter. Rivers flowing from these seasonal springs are known as *winterbournes,* of which Avebury has several. They go on to feed *chalk streams* such as the River Kennet. Chalk streams are exceptionally clear. Rainwater seeping into the ground is slightly acidic; in slowly dissolving the alkaline chalk, it releases some of the flint trapped within the chalk to produce a fine gravel that lines the river beds, preventing the silt beneath from muddying the water.

A clean and reliable water supply that will not run dry in the summer months may be provided by perennial springs, which can often be found where a layer of permeable rock, such as chalk, meets an outcrop of impermeable rock or waterproof clay. Such springs tend to occur in lines along this boundary and over centuries have produced what are known as *spring line settlements* that have eventually grown into villages. If the springs are not entirely reliable, a well dug down into the aquifer will ensure a constant water supply.

Even the tiniest of villages would once have had many wells; old maps show that at one time, Avebury had up to twenty wells. One can still be seen today inside Avebury's Red Lion pub (*below*). Dug in 1600, the 20m-deep well is now a decorative feature. Water can always be seen in the well, its level rising and falling seasonally with the water table. I have recorded a 5m variation in the level between a wet winter and a dry summer. Some wells in the Avebury area fluctuate by an incredible 15m or more.

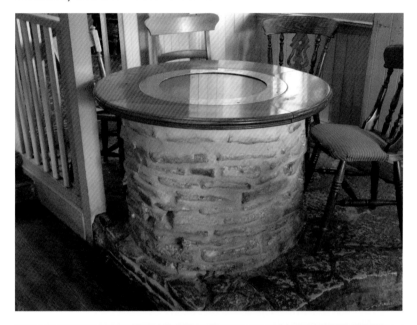

Well in the Keiller Room of the Red Lion, Avebury.

Springs and Rivers

Avebury is sited next to a confluence of two rivers, the Winterbourne and the Oslip. Both are winterbournes ('winter rivers') that usually dry up in summer. Although they drain rainwater from a wide area of farmland, the rivers are also fed by springs.

Chalk springs are special and unique places that were surely regarded as such in prehistory. Where they flow there can be perpetual springtime, even in the depths of winter. Water from underground springs invariably has an all-year-round temperature of about 10°C (50°F). In winter, spring water can be considerably warmer than the frosty ground it emerges from. Spring-fed rivers can be seen to steam in cold, frosty weather (*page 21*). If water from a spring flows across a field it warms the soil. This can stimulate the grass to grow throughout winter when it should be dormant, producing bright green, fresh growth that would not normally be seen until March or April.

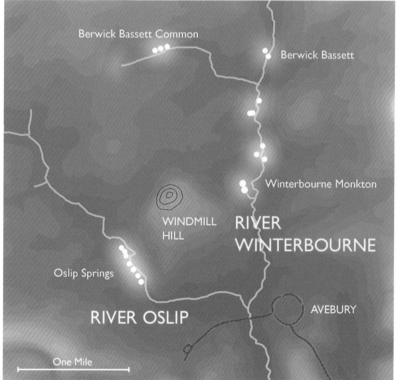

The springs serving Windmill Hill.

RIGHT: A 10 mile by 10 mile area map showing Avebury's rivers and springs.

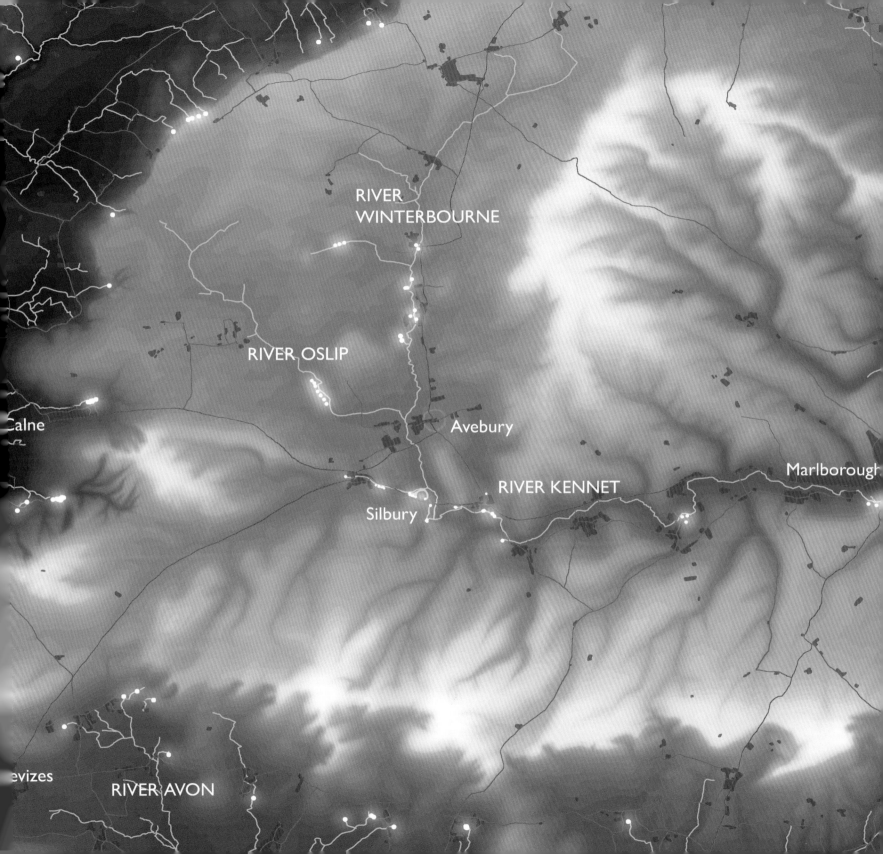

Archaeological evidence suggests that conditions were warmer in the Neolithic, with a water table estimated to have been 2m, or possibly as much as 5m, higher than today's. Springs that are now seasonal may then have run perennially. Only during periods of exceptionally wet weather can we see how the Avebury area may have appeared 6,000 years ago.

Water levels reached an all-time high in the winter of 2012–13, after several particularly dry years when some seasonal springs failed to flow at all. Silbury's ditch flooded and springs that had not been seen for decades began to flow once more. This provided a perfect opportunity to trace Avebury's rivers to their spring sources.

In freezing weather a thermometer may be used to identify springwater at a constant 10°C. Other water sources, such as pools of rainwater, typically measure only about 2°C and may be iced over. Within a 5-mile radius of the Avebury Henge there are more than fifty separate areas of springs.

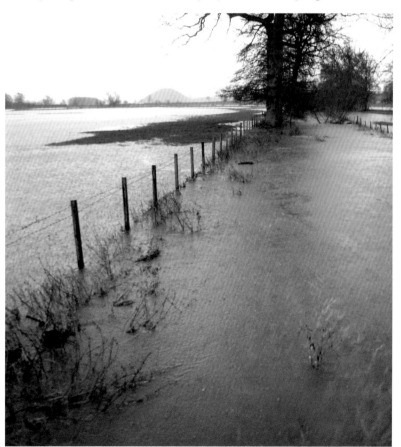

River Winterbourne in flood, from Bray Street bridge.

River Winterbourne

The River Winterbourne flows south to Avebury after passing through the villages of Winterbourne Bassett and Winterbourne Monkton, their Anglo-Saxon names indicating that the river has probably been seasonal for at least the last 1,000 years. Just west of Avebury the Winterbourne joins with a smaller river, the east-flowing Oslip. Downstream of the confluence the river continues south past Silbury Hill, where it is boosted by several springs before flowing on eastward for some 45 miles to become the River Thames.

The furthest spring source I have found for the Winterbourne is about 2 miles north of Avebury, at Berwick Bassett, though there are said to be springs feeding the river from even further north. A little further south there are many springs in and around Winterbourne Monkton, which has a number of delightful public footpaths running through the village, along the banks of the Winterbourne. Here, in the winter months, springs appear, gurgling and bubbling from all along the sides of the river (*below*).

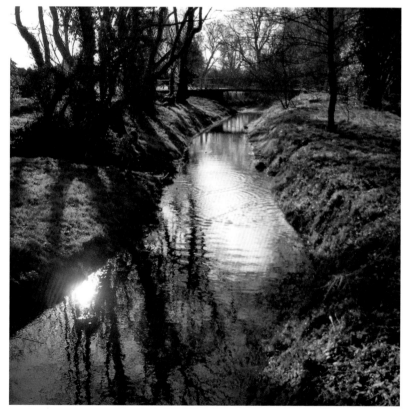

River Winterbourne at Winterbourne Monkton.

River Oslip

Some writers have referred to this river as the *Sambourne*, but that name is not known or used locally – farm workers refer instead to the *Oslip*. Horslips Bridge crosses over the river, but it is not clear where that name originated. A field to the east of the bridge is labelled on some old maps as *The Sambourne Ground*.

Starting about 4 miles north-west of Avebury, the Oslip drains a large expanse of flat and featureless farmland where there are no springs. Carrying only rain-water, it flows east through Yatesbury, thereafter becoming spring-fed as it nears Windmill Hill.

Covering a huge area of about 8 acres, the Oslip Springs may have been the main supply of water for Neolithic people feasting on Windmill Hill, just half a mile away. The springs may even be what first attracted people to the area: it is possible that such extensive springs may have been regarded as a special place in the Mesolithic, like those at Blick Mead in Amesbury, but there has so far been no investigation of the site. The springs rise in an area of rough scrubland bordering a byway known as Vize Way. They continue south-east for almost half a mile, forming small pools in a narrow strip of fenced-off woodland running parallel to the River Oslip.

The Oslip and the Winterbourne form their confluence 90m north of the footpath bridge into Avebury from Bray Street. The united river briefly becomes the Winterbourne, then is a little further on renamed the Kennet. Somewhere near the Bray Street bridge, the river is thought to have been crossed by the now

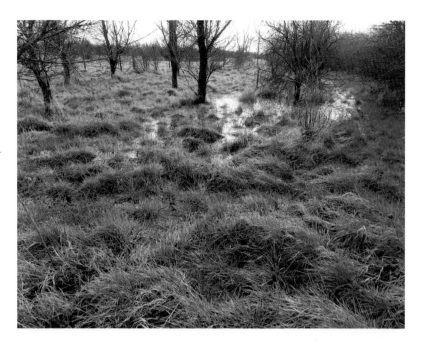

vanished standing stones of the Beckhampton Avenue, so this may once have been a very important place, perhaps for a ritual water-crossing into Avebury. Would it always have been possible to wade across the Winterbourne at this point? The river normally runs in a channel about 3m wide, but in the flooding of winter 2012–13 it burst its banks and spread to around 200m wide: flowing fast, with currents and eddies, it made a dangerously formidable barrier.

The Oslip Springs, with north-east view to Windmill Hill.

The Old Kennet

When Avebury is flooded, as in the north-east-facing photograph below, we can begin to see how its rivers would likely have appeared at the time the monuments were constructed. Today the confluence of the Oslip and Winterbourne is inconspicuously tucked in the corner of a field; when the water table rises to Neolithic levels it covers a vast area, becoming a lake.

For most of its course through the Avebury area the modern River Kennet has been *canalised* – forced into a narrow, man-made channel and sometimes shifted onto higher ground, far from its natural route. Flowing over flat land with gentle gradients, it would naturally sprawl across an area up to 200m wide. During high rainfall the river would form wide, continuous sheets; in drier periods it would become a marshland, shrinking to a skein of thin, meandering braids. When Avebury floods today, the modern River Kennet inevitably bursts its banks and the water follows its prehistoric, natural course: we then see the return of the *Old Kennet*.

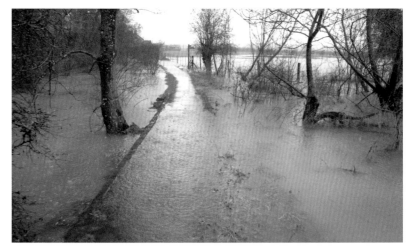

Flooding at Bray Street, Avebury.

Aerial photograph by Philippe Ullens.

Silbury's Ditch Fills

Triggered by sudden high rainfall, the River Kennet bursts its banks; around Silbury Hill the meadow becomes a sheet of water. Much of the floodwater runs off into the Kennet, then on to the Thames and ultimately the sea. However, a great deal of water seeps down into the chalk, charging the aquifers: this is the trigger for Silbury's ditch to begin to fill, a process that takes about three weeks.

The present course of the River Kennet past Silbury is artificial: it has been moved uphill into a narrow, man-made channel at the base of Waden Hill, about 100m north-east of where it would naturally flow. In the weeks following a deluge the original River Kennet returns as a wide, braided river – the *Old Kennet* – flowing alongside its modern counterpart. Today, the River Kennet supplies no water at all to the Silbury ditch, but an ancient southerly route across the meadow may have done.

Avebury is sited close to a confluence of east and south-flowing rivers: Silbury is sited exactly *on* such a confluence. Flowing east to Silbury is the Beckhampton Stream, which only partly feeds the Silbury Ditch; its course across the Silbury meadow has actually been engineered to divert water *away* from Silbury and into the River Kennet. Only a fraction of its flow escapes into the ditch. The Beckhampton Stream also forms braids as it crosses the meadow, expanding at times to become a lake. North-east of Silbury its strands reunite, then are channelled into a drain running off into the modern Kennet. The braided Old Kennet, when flowing strongly, ignores this drain and flows across it.

Springs may be found flowing all along the southern bank of the Silbury Ditch. It is largely these springs that keep the ditch filled with fresh water throughout the winter. South-east of Silbury are more springs, including the well-known Swallowhead. The Pan Springs and Waden Springs are also seasonal; both flow

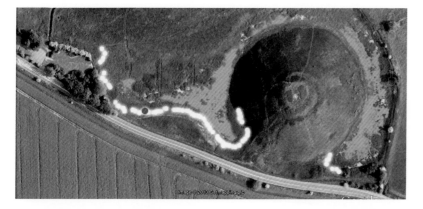

Google Earth image showing GPS positions of springs found flowing into the Silbury Ditch in early 2013. The red spot marks the first spring to appear. In freezing weather the springs, at a constant 10°C, are easily identified by using a thermometer.

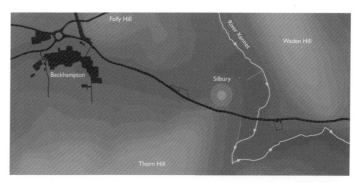

1. After being dry all summer, the Kennet begins to flow on its modern, canalised course.

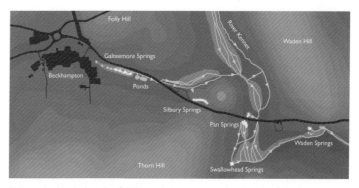

2. As water levels rise, the Old Kennet re-appears and springs begin to flow.

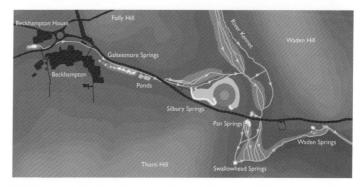

3. With water levels at maximum, the Silbury Springs flow and the system stabilises.

for longer and produce more water than Swallowhead. Further east there are even more springs, forming a line up to East Kennett.

Avebury's monuments are clearly associated with springs. Between East Kennett and Marlborough there is just one spring at Clatford, and near it one monument, the Devil's Den. Springs reappear a few miles further east, near the Marlborough Mound.

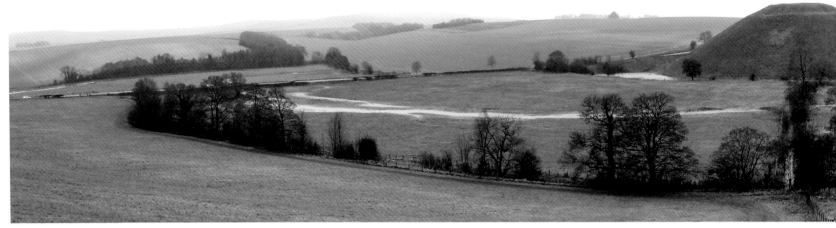

The Old Kennet flows by Silbury.

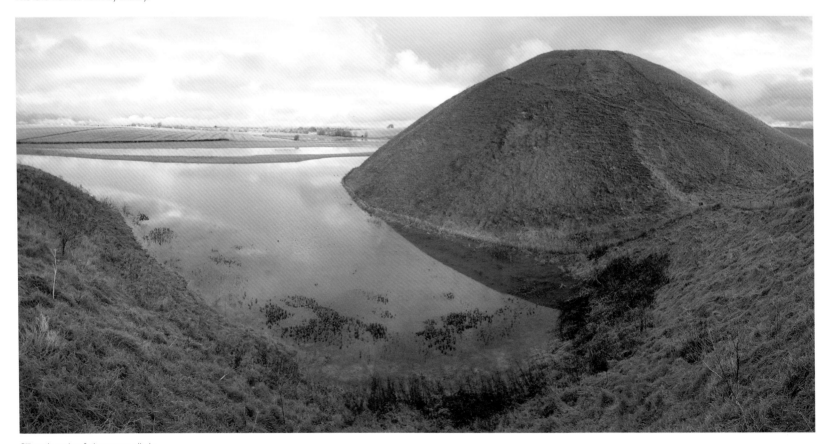

Silbury's spring-fed western ditch.

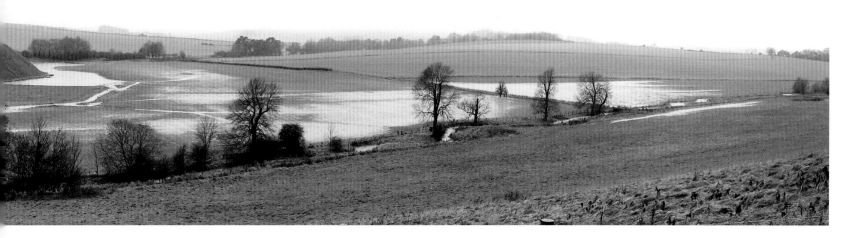

RIGHT: Springs flowing from the edges of the Silbury Ditch. A fall of snow demonstrated why springs may have been regarded as special in prehistory. Only hours after the snow fell holes and bare patches appeared, melted by the warm springwater.

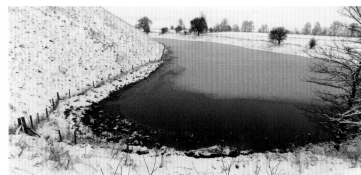

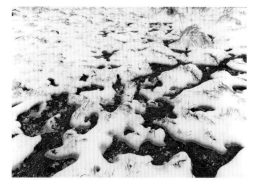

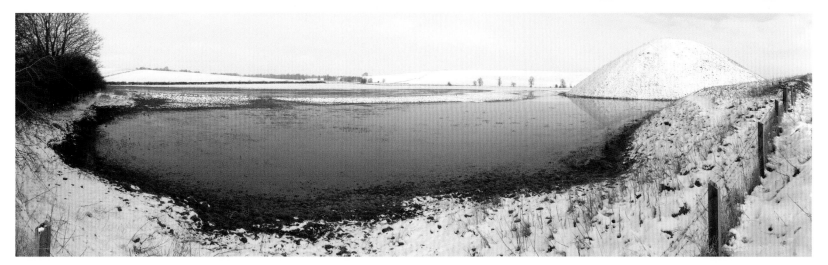

The springs become visible when warm springwater has melted the snow all around the ditch.

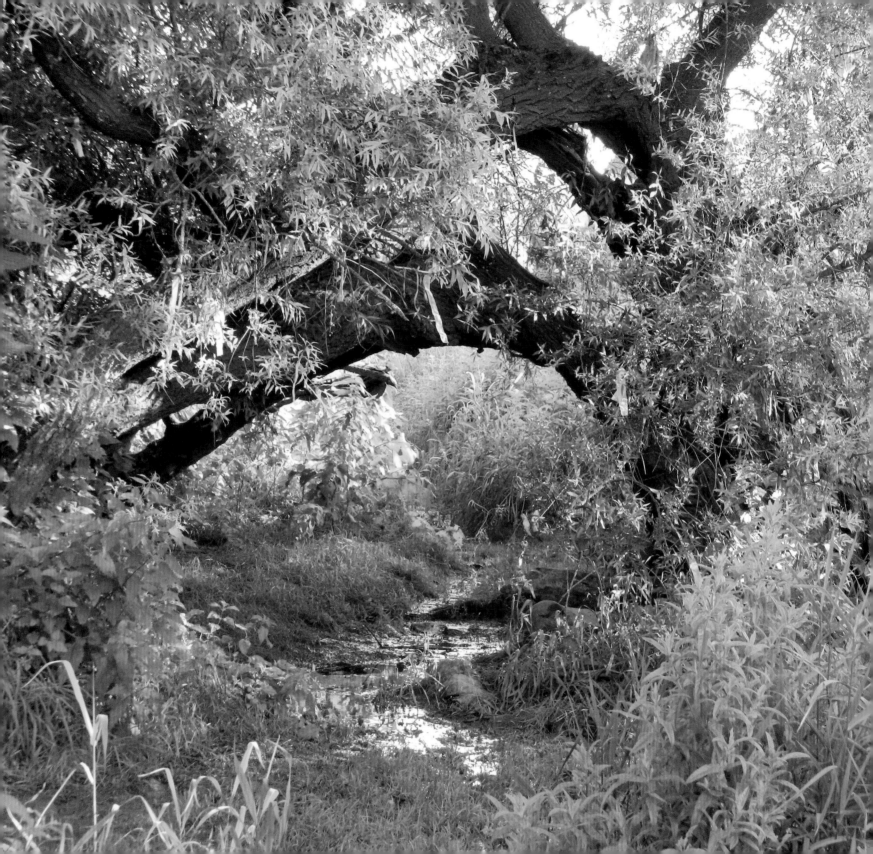

Swallowhead Springs

Of all the springs in the Avebury area, Swallowhead is the best known. Clearly labelled on the OS map, it has become something of a New Age shrine associated with neo-goddess worship. The water emerges from two holes in a low, natural wall of chalk; stones have been arranged around the holes and the immediate area and offerings are frequently left. The water runs north down a gentle, grassy slope and into the River Kennet, under an elderly crack-willow festooned with ribbons.

For most of the year the springs are dry; they used to begin flowing in the autumn but have more recently remained dry until January, February or even later. As well as flowing from the two holes, water rises from the ground in several places along the slope. Those lowest down the slope and nearest the river begin to flow first. As the water table steadily rises, the springs higher up the slope begin progressively to flow. It can be several weeks before the outlets at the top of the slope begin flowing, if they flow at all. It may be that the Swallowhead name originates from the shape made by the River Kennet as it flows south to the springs then abruptly turns east: the shape is man-made. It does resemble the profile of a swallow's head, but this is not at all obvious from the ground, only from maps. The Kennet has been canalised at this point. Instead of running naturally south from Pan Bridge it has been re-routed, probably for the creation of water meadows. Complex and expensive, their careful construction would require plans to be drawn – is that how the swallow-like shape of the redirected River Kennet became apparent?

Pan Springs

South-east of Silbury are the seasonal Pan Springs. Often overlooked, they are sited just south of the A4 road near Pan Bridge. The springs flow into a man-made ditch that runs south to Swallowhead to join the River Kennet. Normally inconspicuous, the springs can expand considerably when water levels are high, appearing even to the north of the A4 road. This volume of water is too much for the usual channel, so a fast and wide river forms, coursing due south with such force that it crosses the River Kennet at right angles (*below*). This section of the Kennet has also been canalised. The swollen river, as well as following its artificial course towards Swallowhead, also overflows, heading due south on its original, natural course to merge with water from the Pan Springs.

Waden Springs

Springwater emerges from several holes in the base of a large mound of soil and rubble that has been tipped from the road above. The mound is not prehistoric, though its origins are still a mystery. Just east of the spring the water flows through a rectangular pond and on into the Kennet. Bubbles can be seen in the pond, where springs rise from below. It is clear that the mound of rubble sits directly on top of an area of very active springs; their true extent only becomes apparent when the warm springwater melts through snow.

Along the River Kennet's eastward course between the Waden Springs and East Kennett there are many more springs. Some may be especially important – notably those at West Kennett Farm, inside the palisaded enclosures (see page 137).

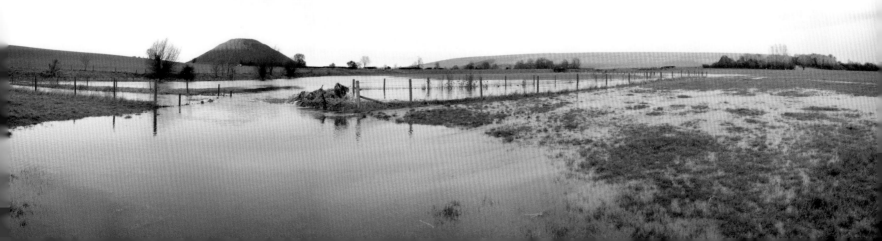

THE ALTON YEW AND SPRINGS

Five miles south of Avebury, in the picturesque Vale of Pewsey, is a magical area of perennial springs. Hidden in a patch of woodland between the twin villages of Alton Barnes and Alton Priors, the springs can be seen bubbling up from the greensand beneath a number of clear pools. The springs may have been regarded as special in prehistory as one of several headwaters of the River Avon, which flows on south to Durrington and Stonehenge.

Close to the springs is All Saints, Alton Priors, a beautiful twelfth-century church (*right*). A venerable yew tree growing in the churchyard is claimed to be 1,700 years old, though it is more likely half that age and contemporary with the church. The Alton yew's hollow trunk has divided into two, yet the tree is perfectly healthy. Without human interference yews have the capacity to live indefinitely. As their lower limbs spread outward they droop to the ground and put down roots that grow into more trees. Over millennia, the trees expand outward in a radial pattern to become a yew grove; what appears to be a forest of individual yews is actually one organism. Aerial shoots grow up in the original hollow trunk and the tree renews itself. Today, this process is usually disturbed by well-meant churchyard 'tidying' such as removing sprawling branches before they reach the ground.

Visitors are advised to drive to Alton Barnes. Follow a sign to 'Saxon Church' from the main road through the village and park by St Mary's church, Alton Barnes. The tiny church has some beautiful glass panels, engraved by Laurence Whistler and his son Simon; it also has a notable yew tree. A sarsen path leads across a field from St Mary's to the springs and All Saints. The field is often muddy and cattle may be grazing. If you visit the churches, please write in their visitors' books.

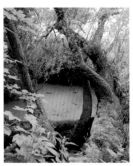

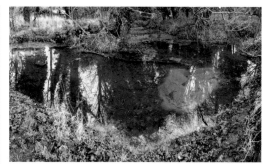
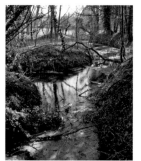

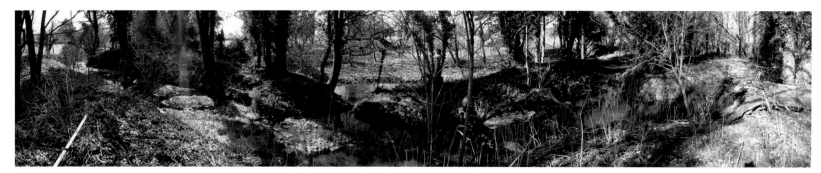

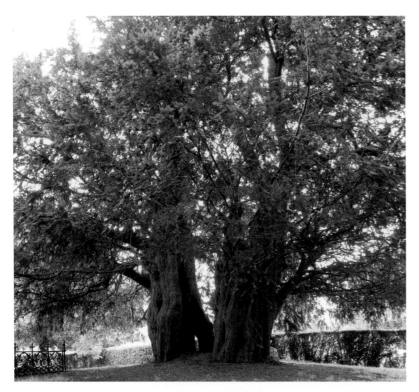
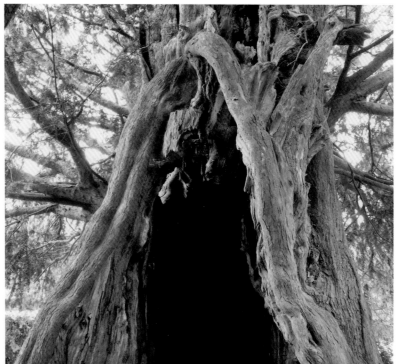

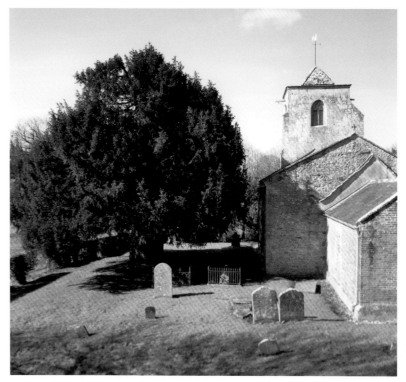

WINDMILL HILL

Date of construction: between 3670 and 3620 BC

A mile or so north-west of the Avebury Henge is the causewayed enclosure of Windmill Hill, the earliest of Avebury's monuments. The name is perhaps misleading, as there is no windmill and the site is barely even a hill, rising only 35m or so above the fields that surround it. The north-western side is steepest and partly obscured by a small plantation of trees; the south-eastern side slopes gently all the way down to Avebury. Windmill Hill is conspicuously visible from Avebury, its

shallow profile enhanced by several Bronze Age round barrows standing proud of the crest. Sited midway between the lower and upper escarpments, the hill has fine views in all directions but particularly of the Avebury area: most of the major monuments can be seen from its summit.

Dating from the early Neolithic, causewayed enclosures are large earthworks often sited on hilltops. England has around seventy examples; there are many more across Europe, with over a hundred in France alone. The enclosures are defined by up to four concentric ditches that are not continuous but were dug in sections, with gaps or 'causeways' between them. Earth from the ditches was piled up to form banks.

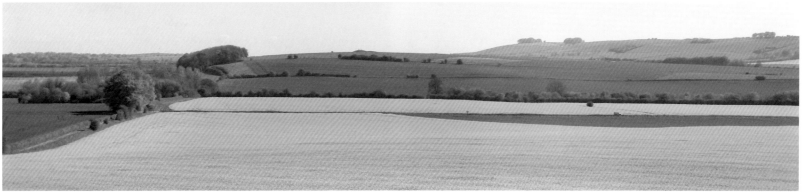

Causewayed enclosures have internal banks sited inside their ditches, unlike the later henge monuments which have external banks. This suggests that henges were designed to symbolically contain something within the enclosure, and that causewayed enclosures had the opposite function – to keep something out or to protect. Some causewayed enclosures undoubtedly had a practical defensive purpose. Hambledon Hill in Dorset, for example, has evidence of timber palisading and at least one episode of violence. In most cases, however, the earthworks were not high and would have been of little use as fortifications.

Windmill Hill was not a permanent settlement, though plant remains indicate that cereals and other crops were grown not far away. Indications are that it was used only occasionally, perhaps annually, for feasting and trade, by people who may have travelled from afar – at least from the Bath and Frome area around 30 miles away. There is evidence that animals consumed at Windmill Hill, mostly cattle, were killed on or close to the site. It was once thought this indicated an annual slaughter of animals that could not be fed though winter, but many of the animals are now known to have not been killed until two or three years old. Isobel Smith and others have compared the site to Tan Hill in the Vale of Pewsey, where an annual fair survived until the 1930s. There are numerous examples of traditional hilltop fairs in Britain, often held well away from permanent habitations, where animals were traded.

The notion that Windmill Hill was used at winter solstice has persisted since the 1950s, but anyone who has ever ventured up there on a winter's night will know that December would be a bad time to hold a social gathering, even if the hilltop was a clearing surrounded by woodland. The hill is usually cold and windy, even in the summer. A far more suitable time might be Lammas, around 1 August and midway between the summer solstice and the autumn equinox. This was the date chosen for Tan Hill and other fairs held on hilltops, and might feasibly be a remnant of some older tradition. For farmers, there would still be plenty of work to be done before resting through the winter but August is a time of plenty, when the first wild fruits can also be gathered.

Windmill Hill has three concentric earthworks (*overleaf*), excavated in the 1920s by Keiller. They are not easy to see today, as they were largely re-filled in the 1950s. Some portions are visible from the ground, particularly after a light fall of snow (*page 37*), but the best view is from Google Earth. In common with other causewayed enclosures, the circuits are not centred to the hill's contours; the outer ditch is offset considerably, extending almost down to the bottom of the hill's north-west side, then passing through a small area of woodland. Ovoid in shape, the outer ditch has a maximum diameter of 360m – around the same size as the Avebury Henge – enclosing an area of nearly 21 acres. Within this

is the almost circular middle ditch, with a maximum diameter of 220m and enclosing 8 acres. The inner ditch is ovoid with a maximum diameter of 85m, enclosing 1.3 acres. The outer ditch has remains of an inner bank; the middle ditch has possible traces and the inner ditch's bank has none.

Vize Way, an ancient byway, runs from the A4 road to Windmill Hill.

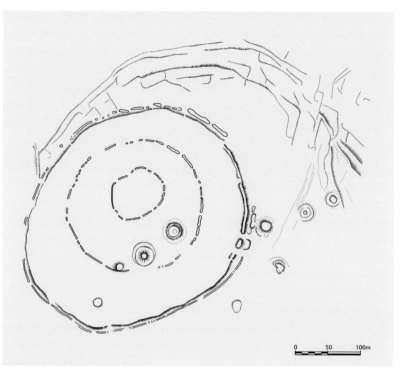

Plan of earthworks on Windmill Hill.

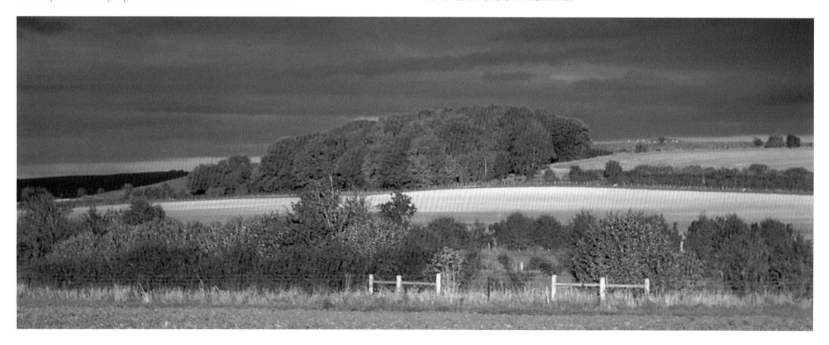

Keiller excavated an enormous quantity of finds from the ditches, including animal and human bones, flint tools and a distinctive form of pottery dubbed Windmill Hill ware. The earthwork was attributed to the 'Windmill Hill Culture' – a term that was used for many years to describe people of the early Neolithic across much of southern Britain, but is now considered too generalised. Since Windmill Hill pottery was also found inside the West Kennet long barrow, it seems highly likely that the two monuments were built by the same people.

Latest Bayesian analysis of carbon dating indicates that Windmill Hill's inner ditch was dug first, probably in 3680 to 3650 BC, followed by its outer ditch. After a pause, during which the workers may well have gone off to construct the West Kennet long barrow, the middle ditch of the enclosure was dug. The entire process took around fifty years. For over 300 years the enclosure continued to be used, with more material being deposited, whilst other similar sites were abandoned after only a generation or so.

Keiller and Windmill Hill

Alexander Keiller began his excavations of Windmill Hill in 1925 after making aerial observations, photographs and detailed plans over the previous year. Keiller had been persuaded to buy part of the site when it became known that the Marconi company were intending to erect a radio mast on the hill. Although he intended to excavate the entire site and publish his findings at three-year intervals, a car crash in 1929 left him unable to work for a time and the work came to a halt.

Keiller bought more land on Windmill Hill in 1937 and now owned the entire enclosure. Almost all of the excavated ditches were dug out again and he restored parts of the banks, re-turfing some of the barrows damaged by rabbits. The whole 70-acre site was then ringed with rabbit-proof fencing and opened to the public. By the late 1950s the deeper ditches and banks were beginning to crumble and erode. Eventually soil and rubble were brought in from outside the site and the ditches almost filled in, leaving just enough of a depression for their outlines to be visible.

The excavations produced around 20,000 pottery sherds, dating mostly from the early Neolithic. Including the finds from later excavations, the remains of some 1,200 vessels have been recovered. Much of the pottery was made locally in the *Windmill Hill* style; some came from as far away as Cornwall. It is clear that the Windmill Hill people had extensive trade links, since polished stone axes were found from Cumbria and every major axe-manufacturing centre in Britain. Cuttings made in the banks of the enclosure produced many worked flints, a hearth of sarsen stone and many broken animal bones, mainly of cattle. Evidence of cereal production included flint sickles with a silica lustre that had probably formed from cutting plant stalks. Some pieces of stone were fragments of *querns* and *rubbers* used for processing grain.

It appears that as soon as the three Neolithic ditches were dug, they began to be filled in again. This was partly due to natural silting but largely due to the deposition of what we would term 'rubbish', though it seems to have been regarded quite differently by Neolithic people, who likely attached some symbolic or religious importance to it. The majority of Keiller's vast quantity of finds came from the ditches. There was a great deal of animal bone, largely from cattle. Bones of pigs, sheep or goats and dogs were found; many were *articulated* (joined to other bones) indicating that they had been deposited as butchered and partly eaten joints of meat.

Such conspicuously wasteful meat consumption has been interpreted as evidence of feasting. Small pieces of human bone were also found; accurately dated to match bones from inside the West Kennet long barrow, it has been suggested that they came from the same source. As well as these fragments, some entire skeletons were found, including those of several children, a goat, a pig and a dog.

Many objects of carved chalk were found. Some are thought to be figurines representing human figures, but they are crude – little more than amorphous lumps with an incised line to divide the legs. Other chalk objects have obvious

sexual symbolism: carved penises, cups thought to represent vulvas and a large number of chalk balls mostly found in pairs, so assumed to represent testicles.

Most of this material was not randomly tossed into the ditches, but was carefully deposited according to some unknown system that suggests ritual meaning. Examples include three pottery sherds nested inside each other, something that was unlikely to have happened by chance as they were discarded.

After its primary use of around 300 years Windmill Hill was visited only occasionally, but was still revered for millennia. As illustrated (*opposite*) the hill is intervisible with the other monuments of the Avebury Complex, giving the impression that the 'founding fathers' watched over the later works of their descendants.

Bronze Age people had a great respect for the past, since they often built their round barrows on or close to Neolithic sites or paths, honouring the people and events of previous millennia. The many round barrows on Windmill Hill were sited there as much as 2,000 years after the causewayed enclosure was constructed.

Why Windmill Hill?

There are several reasons why Windmill Hill may have been regarded as sacred or special long before the construction of any earthworks. Its close proximity to the extensive Oslip Springs (*see page 25*) may likely have been an important factor. Though not particularly high, it is the only hill in an otherwise flat and featureless landscape; the inner earthwork may have monumentalised a natural hilltop clearing surrounded by woodland. Viewed from Yatesbury, on its western side, Windmill Hill is subject to remarkable effects of lighting that can appear quite magical; rainbows form over the hill surprisingly often (*below*). On a windy day with a mixture of sun and cloud, the hill can change quickly and dramatically, adding to the impression that this is a 'special place'.

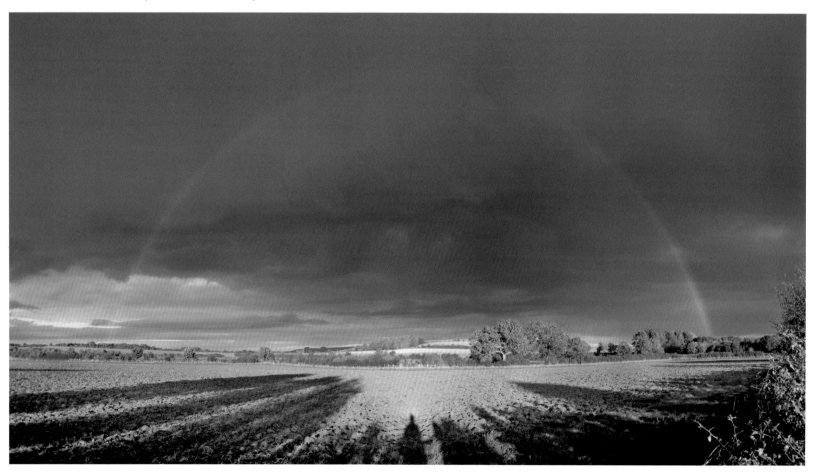

VIEWS FROM WINDMILL HILL

Avebury Henge bank Swindon Stone West Kennet Avenue Sanctuary

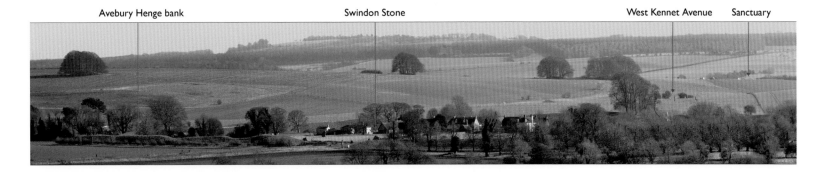

Avebury Sanctuary EKLB WKLB & Silbury Longstones

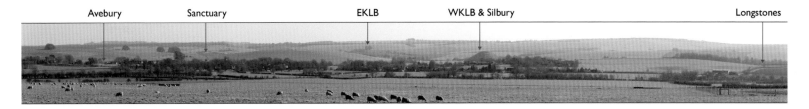

East Kennet long barrow West Kennet long barrow Silbury Hill Eve Adam

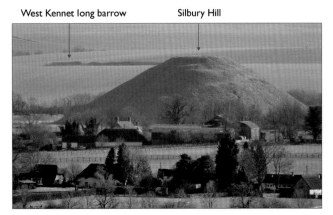
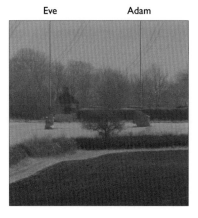

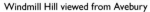

Windmill Hill viewed from Avebury

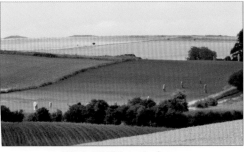

Windmill Hill from the Sanctuary

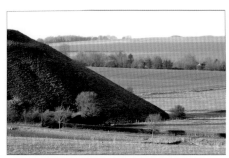

From the West Kennet long barrow

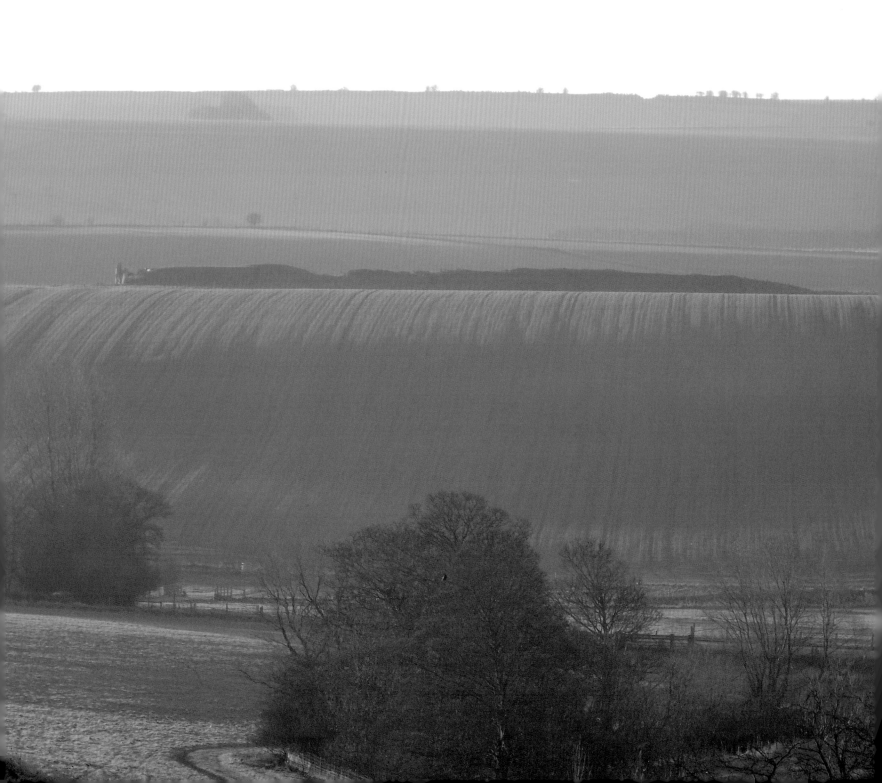

WEST KENNET LONG BARROW

Date of construction: 3670–3635 BC

Visible for miles around, the West Kennet long barrow (WKLB) is sited just below the crest of a hill, half a mile south-east of Silbury. Most days, a steady procession of visitors can be seen walking up and down the track leading to the monument from the A4 road. The WKLB is probably Britain's best-known example of a *Cotswold-Severn long barrow*. Its imposing but badly damaged mound, with parallel ditches on either side, is unusually long at 104m. Just less than a mile to the south-east is the East Kennet long barrow (EKLB) which is comparable, but largely unexplored, and difficult to see beneath its covering of trees and scrub.

The WKLB's mound rises to an opening at the eastern end, which is fronted by a facade of sarsen slabs, some of them very large. Inside are five burial chambers: two pairs are arranged either side of a central passage, with a larger chamber at the western end. Built from slabs of sarsen stone with infills of dry walling, the structure is roofed by more huge sarsen slabs. In common with other Cotswold-Severn tombs, the chambers and passage occupy only about 10 per cent of the mound – there are no more hidden chambers beyond what can be seen (*plan, page 42*).

Inside the solid mound is a central spine of sarsen boulders, covered with chalk rubble from the side-ditches, which are now almost ploughed out. At the eastern end of the mound is a concave forecourt of large sarsen slabs, set upright. In between them is drystone walling.

Before restoration by Stuart Piggott in 1956 the barrow was in a ruinous state and appeared as little more than a scatter of sarsen stone (*right*). Surprisingly, beneath this the chambers were intact and undamaged. Most of the other stones were there but the facade had collapsed, with its largest slab laid flat. The roofing slabs were in disarray and some were damaged, partly from unsuccessful attempts to carry them away for building stone.

Almost all the stones were still on site, although several had been broken with sledgehammers. Some roofing slabs had apparently been broken in 1859, when the antiquarian John Thurnam's labourers dug down into the end chamber. Fortunately, although Thurnam dug on into the central passage he failed to notice the side chambers, which were to remain hidden for another century. They were eventually found by Piggott and Atkinson, who excavated in 1955.

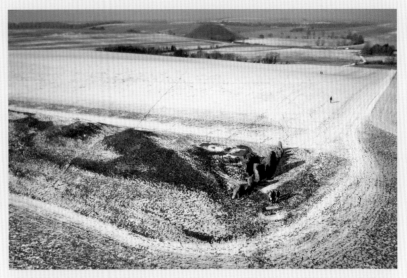

WKLB looking north-west, with Silbury Hill beyond.

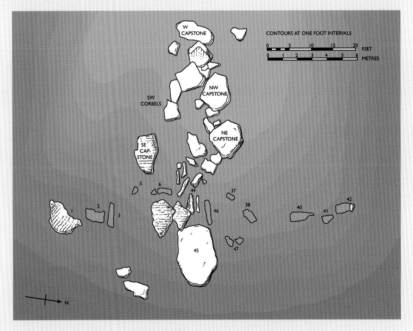

Plan of WKLB as it was in 1956 before restoration.

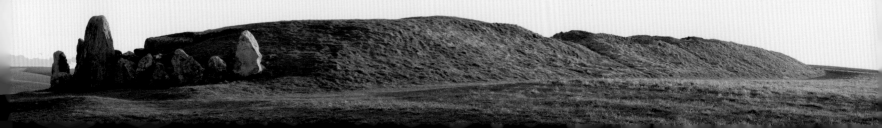

The WKLB is currently believed to have been constructed in 3670–3635 BC, based on carbon dates obtained from the earliest burials found inside. It may, of course, have been constructed before the burial period. This period of 'primary mortuary activity' lasted for only ten to thirty years: just one generation.

After little more than a century the side chambers were sealed off with sarsen stones (the reason Thurnam had failed to notice them) and the entrance was formally closed. Further burials of bones, cremated remains, pottery and other 'cultural material' continued to be added for another 1,000 years or so, by temporarily lifting the roof slabs. Eventually, the chambers were filled up to the roof with chalk rubble containing these deposits. The period of secondary deposition ended around 2200 BC – shortly after Silbury Hill and the Palisades were constructed.

On the floors of all five burial chambers had been placed the bones of probably thirty-six individuals – men, women and children of all ages, from 3 to 50 years. The bones were not distributed randomly, but as so often in the Neolithic, there was some system of organisation that we can only guess the meaning of. In the far western chamber were only males; the inner SW and NW chambers contained mainly adults of both sexes; in the outer SE and NE chambers were old people and juveniles. The bones were placed towards the back of each chamber, which suggests that some space was allocated to the living, perhaps for rituals. The WKLB also has an unusually high roof: at around 2.1m it is twice the height of many long barrows. This, combined with the monument's strange and unusual acoustical properties, would make it well suited to ceremonial activity.

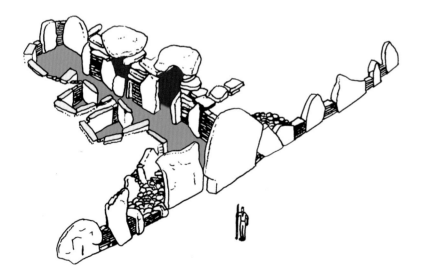

Inside the restored barrow, shown without roofing slabs so the chambers may be seen.

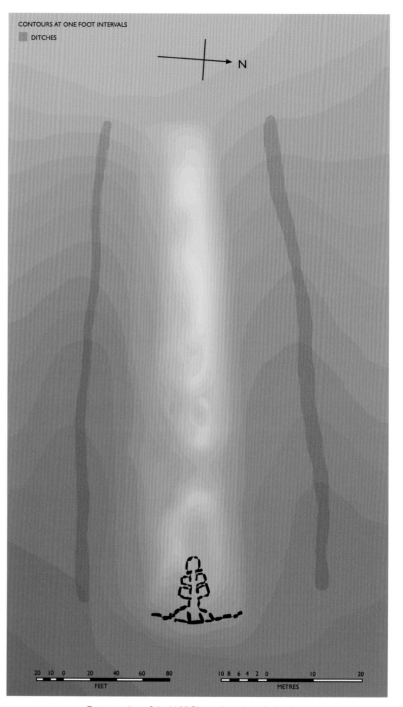

Contour plan of the WKLB's earthwork and chambers.

In today's restored monument, virtually all the sarsen stone is original. However, the original construction also included sections of dry walling made with small, thin slabs of limestone imported from outside the area, as commonly found in other Cotswold-Severn long barrows. Much of the stone used as dry walling in the WKLB was identified as originating from Calne, 7 miles to the west; some though, came from an area between Frome and Bradford-on-Avon, some 20 miles to the south-west. Well over a ton of this 'foreign' stone had been imported to build the barrow. Almost all of the original dry walling had rotted by the 1950s, so it was replaced with new stone from Calne.

Stone numbers of the WKLB.

The Facade and Forecourt

At the barrow's eastern end is the *facade*, forming a straight line from stones 1 to 42 and dominated by the enormous stone 45 at its centre. According to Piggott, this stone was 'an enigma' before the 1955 excavations began. His eventual interpretation was that stone 45 was not erected until the monument's second phase, when the period of primary burial ended and the tomb was 'decommissioned' and sealed shut. Stones 44 and 46 were leaning badly before restoration; Piggott believed that they had once held aloft a large horizontal slab, a 'false portal' stone that had since been taken away.

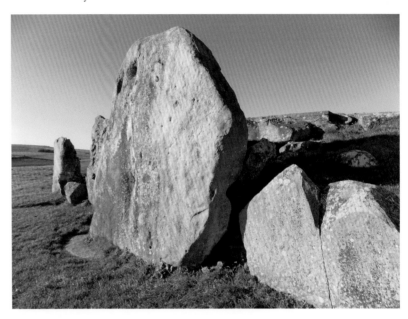

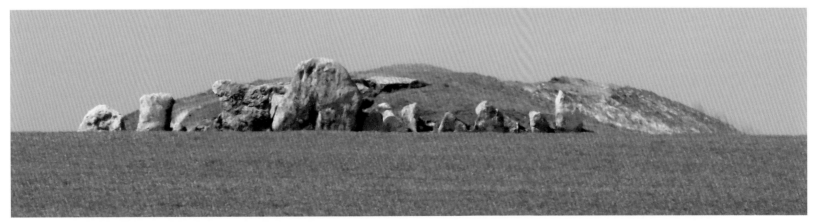

Stonework at the eastern end of the barrow is thought to have been altered several times, as illustrated below.

First was added a *forecourt* – a curving arrangement, radiating out from the mouth of the central passage.

In the second stage, seven stones of the facade were erected to extend outwards from the forecourt.

Finally, when the tomb was sealed shut after its period of primary use, blocking stones were placed in the entrances to the side chambers from the passage – two that still exist in the NW and SW chambers are shown in black on the plan below. The open mouth of the passage was sealed by the addition of stones 44 and 46, possibly holding a 'false portal' capstone that touched against the huge stone 45. Large stones were placed either side of stone 45; the triangular areas between them and the forecourt stones were filled up with sarsen boulders. The infill at the south (left) side has since been removed to allow access inside the barrow.

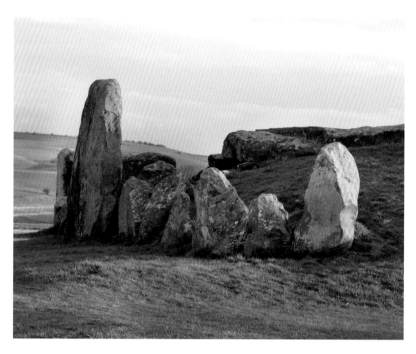

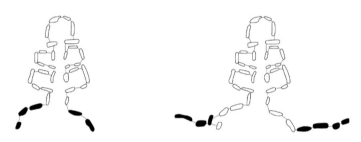

Stage 1 – forecourt stones shown in black. Stage 2 – facade added to forecourt.

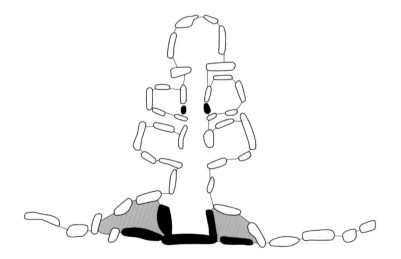

Stage 3 – blocking stones shown in black, infill of sarsen boulders in grey.

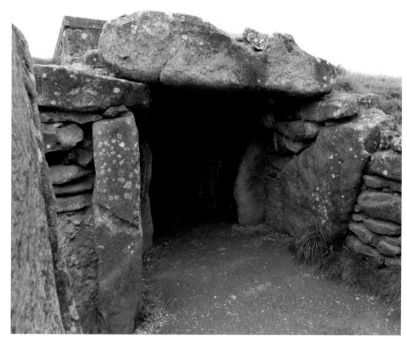

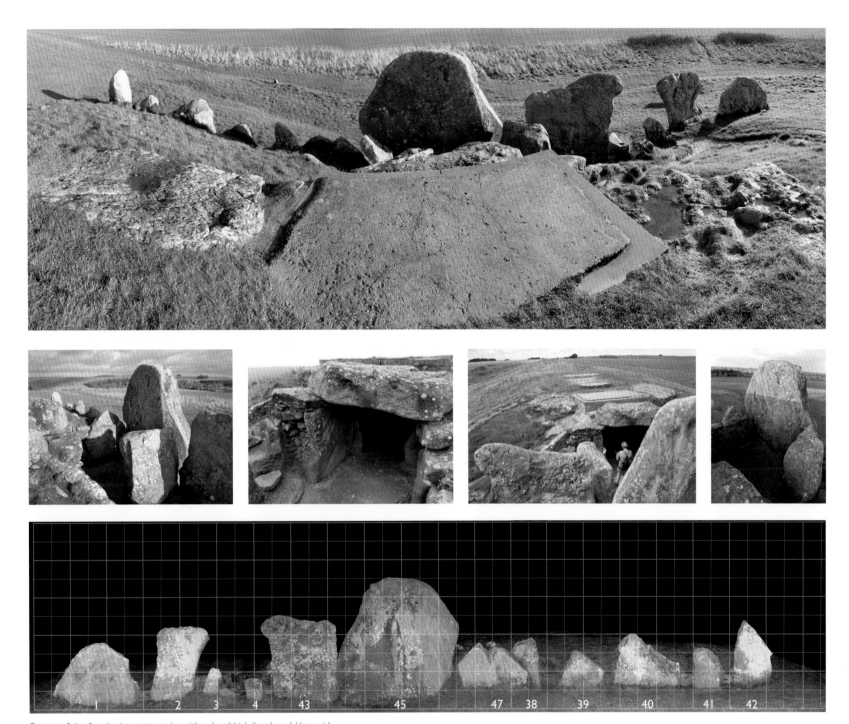

Stones of the facade shown to scale, with a 1m (thick lines) and ½m grid.

Inside the West Kennet Long Barrow

Entering the structure from the forecourt takes us into the central passage. At 8m long, the passage is 2m wide at the mouth, narrowing to 1m. The roof, set at over 2m, is unusually high. Unlike most other Cotswold-Severn tombs, anyone can walk around inside without needing to duck or crouch.

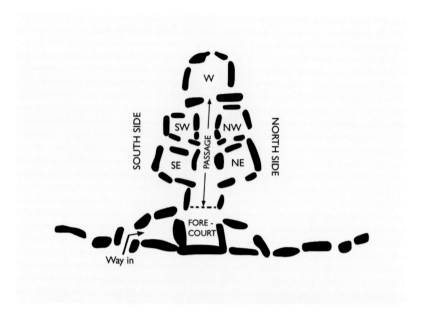

SE chamber roof

SW chamber roof

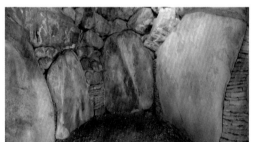

SE chamber

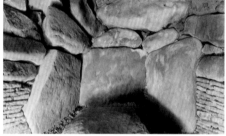

SW chamber

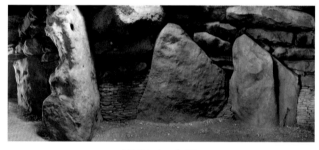

W chamber, S side

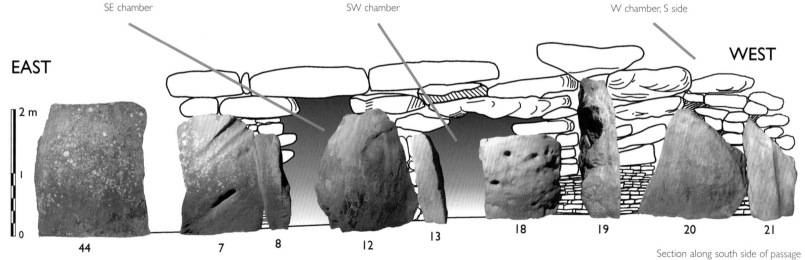

EAST

2 m

1

0

44 7 8 12 13 18 19 20 21

WEST

Section along south side of passage

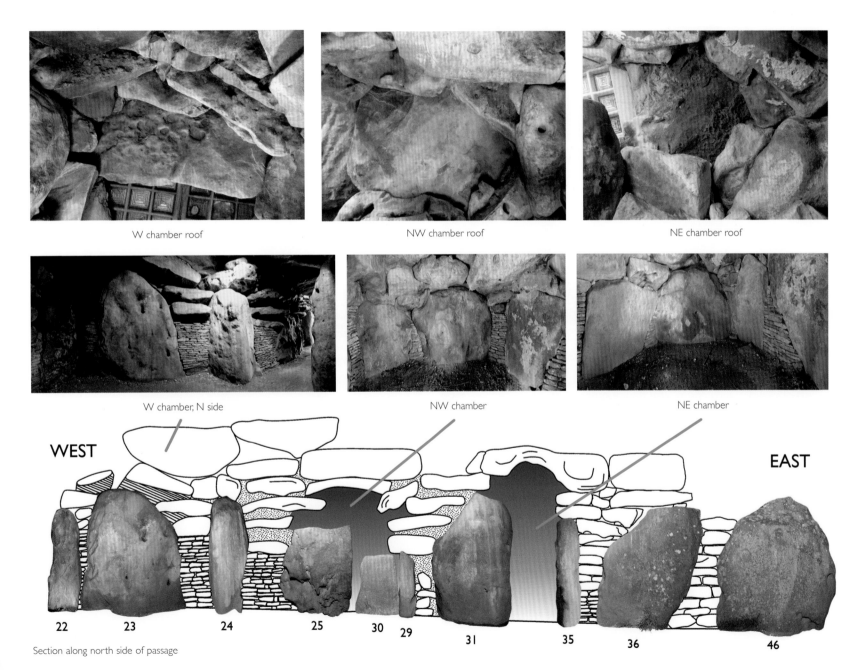

W chamber roof

NW chamber roof

NE chamber roof

W chamber, N side

NW chamber

NE chamber

WEST

EAST

22 23 24 25 30 29 31 35 36 46

Section along north side of passage

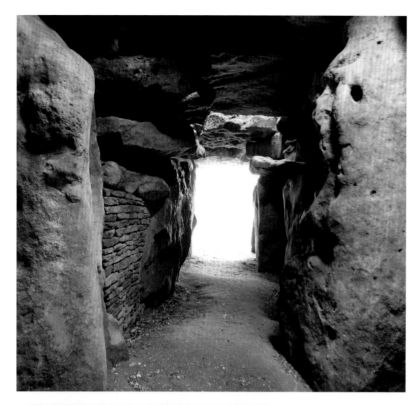

Just inside the passage there are openings into the chambers left and right. The first pair of chambers, the SE and NE, are the biggest: each is approximately 2m deep, 1½m wide and just over 2m high.

A short way further down the passage are two more openings. The one on the right, to the NW chamber, is partly obstructed by a small sarsen stone about 1m high. This is the blocking stone that was used to seal the chamber. There was a matching blocking stone in the entrance to the SW chamber on the left, which is now laid flat in the centre of the chamber. This second pair of chambers are three-quarters the size of the first pair. At the far end of the passage is the almost circular west chamber, the largest of the five chambers at almost 3m across.

The 1950s restoration included fitting several thick glass roof-lights, so that visitors might see their way. Most have now been covered over, leaving just one in the passage and another in the west chamber, enhancing the atmosphere of gloom that might be expected of a tomb.

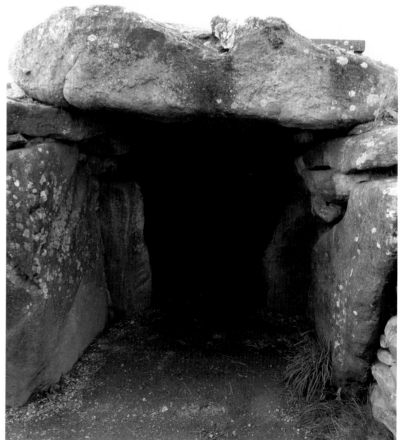

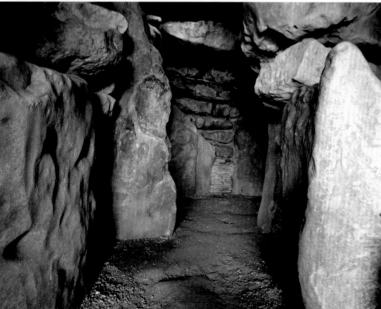

Light-beams in the Long Barrow

The sun's movement around the sky produces curious light effects inside the West Kennet long barrow that change with the seasons. The most spectacular events may be seen around the time of the spring and autumn equinoxes, 20 March and 22 September, when the sun rises due east and sets due west (*see diagram page 121*). For a few weeks either side of the equinoxes, a narrow beam of light enters the monument shortly after sunrise.

Initially dart-shaped, the light moves quickly along the south side of the passage to the western chamber, where it appears as a small, brilliant dot on stone 22 of the far wall, marking the axis of the barrow. The light beam then exits by moving along the north side of the passage, illuminating the chambers on its way. The light beam takes over an hour to complete this journey. Observing the phenomenon is not easy, as sunrises in the spring and autumn are so often obscured by cloud and rain.

It is surprising that sunlight is able to enter the WKLB at all, since there is a wall of huge blocking stones in the way. However, there is just enough of a gap between stones 45 and 43 to let light into the passage, providing the sun has risen a few degrees above the horizon. The WKLB's central axis points to 85.5° – very slightly north of due east. The angle of stone 45 prevents sunlight shining to the end of the passage until the sun has moved at least 90° (due east).

To be inside the monument as the sunbeam moves around it is an extraordinary experience that dramatically alters how we perceive the monument. We are accustomed to a space that is dark, dank and sombre: the addition of one tiny

dot of sunlight transforms it into a place of wonder. We see the light-beam move surprisingly rapidly along the passage; it hits the back wall and grows in size; moving through the barrow it continues to grow, until the chambers are so filled with light it is barely possible to look at them.

The light effects are so theatrical that we might suspect they were deliberately engineered, but it seems they were not. There is good evidence that the blocking stones date to the period of final infill of the passage and chambers, so it is likely the effects are accidental.

Before restoration, the enormous stone 45 and its companions were laid flat but there was no doubt about where they should be re-erected, as correctly shaped sockets were found, cut into the floor of the forecourt.

The following two pages show a light-beam moving around inside the WKLB as a chronological sequence, shot on 15 September 2013.

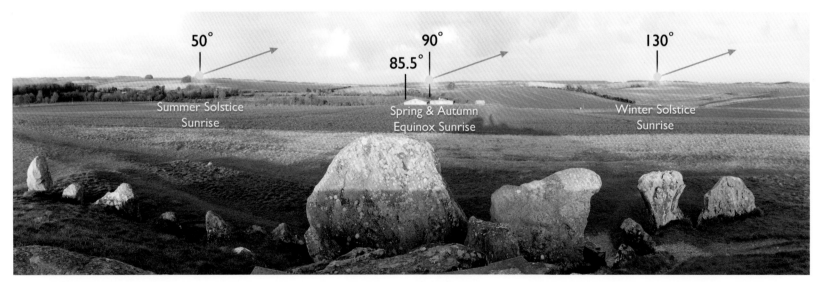

50° Summer Solstice Sunrise

90° 85.5° Spring & Autumn Equinox Sunrise

130° Winter Solstice Sunrise

Sunrise positions throughout the year, as seen looking east from the top of the WKLB. At the winter solstice position is the East Kennet long barrow, its covering of trees showing as a small, dark patch. The EKLB is itself aligned to winter solstice sunrise.

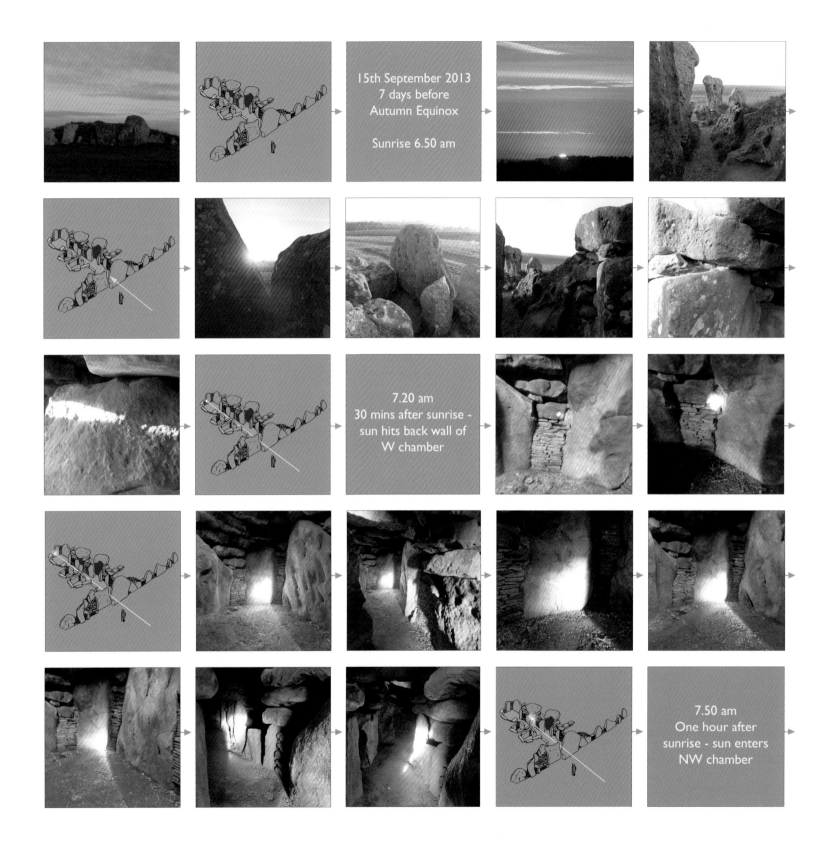

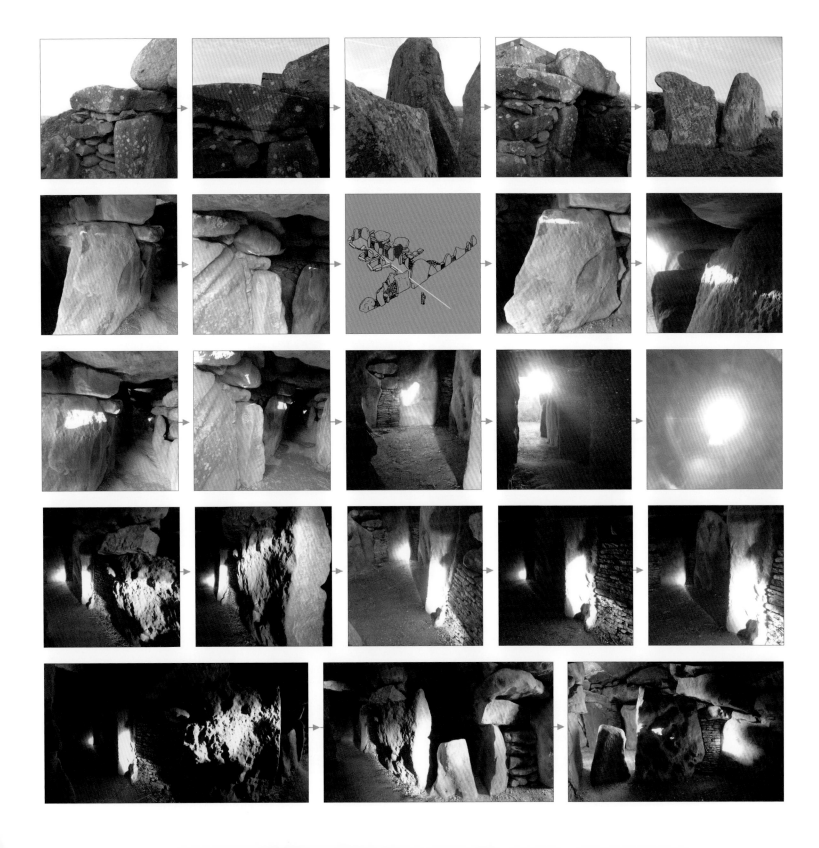

Polissoirs

The Avebury area has several stones known as *polissoirs* that were used for polishing flint axes; some were later incorporated into monuments (*see page* 69). Inside the West Kennet long barrow there are at least six polissoirs.

Flint tools would first have been knapped roughly to shape, then rubbed against the hard and abrasive sarsen stone until polished smooth. In order to do this comfortably the polissoir should be laid flat, as water is used to produce a finer polish; it is also easier to apply pressure downwards, with the aid of gravity. Surprisingly, all of the polishing marks in the WKLB are on vertical surfaces, indicating that the stones were most likely used as polissoirs before they were erected. They may have been used for polishing flints many centuries before construction of the monument began; if so, then stones bearing the marks of polishing were perhaps regarded as special, even revered.

This certainly seems to be the case with stone 18, the WKLB's best-known polissoir. The stone has several smooth, polished areas, as well as an obvious vertical hollow groove. It has been erected in a way that displays the polishing marks prominently.

A small but extremely smooth polishing area may be found on stone 21, sited prominently at the back of the western chamber. The polishing area is in the centre, about three-quarters of the way up the stone (*below*).

Stone 24, which guards the entrance to the western chamber, has an obvious polishing area. It is on the west side of the stone, so can only be seen from inside the western chamber. The area can be found low down on the right side of the stone (*below*).

Though they are not quite so obvious, polishing areas may also be found on stones 7 and 31 of the passage. Piggott also reported finding a polishing area on stone 43 of the facade: it cannot be seen today, as it was hidden by the re-erection of the stone. Polishing areas are often difficult to detect by eye, particularly in poor light. The best way to find them is by touch: the polished areas feel smooth as glass, in contrast to the rough natural sarsen around them.

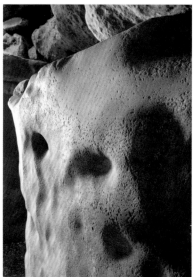
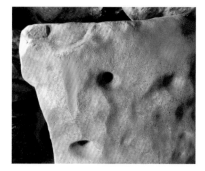
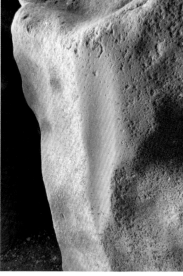

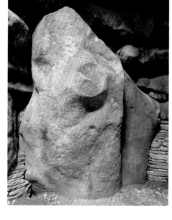

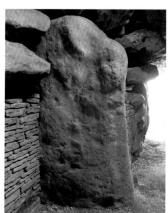

Acoustics of the West Kennet Long Barrow

Musical resonances of the side chambers

Some rooms resonate strongly at a specific frequency; the effect is particularly obvious in a small room full of reflective surfaces, such as a bathroom. When a note is sung that matches the resonant frequency of the room it will sound louder than other notes and may also ring on for some time afterwards.

The four side chambers of the West Kennet long barrow have clear and specific resonances. On entering the barrow, the first two chambers left and right resonate at 84 Hertz (Hz) which is a low note E, same as the lowest open string of a guitar. The second two chambers left and right resonate at 110Hz which is the note A, same as the second lowest open string of a guitar. The second two chambers have a weaker resonance than the first two, probably because their stonework is rougher and less reflective to sound. The most powerful resonance of all may be found in one small area of the passage, between the first two chambers and only at head height. It is another A, a resonance of 110Hz. The far western chamber is extremely resonant to all frequencies, presumably because of its almost spherical shape.

Both of these resonant frequencies may be sung, but only by a man with a very deep voice. The lowest, note E at 84Hz, is just below the range of a baritone and can only be sounded with any intensity by a bass singer. Voices generally deepen with age and the ability to sing a low E is more common in men approaching fifty.

The two resonant notes E and A form a musical interval known as the *perfect fourth*. The hymn Amazing Grace begins with this interval. Expressed mathematically, this is a ratio of 4:3. This same ratio is also found in the proportions of the structure: the floor areas of the outer and inner pairs of chambers are proportioned 4:3. Since the resonant frequency of a room is dictated by its size this is not so surprising, but other Cotswold-Severn monuments such as Notgrove, Burn Ground, Luckington and Stoney Littleton also featured the 4:3 ratio in their design (*below*). In his report of the WKLB excavations, Stuart Piggott wrote: 'It is clear that some kind of a regular plan was envisaged, presumably to definite units of measurement and with a knowledge of ratios.'

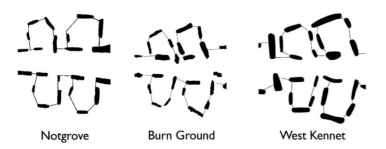

Notgrove **Burn Ground** **West Kennet**

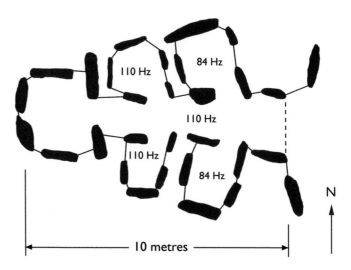

Resonant frequencies of the West Kennet long barrow.

Infrasound

Exploring the West Kennet long barrow at night, alone by torchlight, can be an unsettling experience, due partly to an acoustical effect that is exaggerated by the darkness. Moving around inside the structure produces *infrasound* – frequencies that are too low to be detected by human hearing, but that can still have a profound effect on the body and brain. Infrasound initially produces feelings of unease, mild panic and impressions of a 'presence' – the feeling that we are not alone. Prolonged exposure may produce hallucinations and altered states of consciousness: this could have been exploited in prehistory if, as suspected, the monument was used as a venue for rites of passage or initiation. It may also explain why so many people report having strange experiences such as 'seeing things', often fleetingly, inside the barrow.

Infrasound is produced in the barrow by resonance of the central passage and the western chamber. The effect is similar to producing a note from a bottle. The easiest and quickest way to set the passage resonating is to whirl a bull roarer (*overleaf*) at either of its ends – either inside the western chamber or outside the passage in the forecourt. The bull roarer produces low-frequency sounds that trigger the natural low resonance of the passage; the effect is profound. As soon as the bull roarer begins to spin the entire monument comes alive with sound and the impression of movement. All who have experienced this have had instant and similar reactions, which include goosebumps and shivering, a sense of excitement and danger, mild panic and impressions of a 'presence'. The first time I tried it myself, alone in the dark on a winter's night, the feeling that there was another person in the chamber was overwhelming. These are natural responses to infrasound: the low, inaudible frequencies appear to trigger an innate flight instinct.

It is possible too, that these very low frequencies may affect the way we think. The billions of neurons in the human brain electrically fire in sequence, with a periodic wave motion that can be detected by an EEG machine. The speed of this oscillation varies, and certain frequencies are associated with particular mental states. The frequency of brainwaves can be deliberately manipulated by stimuli such as flashing lights, oscillating magnetic fields or sound; the brain will 'lock in' to the frequency of the stimulus and begin to 'entrain' or oscillate in sympathy with it. Some shamanic drummers can allegedly produce trance states by simply beating a drum at the required brainwave frequency.

If brainwave entrainment can be produced by low-frequency sound, then the WKLB has the potential to produce altered states of consciousness when resonated. The 10m-long central passage resonates at around 9Hz which may stimulate both theta and alpha waves. *Theta waves* oscillate at between 5 and 8Hz – they are associated with daydreaming, meditation, creativity and pre-sleep. *Alpha waves*, between 8 and 13Hz, are produced by those skilled in deep meditation techniques. Alpha waves are claimed to promote creativity and accelerated learning, as well as a relaxed and pleasant state of awareness.

Was the Passage Resonance Used in Ritual?

Whilst the chambers of the barrow certainly held human bones, the precise function of this and other long barrows remains unknown. Certainly ritual and ceremony would be expected. In many traditional cultures, coming-of-age ceremonies involve terrifying and disorienting those who are initiated; the chambers of the WKLB would have been ideally suited to this. Dark and reeking of death, they would have contained human bones and partially decomposed corpses; some, it seems, were arranged in a sitting or squatting position. This, combined with the acoustical effects, must have been overwhelming for initiates who had been ritually prepared and primed for an extraordinary experience, and perhaps deprived of food, water and sleep. They may also have ingested plant hallucinogens.

If the monument was actually used for rituals of initiation, then initiates would have more likely occupied the western chamber and possibly the side chambers: since all are connected to the passage, the effects of the resonating passage should also be felt in the chambers. The passage and chambers may have been made to resonate by drumming, chanting or whirling a bull roarer from the forecourt.

I have found that any sound made in the forecourt will cause the passage to resonate: the shape of the forecourt helps to 'funnel' sound into the passage. If sounds are made in the forecourt, the resonance and its effects can be felt most strongly in the western chamber. Whirling two bull roarers together in the forecourt has been found to be particularly effective, producing a constant booming sound throughout the entire structure.

Bull Roarers

Widely claimed to be the world's oldest musical instrument, the bull roarer is usually a thin slat of wood or bone shaped like an fish; when tied to a string and whirled it spins, producing a low humming sound, as well as other frequencies too low to hear. Neolithic flint 'knives' can also function as bull roarers.

Almost every culture in the world has independently invented the bull roarer; it is so ubiquitous that it would be surprising if it was **not** used in Neolithic Britain. In some traditional cultures the bull roarer is described as 'the voice of the ancestors'. Examples up to 15,000 years old have been found across Europe.

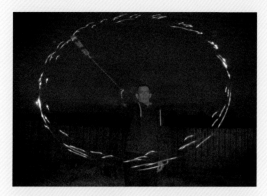

A bull roarer fitted with an LED demonstrates how it spins on its long axis as it is whirled.

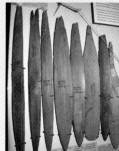

Bull roarers from around the world. Part of a large collection in the Pitt-Rivers Museum, Oxford.

It is likely that brainwave entrainment could be produced by other similar monuments when infrasonically resonated: there are at least a dozen other Neolithic structures around Britain with resonating passages that have the potential to influence brainwaves. I have used a bull roarer to resonate other well-known passage-graves, including Newgrange in Ireland, Maeshowe on the island of Orkney and Barclodiad-y-Gawres on Anglesey. In all of them, a powerful but almost inaudible vibration was felt by people inside the monument when a bull roarer was whirled outside the mouth of the passage.

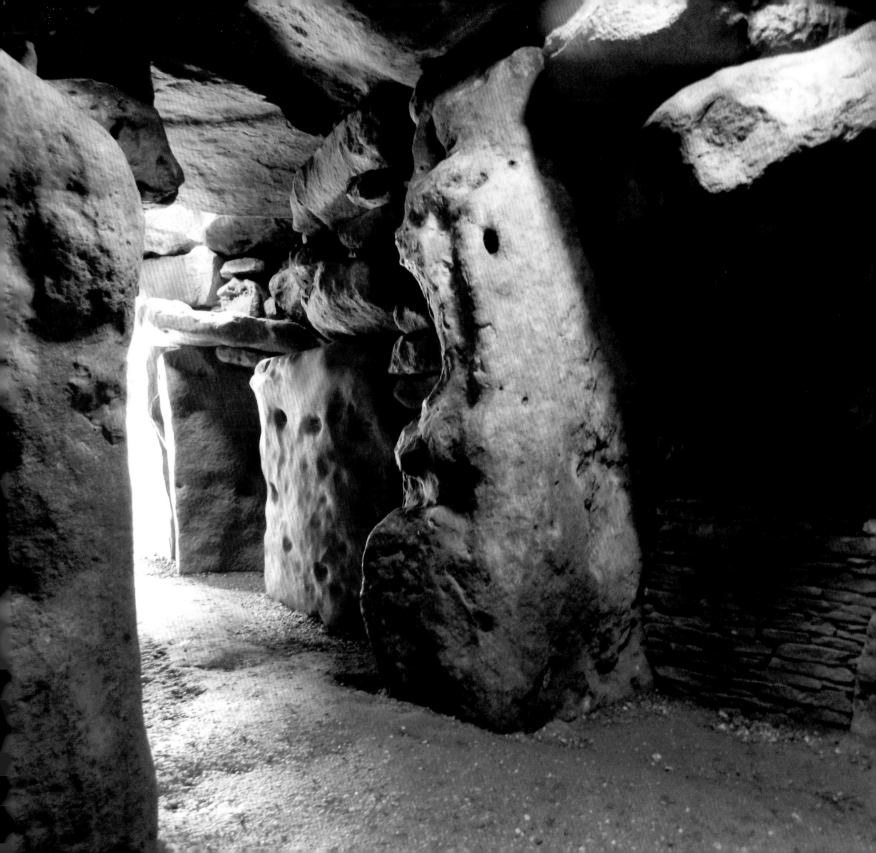

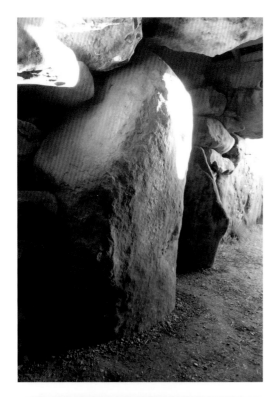
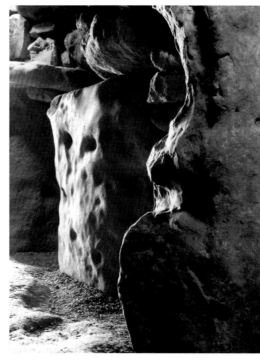
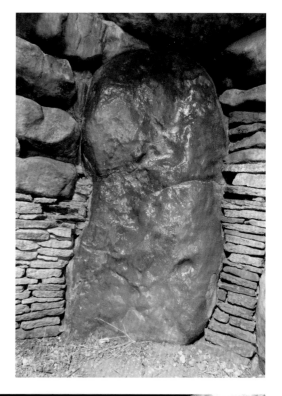

Inside the West Kennet long barrow.

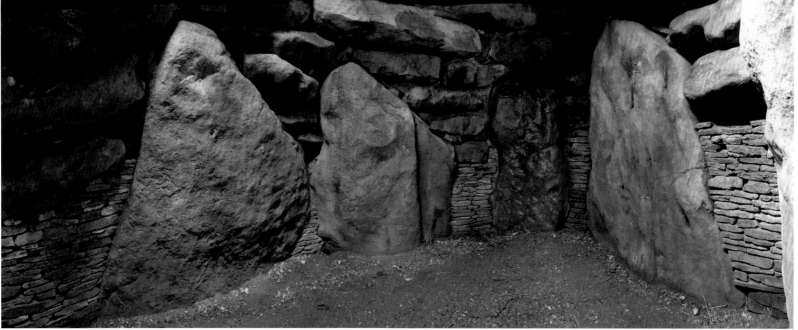

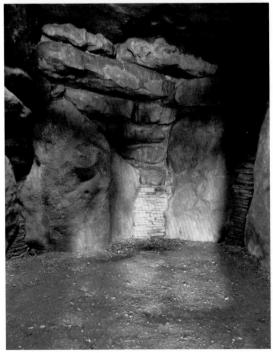

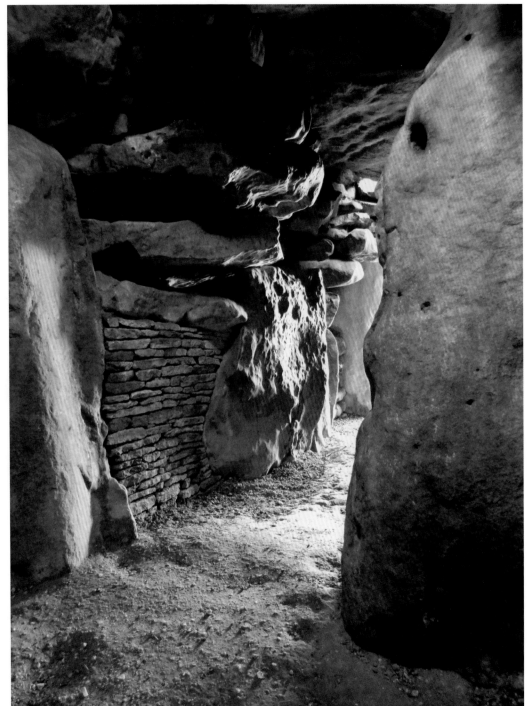

AVEBURY: THE BANK AND DITCH

Date of construction: estimated 2630–2460 BC

Visitors entering Avebury from the National Trust car park follow a footpath past the village sports field, emerging eventually onto the High Street – the western entrance to the henge. They turn a corner and are suddenly presented with a stunning demonstration of the monument's vast scale, when the massive bank and ditch of the south-east quadrant are seen in cross section. Entering the henge makes a powerful impression on today's visitors, who are quite accustomed to wonder and spectacle. Just imagine how the experience may have been over 4,000 years ago.

Avebury's great bank rises more than 5m above the ground surface and is an average 26m wide at its base; the ditch inside it is almost 4m deep and around 21m wide at the top. But these are not the original proportions – weathering and silting over millennia has moved material down from the bank into the ditch and also eroded the ditch's profile, which was originally much steeper.

When Harold St George Gray excavated a south-east portion of the ditch in the early twentieth century he discovered its original depth to have been an incredible 9m (30ft) – two or three times what it is today! The ditch's sides were very much steeper: its flat bottom was between 2.4 and 5.1m wide and the top around 9 to 10m wide. The bank may also have been much steeper, in which case it would have eroded very quickly and silted up the ditch. Archaeologist Paul Ashbee suggested that the builders must have been aware of this and may even have intended to produce an antique appearance, again evoking much older enclosures such as those on Windmill Hill.

Inside the bank is a core of loose chalk rubble deposited in piles and held in place where needed by large blocks of chalk, forming retaining walls. Timber may also have been used in places to stabilise the rubble. The structure was finished off with a finer layer of chalk and soil to help seal it against the weather.

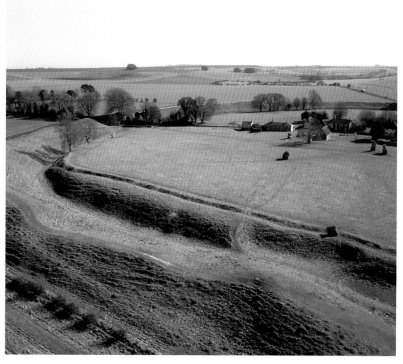

North-east earthwork.

South-west ditch in summer and winter.

Buried inside the core, traces have been found of a primary bank, some 2.5m high and 9m wide. Built of turf covered with chalk rubble, it may have served to initially mark out the course of the final bank.

At the four entrances or *causeways* the bank was made higher and the ditch, source of its material, was dug correspondingly deeper and wider, exaggerating the impression of grandeur for visitors entering the enclosure. This effect was further enhanced by lowering the ground surface of the causeway by a metre or more. Averaging 15m wide, the causeways appear from limited excavation to be original, though all but the eastern have been badly mutilated by road-widening work over recent centuries.

A busy route for stagecoaches once passed through Avebury and traces of it can still be seen: the north-east bank has been particularly cut up by carriage wheels. Around the southern entrance the bank was partly levelled and reshaped to make provision for a toll-house on the private turnpike road. The western entrance has been obliterated by the present village and a large portion of the western bank was destroyed where a huge barn was cut into it (*see pictures opposite*).

Berms

If material for a bank is piled up too close to the ditch it is excavated from, it will simply fall back in again; the bank must be built a distance away, producing a horizontal *berm* between it and the ditch. Erosion has largely obscured the berm in Avebury but it can still be seen in the south-east quadrant, notably by the southern entrance (*below*).

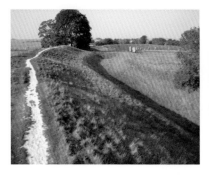
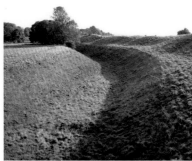

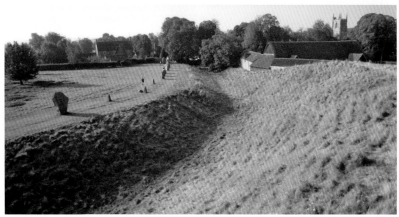

North-west earthwork with the Great Barn.

Gray's excavation turned up forty-four L-shaped picks, made of red-deer antler, that were used to dig the ditches. The picks had been carefully deposited in the bottom of the ditches rather than simply thrown in as rubbish. This implies that the digging was in itself a ritual act and the tools used were afforded some form of sanctity. Antlers were also used as rakes; cattle shoulder blades were used as shovels. Loosened chalk would then have to be carried away, probably in baskets of reed or wicker. As well as the work of digging, there must have been much activity behind the scenes, such as providing a supply of antlers and baskets. Most of the enormous quantity of antlers found were shed naturally from living deer.

Water in the Ditches

For many years, it was debated whether or not the Avebury ditches would have carried water. Gray decided against, arguing that the water table would not have been high enough and that there was no evidence of silt in the bottom of the ditch that he excavated. However, it now seems that the water table was substantially higher when Avebury was constructed, and why should there be any silt? If water simply came up through the porous chalk as the water table rose, then went down again, it would leave no evidence. Silt would only be deposited if a river carried it from elsewhere – here, there was no river.

Evidence for water in the ditches came in February 2013, when groundwater levels were higher than for many years. The water in the Red Lion's well was seen to have risen 5m above its recorded summer level, showing an annual variation between 145.7 and 150.6m above sea level. Gray's excavated ditch was 9m deep, with its bottom at 149m. The altitude of the original ditch bottom varies around the rest of the henge between 146 and 161m, so even with today's reduced water table, some water would be seen in the bottom of a 9m-deep ditch. It would only appear at the wettest time of year, and may be less than a metre deep, but the ditch was certainly made to cut into the water table.

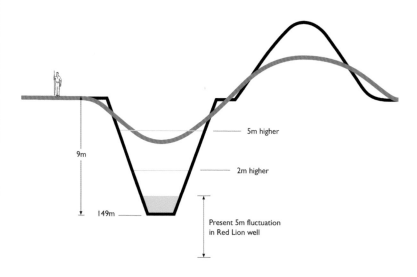

Cross section showing the original profile of the earthwork in black, with today's eroded and silted profile in green. Even with modern reduced water levels the ditch would have held some water when freshly dug. It is thought that levels were 2m to 5m higher in prehistory.

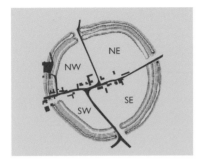

Even if water levels were higher when the ditch was dug, it is unlikely to have ever been much more than half full. Because chalk is porous, the level of water in the ditch would not be any higher than the water table, at least not for long. After a heavy rainstorm the level may temporarily rise, but the extra water would seep away in a matter of days.

North-west ditch in February 2014. With even more rain than the previous winter, water was seen standing in the ditch for several weeks. Jim Gunter reported it was 'about 0.3m deep – just over the top of my wellies'. The level of water in the Red Lion's well was at least a metre higher than previously recorded. (Photo by David Field)

The intention may not have been to produce a ditch full of water like a castle moat, but simply to make contact with the water table, perhaps in a single ritual event. If water was regarded as a conduit between our world and the Otherworld, perhaps it was needed to potentise the ditches? Placed inside the banks, they were not for defence, but maybe to contain some power. The evidence from Gray's excavation was that the ditch very quickly began to fill with chalk rubble, probably after the first winter, so the water in its bottom may never have been seen again.

It is likely that Neolithic people considered the earth and underground water to be sacred, and treated them with reverence – so much so they cut a 9m-deep ditch into the chalk to reach the water table, a serious and potentially hazardous undertaking.

The Avebury earthwork is not actually a true circle – each of its four segments has a different shape and only one is circular. The circularity of the south-east quadrant is extremely accurate, demonstrating great skill in surveying as well as construction. The other three quadrants are more angular, with 'dog legs'. It is often assumed that this irregularity is accidental, perhaps the result of assigning different gangs of workers to each sector. This is possible, but the shape could just as likely be deliberate. Or were there huge sarsens in the way that could not be moved?

Comparing the Avebury plan with other henges is revealing, as several also have a similar combination of circular and angular elements. Marden, largest of the Wessex 'super-henges', resembles Avebury quite closely in shape, with a pronounced dog leg on the north-eastern side that is very similar to Avebury's. Perhaps that shape had a symbolic significance that we are unaware of? It is also interesting to note the similarities between the Avebury Henge and the much older earthworks on Windmill Hill where the outer ditch, though elliptical, has a maximum diameter of around 360m, so a corresponding radius of 180m. This size is matched closely by the radius of the south-east earthwork.

Most of the bank, as we see it today, has an uneven and undulating profile; the exception is the north-west section, which is smooth and level. This is not original – it was deliberately sculpted to its current state by Keiller in the 1930s. The north-west bank was badly damaged and covered with trees when Keiller began his restoration; he had the trees cut down and their stumps removed with explosives!

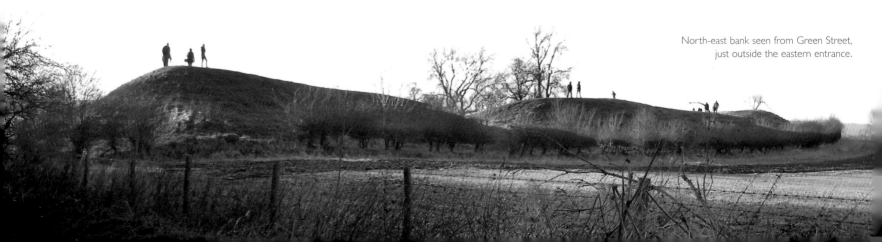

North-east bank seen from Green Street, just outside the eastern entrance.

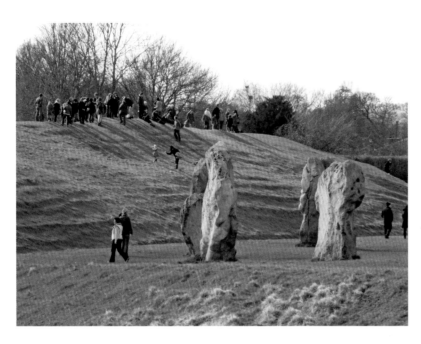

Local children use the south-west bank for winter tobogganing and Easter egg-rolling.

North-east ditch.

North-west ditch and northern entrance.

The irregularity of the other banks may be due to uneven settlement of the material inside it, but it may also be deliberate. It has been suggested that there were astronomical reasons for building an uneven bank – perhaps certain star-risings or settings were highlighted by this artificial horizon?

Though there are similarities between the Avebury earthwork and those of other henge monuments, there are major differences. Avebury's ditch is far deeper and steeper than any other and its bank correspondingly higher. Avebury is also unique in that it has produced comparatively few finds: the similar-sized henges of Durrington Walls and Mount Pleasant were littered with vast amounts of pottery, flint tools and animal bone – signs of human occupation and activities such as feasting. Those similar artefacts recovered from Avebury tend to date from a phase of occasional occupation well before the henge was built – probably around 3000 BC or a few centuries later.

What ritual deposits there were in Avebury were concentrated in the ditches. These include the tools found by Gray, such as antlers and worked cattle ribs, as well as pieces of human bone. It seems that from around 2300–2000 BC (start of the Early Bronze Age) there was some kind of change in beliefs, as far more human bone began to be deposited in the Avebury ditches: not entire skeletons but just long-bones, jaws, collarbones and pieces of skull. These were ancestral remains, from bodies that had previously been buried or stored elsewhere. This was highly unusual for the time, as individual burial had become the norm, yet archaic rituals were being continued, or possibly resurrected, in Avebury.

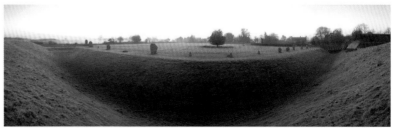

North-west ditch.

INSIDE THE HENGE

Keiller's Restoration of Avebury

Avebury as we see it today is largely the result of Alexander Keiller's restoration work in the 1930s. Work began in 1934 with excavations on the Avenue. Keiller set about re-erecting the stones, placing concrete markers or 'plinths' where lost stones had stood. Determined to continue the restoration into the henge itself, he arranged to buy the entire Avebury monument and as much of the surrounding land as possible.

When Keiller bought the Avebury site it was a sorry mess, overgrown and covered with ramshackle farm buildings and rubbish; few of the stones we see today were standing, or even visible. It was well known from Stukeley's first-hand accounts that many stones had been toppled in the early 1700s and deliberately broken up by the application of fire and water. This had continued for over a century, during which time scores of megaliths were converted into the walls, houses and barns that make up the present village. But the Revd A.C. Smith and others had shown in the 1880s that yet more stones lay buried below the ground, by probing for them with rods. It was not until Keiller began to clear the site that the true scale and age of these stone burials became apparent: pottery and coins found with the stones showed that they had been buried in the medieval period, far earlier than previously thought.

Keiller's work on the henge began in 1937 with the clearing and restoration of the north-west quadrant. In 1938 he moved on to the south-west quadrant and to the south-east in 1939. Keiller's vision was to see Avebury as fully restored to its original state as possible and the work was on a massive scale. Buried stones were re-erected; the earthworks were cleared of rubbish and trees; houses were demolished.

Work that was intended to continue for twelve years was brought to an abrupt halt by the outbreak of war and in 1943 Keiller sold Avebury to the National Trust for the price he had originally paid for it as agricultural land, ignoring the fact that virtually his entire fortune had gone into paying for the restoration. His work was never completed, although the National Trust continued to demolish houses until the 1960s.

The Stone Settings

Visitors to Avebury cannot fail to be impressed by the vast size of its standing stones, but the patterns in which they are arranged are far from obvious on the ground and can appear a confusing jumble. At almost a quarter of a mile across, the outer stone ring that follows the shape of the earthwork is truly enormous; there is no point on the ring from where its opposite side can be seen, as houses obstruct the view.

Inside this are the remains of two more inner stone rings, both of around 100m in diameter. The southern ring is suggested by an arc of five large stones but the northern ring is virtually destroyed and marked only by four isolated stones, two of which have fallen. To add to the confusion, there are further arrangements of stones which seem to be peppered around the site. By exploring the henge slowly, one quadrant at a time, we can begin to make some sense of this; we also need a way of identifying the individual stones.

Identifying the Stones

Several numbering systems have been used over the years. This book uses Isobel Smith's system, as featured in her 1965 report of Keiller's excavations (*plan, opposite*). Smith's numbering assumes ninety-eight stones in the outer ring, estimated by measurement. The stones of the two excavated western quadrants are not spaced evenly – they are between 7.3 and 14.3m apart, an average of 11m. Using this distance to calculate stone positions in the unexcavated half of the ring produces a total of ninety-eight stones, but the spacing may not necessarily have been consistent all around the ring.

The most recent geophysical survey by Martin Papworth (2003) shows many buried stones in the unexcavated north-east quadrant, as well as the traces of holes where destroyed stones once stood. From Papworth's data it now seems possible that the outer ring was originally built with 'at least 100 stones' and probably 103, but this can only be confirmed by excavation – something not likely to happen in the foreseeable future. For now, Smith's numbering system remains the accepted standard.

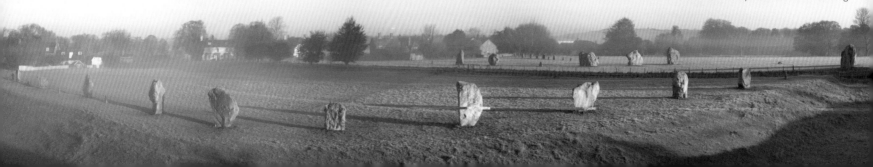

Avebury's south-west quadrant. Before Keiller's restoration only one stone was standing.

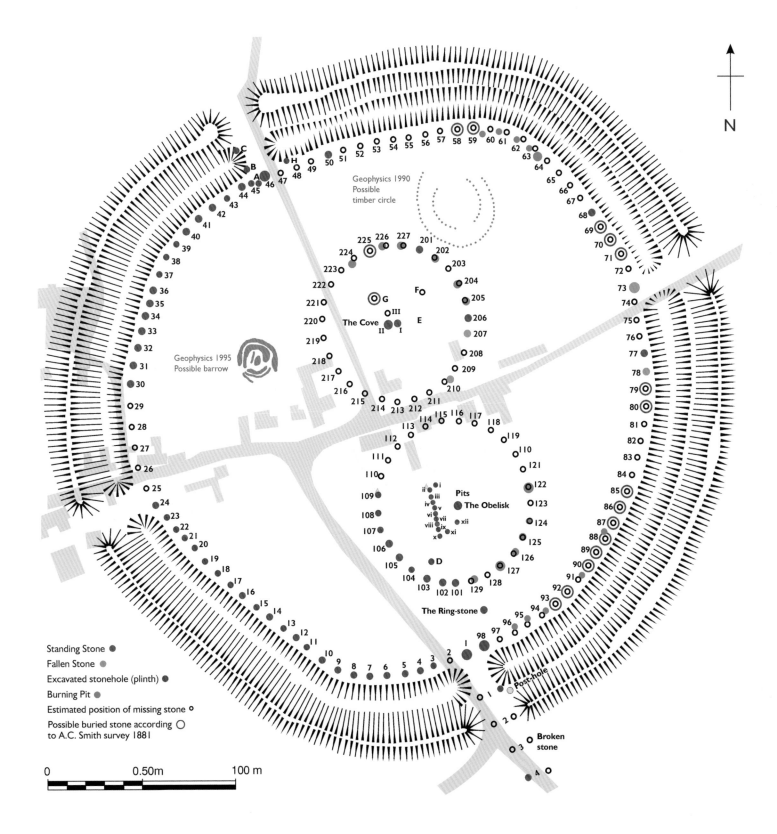

Geophysics 1990
Possible
timber circle

Geophysics 1995
Possible barrow

The Cove

The Obelisk
Pits

D

The Ring-stone

Post-hole

Broken
stone

Standing Stone ●
Fallen Stone ●
Excavated stonehole (plinth) ●
Burning Pit ●
Estimated position of missing stone ○
Possible buried stone according ◯
to A.C. Smith survey 1881

N

0 0.50m 100 m

Today only thirty-one stones of the outer ring are visible, some fallen and others reduced to broken stumps; another sixteen are represented by concrete markers. The stones are numbered clockwise, starting with what was the western portal stone of the southern entrance as stone number 1. Confusingly, this stone is not in the south-west quadrant where it should be, but in the south-east quadrant, with its partner 98 (*below*). The road, which originally ran between the two huge stones, has been moved to the west.

The stones of the two inner stone rings have also been numbered clockwise: the northern ring begins with 101 and the southern ring with 201. Two internal features of these rings, *the Cove* and *the Obelisk* still have the names Stukeley gave them, as does the *Ring-stone* in the south-east quadrant. A line of small stones inside the southern ring are each numbered from i to xii. Finally, eight stones and stone-holes apparently unrelated to other features have been assigned letters from A to H; they may be found in both inner rings and by the northern entrance.

The stones of the outer ring closely follow the shape of the ditch – Keiller recorded the stones as being sited 'a uniform 22ft from its present inner edge'. It was once thought that the stones must have been positioned before the earthwork was constructed but the reverse now seems more likely. There are only four narrow causeways into the henge, through which stones must have been dragged. This would have been inconvenient, though not entirely impractical; however, if the largest stones were already inside the henge before they were erected, it would have been less of an issue.

There are few radiocarbon dates for either the earthwork or the stones and, of those that are available, most are from charcoal. Dates obtained from wood can never be regarded as accurate, since the wood may have been extremely old before being burned or buried. The most reliable date is probably from a piece of pig bone found under stone 44, indicating a date between 2,600 and 2,000 BC. Although far from precise, this does suggest that construction of the first-stage earthwork occurred well before the stones were erected – probably between 3,000 and 2,700 BC.

The second-stage earthwork has been rather more accurately dated from four antler picks used in its construction: these fall within the period 2,630 to 2,460 BC. But the dating issue is extremely complex, as such a huge structure is likely to have been built in several stages, each of which may have spanned several centuries. There are four quadrants and several stone settings, which are unlikely to have all been constructed simultaneously. To complicate things further, there are indications that the builders moved and re-set some stones, and that this work may have continued into the Bronze Age.

Erecting Avebury's stones must have been an immense, communal effort, even if the stones were already nearby – they are mounted like teeth, in sockets carved into the underlying chalk and shaped to match each stone's contours. Most of the stones erected weigh approximately 20 to 30 tons, but there is much variation, and the largest weigh up to 100 tons. The sockets are not deep: they are typically cut only a foot or so into the chalk. The usual method for erection

Stones 1 and 98 mark Avebury's original south entrance.

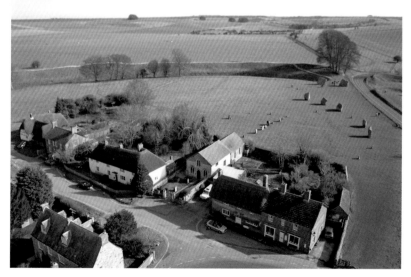

South-west quadrant, south entrance, Southern Inner Ring and Green Street.

was to cut the socket near vertical, with one side angled more gently to allow for more control as the stone was slipped into position. Some sockets had a further line of wooden 'anti-friction stakes' driven into the chalk to guide the stone as it slid down into the socket; some sockets also bear the marks of wooden levers or props used in the work.

Interestingly, Isobel Smith noted that stone 44, near the northern entrance, is the only stone known to have been guided into its socket from the ditch side: all those examined were erected from the inside of the henge outwards. This is a further indication that the ditch was probably already dug when the stones were erected.

Once in place, the stones were stabilised with packing material to fill any space left in the hole and to reinforce its edges. Sarsen boulders were commonest but clay, flint and blocks of lower chalk were also used. The dark brown clay was not local, but imported from several miles away; the chalk too was from layers far deeper underground than the stone sockets reached. It seems that the packing, and the ways in which different materials were combined, had a symbolic significance. Some of the sockets were also 'seeded' with deposits of flint and fragments of foreign stone, some from tools such as polished axes.

Stone 40. When Keiller restored the north-west quadrant in 1937 this stone was found inside a nearby wall. Matched to its socket in the chalk bedrock, it was re-erected. Like all the standing stones of Avebury, stone 40 is set in concrete.

Beneath the buried stone 9 a male skeleton was found, with coins dating to about AD 1320 and a rare pair of scissors. Keiller concluded that the man was an itinerant barber-surgeon, accidentally crushed as the stone was toppled. However, he could just as likely be a tailor, deliberately buried after a natural death.

Most of the sarsen stones are set to precisely follow the line of the ditch and are each aligned to it, so that when viewed from above the stones form a broken line of dashes. Not all the stones sit on this line though — a few are skewed by around 30 degrees. Considering the effort involved in erecting a stone this may be deliberate, but why? Astronomical alignments are an obvious possibility — perhaps the stones point to where a particular star, or the sun or moon, rose or set at some significant time?

The alignments may not necessarily be celestial — the skewed stones may be pointing to distant places. But none are obvious, and of course we do not know how such an alignment may be intended anyway. Should it be the direction a stone faces, or the direction *across* its face? The stones of the two inner rings are similarly aligned to mark out the circumference in dashes but none appear to have been skewed.

It has been claimed that all the stones are set with their smoothest, flattest faces to the inside of their settings, but this is not strictly true. Some stones are very uneven on both sides and it is impossible to say which is flattest; the eastern half of the henge has frustratingly few stones standing anyway, ruling out any generalisation. Out of thirty-six stones that are definitely flatter on one side, only twenty-one are set with their flattest sides inward.

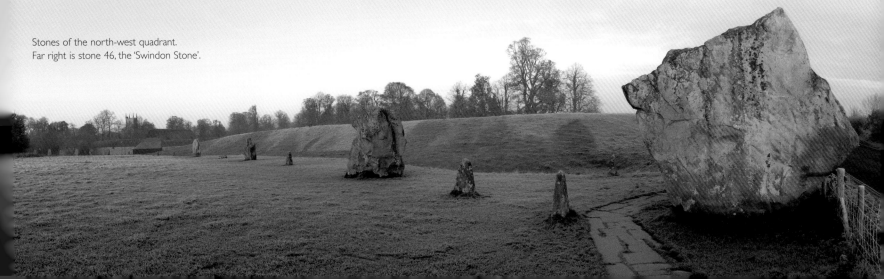

Stones of the north-west quadrant.
Far right is stone 46, the 'Swindon Stone'.

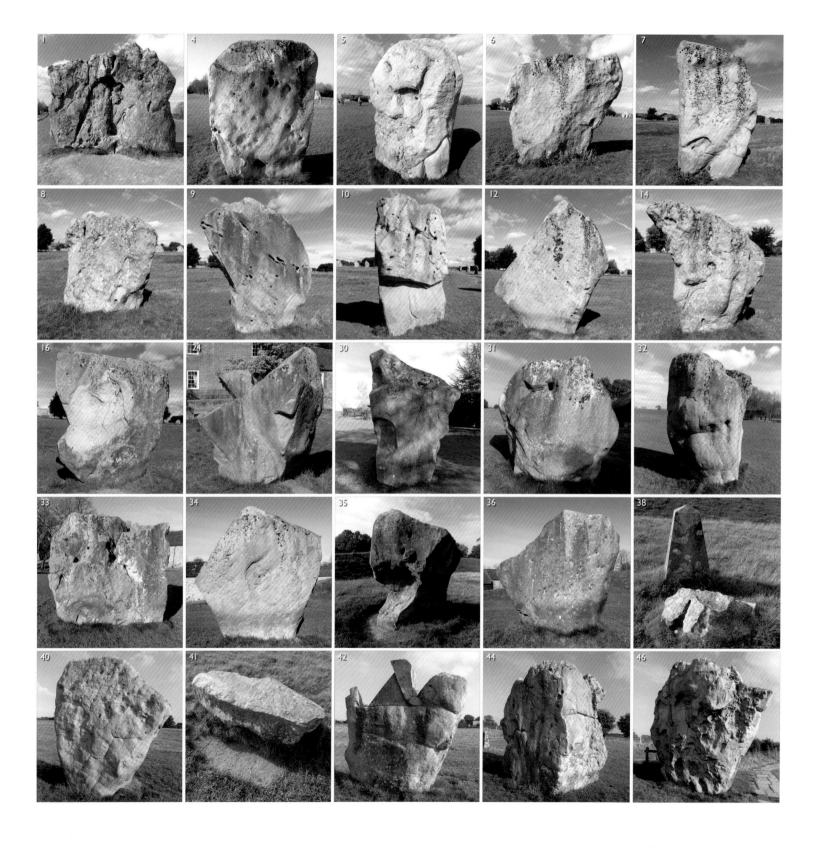

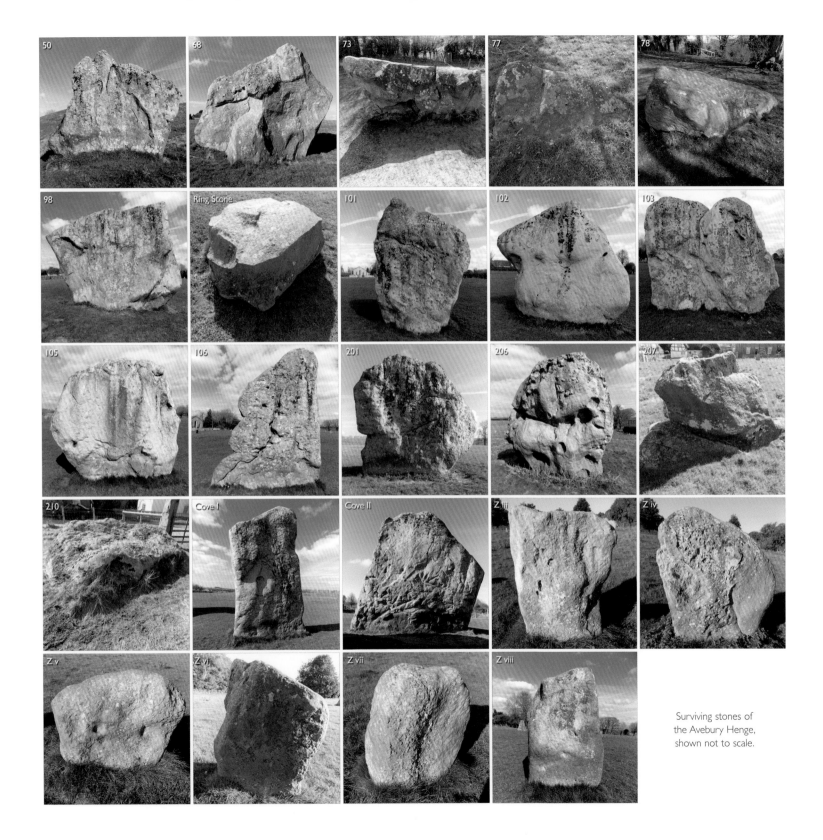

Surviving stones of
the Avebury Henge,
shown not to scale.

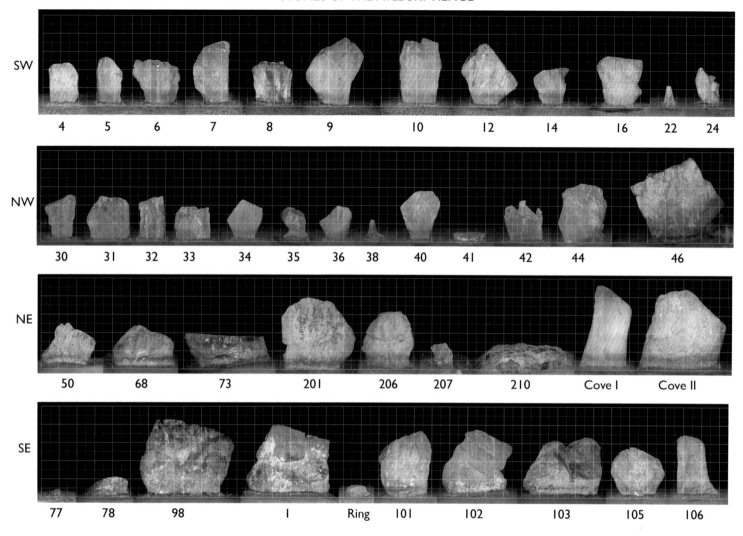

SW | 4 | 5 | 6 | 7 | 8 | 9 | 10 | 12 | 14 | 16 | 22 | 24

NW | 30 | 31 | 32 | 33 | 34 | 35 | 36 | 38 | 40 | 41 | 42 | 44 | 46

NE | 50 | 68 | 73 | 201 | 206 | 207 | 210 | Cove I | Cove II

SE | 77 | 78 | 98 | 1 | Ring | 101 | 102 | 103 | 105 | 106

The surviving stones of the Avebury Henge's four quadrants are shown above, all to the same scale and with a superimposed grid of 1m and ½m squares. Stones of the Z-feature are not included. Note that many stones have a dark line at their base: this is staining from the soil that was built up higher before Keiller's restoration. Keiller and Piggott classified the stones into two types: Type A stones are taller than they are broad, 'pillar-like', symbolising the masculine; the broader Type B

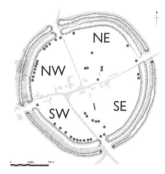

stones tend to be square, are sometimes mounted on one corner to form a lozenge, and are regarded as feminine. Keiller and Piggott believed that some stones had been modified to conform more closely to these shapes, but that idea has now been largely rejected. One need only glance at a picture of all the stones in a quadrant to see that their 'Type A and B' theory is an over-simplification. Some stones are indeed pillars, others are lozenges, but most are of more complex shapes that cannot be so easily defined.

POLISSOIRS

On Fyfield Down is a large sarsen stone known as the *polissoir* or 'polisher', which was used for shaping and polishing prehistoric flint or stone implements. Quite rare in Britain, polissoirs are more common in France, hence their name. Tools such as flint axes would be roughly knapped into shape, then rubbed against the polissoir until made smooth: being naturally hard and abrasive, sarsen stone is ideal for this job. Sand and water may have been added to give an even smoother final finish. Despite the hardness of sarsen, it too was also eventually polished and worn smooth in the process, producing a shiny, glass-like surface. The Fyfield Polissoir is a spectacularly beautiful object, its deeply cut grooves and hollows representing what may have been many centuries of laborious manual work. Several Avebury stones also have polishing marks.

Some polishing stones were later re-used as megaliths. After many years of use laid flat as polishers they were erected as standing stones or incorporated into structures such as the West Kennet long barrow, which has several conspicuous polishing marks. Some of Avebury's standing stones have several definite polishing areas; others are less certain. The most obvious example is on stone 24 of the south-west quadrant, the nearest stone to the High Street. Polishing areas may also be found on stones 4, 6 and 31, and there may also be others.

Some areas of the Fyfield Polissoir (*below*) have a surface as smooth as glass. Polishing areas on the Avebury Henge stones are less obvious to see, but may be found easily by touch.

Stone 24

Stone 4

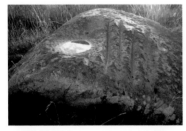

The Fyfield Polissoir.

Stone 6

Stone 31

SOUTH-WEST QUADRANT

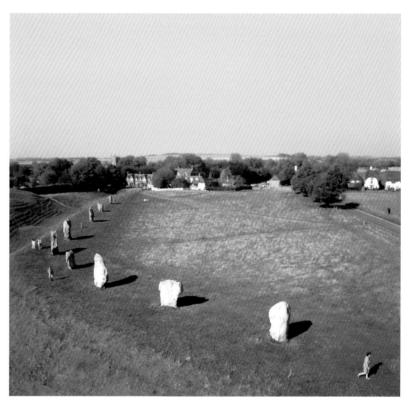

When Keiller's restoration of the south-west quadrant began in 1938 only stone 8 was still standing: another lay fallen and two stones were just partly visible, as they had been toppled and incompletely buried.

Today, this quadrant contains twenty-two stone positions, numbered from 3 to 24, but this is not as it should be: the southern entrance to the henge has been altered and was shifted eastward as the modern roads evolved. Consequently stone 1, which should be in the south-west quadrant, is now across the road in the south-east quadrant. Stone 2, or rather the position where it once stood, is underneath the road. Keiller's team excavated the entire arc of the south-west quadrant, discovering six buried stones as well as the partially buried stones 7 and 12. All were re-erected and set in concrete, as was stone 8. Stone 24 (*top, centre*) was partially re-assembled from broken fragments used in a building.

Stone 8 (*below, left*) is skewed out of line, as are stones 33 of the north-west quadrant and 33b of the Avenue. Curiously, all are about the same shape and size, and were never toppled. Etched into the back of stone 8 (*top, right*), the Awen symbol may be 'Druidical' graffiti from the nineteenth century. Alternatively, it could be an Ordnance Survey benchmark, but without Druidic dots or an OS bar above the arrow, either is incomplete.

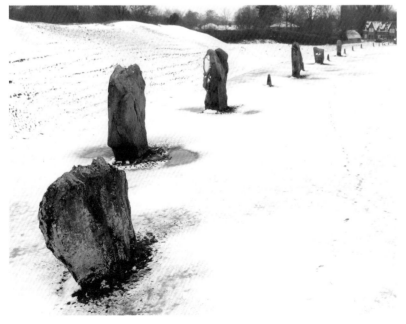

The skewed stone 8.

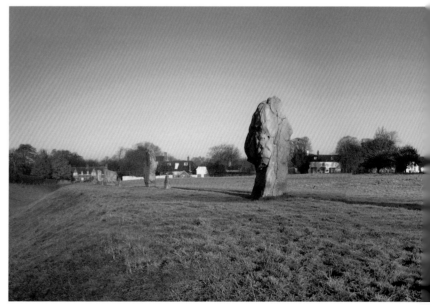

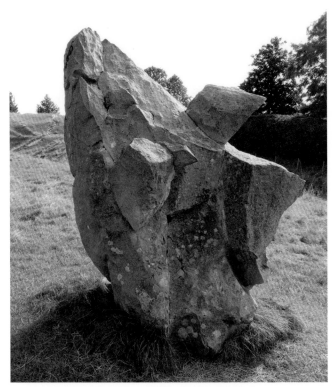

Stone 24.

'Awen symbol' on stone 8.

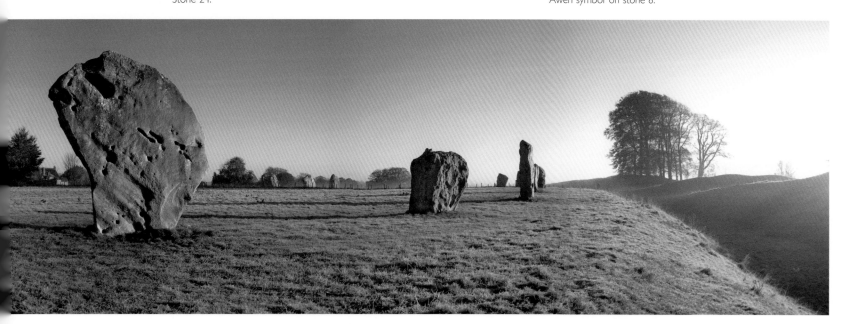

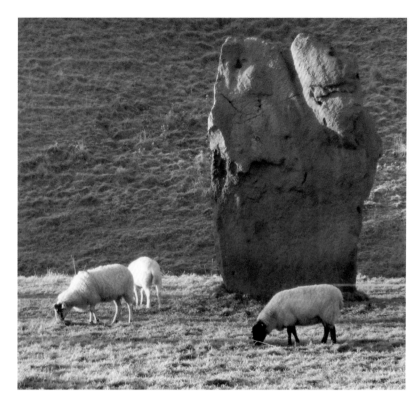
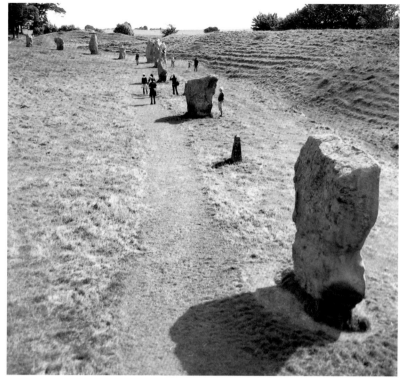

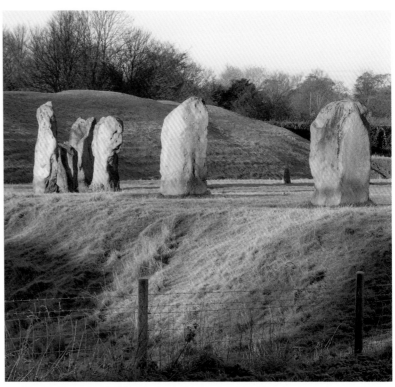

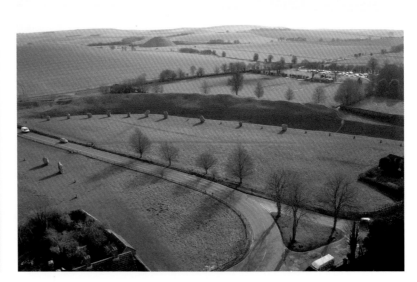

NORTH-WEST QUADRANT

The first part of the henge to be restored, the north-west quadrant was in an exceptionally poor state in 1937, obscured by rubbish and overgrown with trees and bushes. Explosives were used to remove tree stumps and a mechanical digger removed all that had been dumped in the ditch. A turf-covered stone boundary wall following the line of the large, outer stone ring had to be dismantled; in doing this the remains of six, mostly broken, stones were found. Only stone 40 was undamaged; the rest were re-assembled where possible, using cement. Stones 30 and 31 were found buried intact and re-erected. The only four stones still standing – 32, 33, 44 and 46 – were fixed in place with concrete. The former positions of five destroyed stones were marked with concrete plinths.

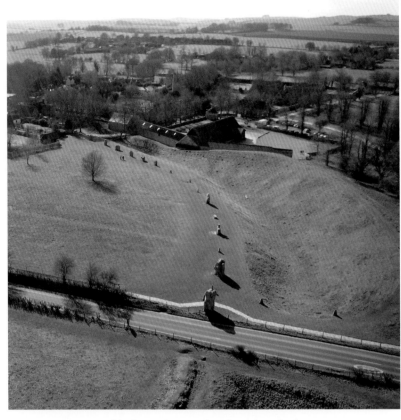

Northern entrance and north-west quadrant.

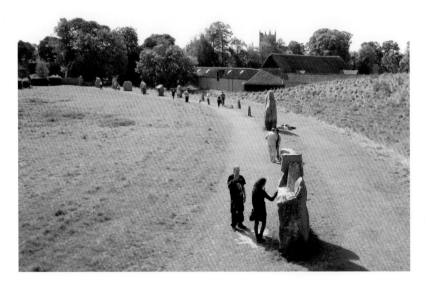

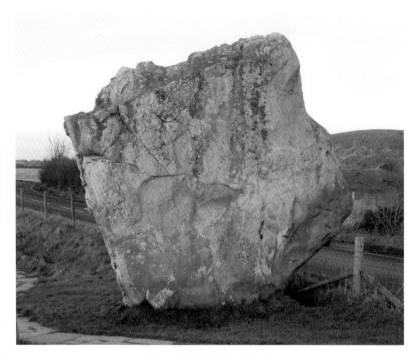

Stone 46, the 'Swindon Stone'.

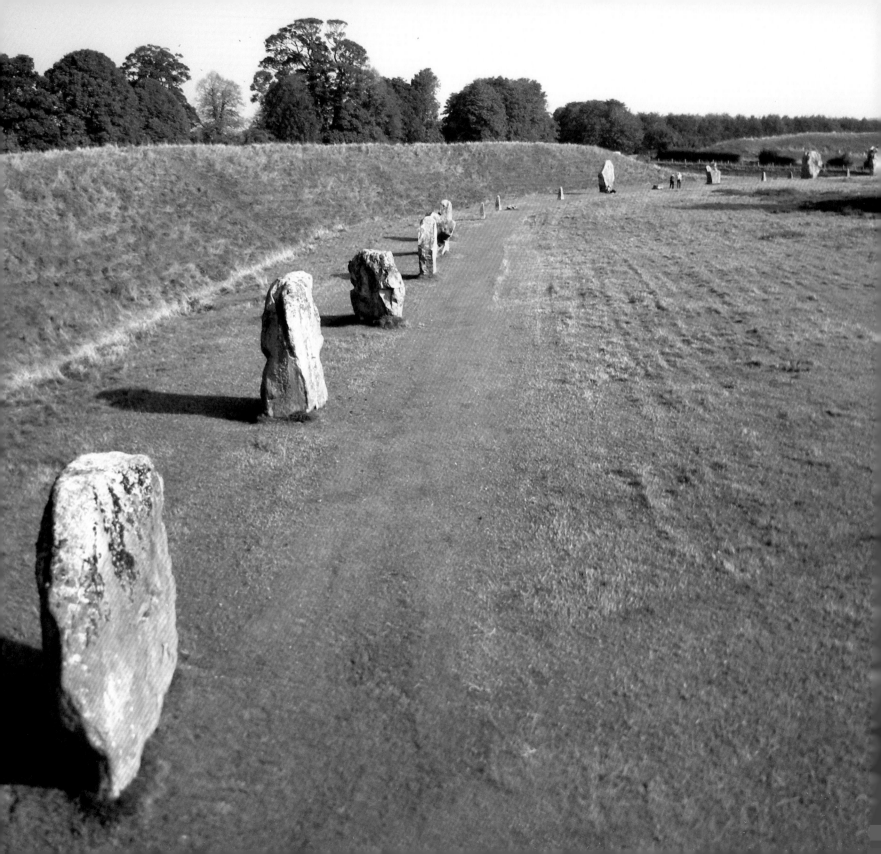

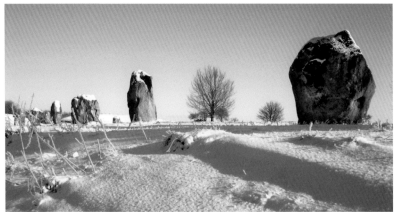

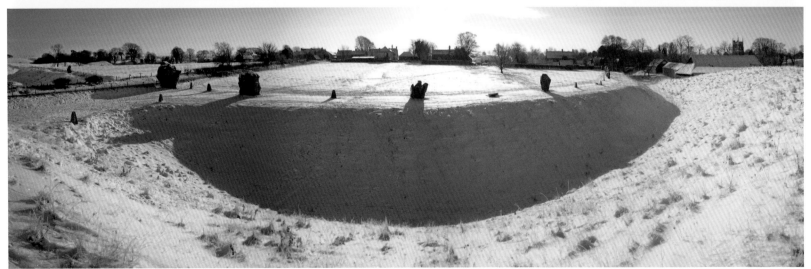

NORTH-EAST QUADRANT

Very few stones are visible today in the north-east quadrant, which was not excavated or restored by Keiller. Of the stones of the outer ring, only two are left standing and another lies fallen. This quadrant appears to have suffered particularly badly from the stone-breaking episode of the late seventeenth century. A.C. Smith spent a week in 1882 exploring the henge with probes, looking for buried stones. In the north-east quadrant he found only five buried stones of the outer ring, and eleven pits where destroyed stones had been. This was confirmed by a 2003 geophysical survey, which detected seven buried stones and concluded that most of the stones had been broken up and taken away from this quadrant. The survey also indicated occasional traces of stone fragments and packing material below the ground, where stones had once stood.

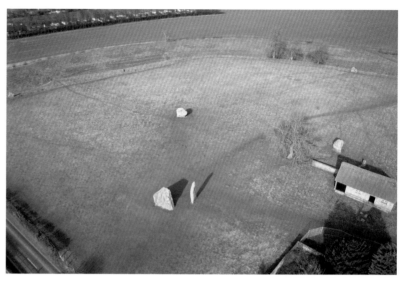

The two Cove stones mark the centre of the largely destroyed northern inner ring. Its perimeter is indicated here by stones 201 and 206. Stones 50 and 68 can also be seen.

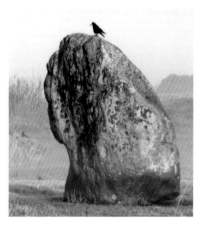

Stone 201.

Stone 73.

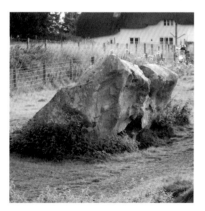

Stone 210.

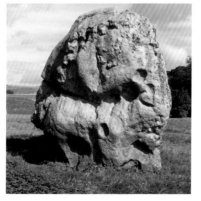

Stone 206.

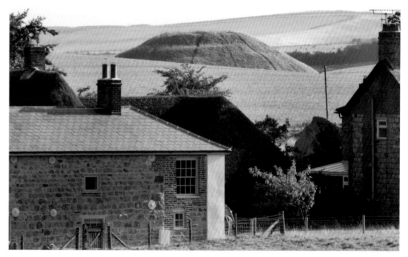

Silbury viewed from the north-east quadrant.

A 1990 geophysical survey found traces of what may be a timber circle, sited between the outer ring and the northern inner ring, just north of Stone 201 (*see large henge map*). An image was produced of two concentric rings made up of closely spaced dots, resembling holes where timber posts may once have stood. The two rings are not circular but slightly elliptical. The outer ring is roughly 50m in diameter and the inner ring roughly 30m – around the same diameter as the outer ring of the Sanctuary.

The Northern Inner Ring

Most of this feature is contained within the north-east quadrant, though it crosses the Swindon road and a small portion lies within the north-west quadrant. The ring of stones appears to have originally been egg-shaped, though the part within the north-east quadrant was broadly circular and around 100m in diameter. Isobel Smith assigned numbers to the stones in 1965. Based on 'the standard interval of 36ft' she envisaged a circle of twenty-seven stones, as shown on the large map fronting this section. Stukeley had estimated thirty stones. Gillings and Pollard, after comparing all the modern and antiquarian data available, concluded that the ring originally comprised twenty-eight stones. Their positions (*right*) are not all stone-holes – some are burning pits and other geophysical anomalies, so are not evenly spaced.

The Cove

Marking the centre of the northern ring is Avebury's most iconic feature, *the Cove*. Two enormous slabs of sarsen stand close together, forming a near right angle. The Cove is thought to have been originally a three-sided box-like setting, open to the north-east. Cove Stone I is a tall, thin, rectangular shape; Cove Stone II is the same height as Cove Stone I (4.5m) but twice its width and something of a cross between square and lozenge-shaped. Stukeley was told that the missing Cove Stone III, which fell in 1713, was tall and narrow like its opposite, Cove Stone I.

In 2003 both stones of the Cove were thought to be increasingly leaning and in danger of falling over. A huge scaffolding rig was erected to support the stones, so that archaeologists could dig down to their bases and hopefully recover some dating evidence before securing the stones with concrete. The smaller Cove Stone I was found to be moving, so it was straightened slightly. Cove Stone II, however, surprised everyone: it was far bigger than anticipated and was in no danger at all of falling over. Its predicted depth below the ground surface was 1.2m, but as the archaeologists dug, they found that the base was as much as 3m below the present ground level. This meant that the stone was also far heavier than expected and that the rig built to support it was probably inadequate; instead of an estimated 70 tons, it probably weighs an incredible 100 tons. So, at around 2.4m below ground level, the excavation had to stop for safety reasons before reaching the base of the stone.

It is possible that the gigantic Cove Stone II may have once stood alone as a *menhir*, rather like the Rudston Monolith in Yorkshire. If this huge slab of sarsen was originally lying just where it is now, that may have been enough of a reason to build the northern inner ring around it – the entire henge may even have been sited where it is because of this one great stone.

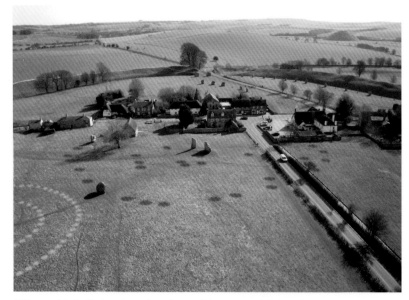

Gillings and Pollard's data shown in red; part of the suspected timber circle in yellow.

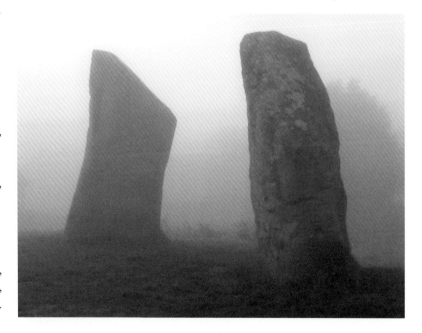

The two Cove stones are quite different. Cove Stone II has criss-cross indentations that may have been made by fallen branches before the stone hardened. Stone I has a large round feature probably made by a tree growing through the sarsen as it formed. Cove Stone I is unlike any other Avebury stone and there is good reason to suspect that it may have been imported from some distance away.

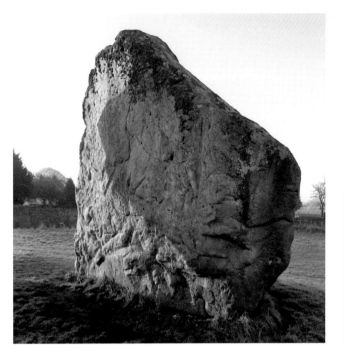

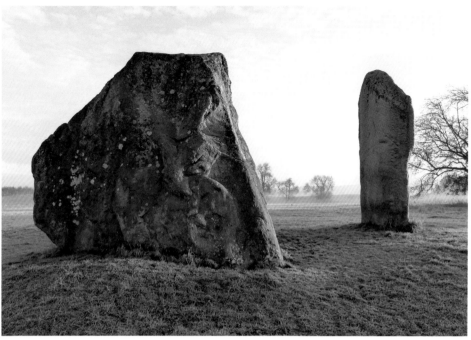

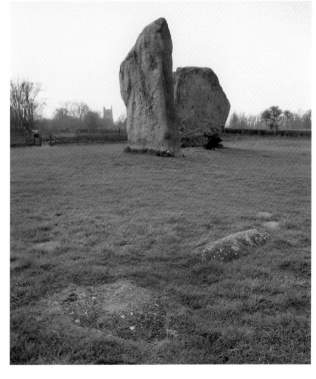

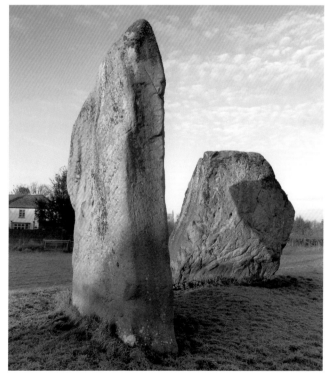

In the area around the Cove there
are also several buried stones.
Some are visible: the E stones
(*right*) are quite easy to find.

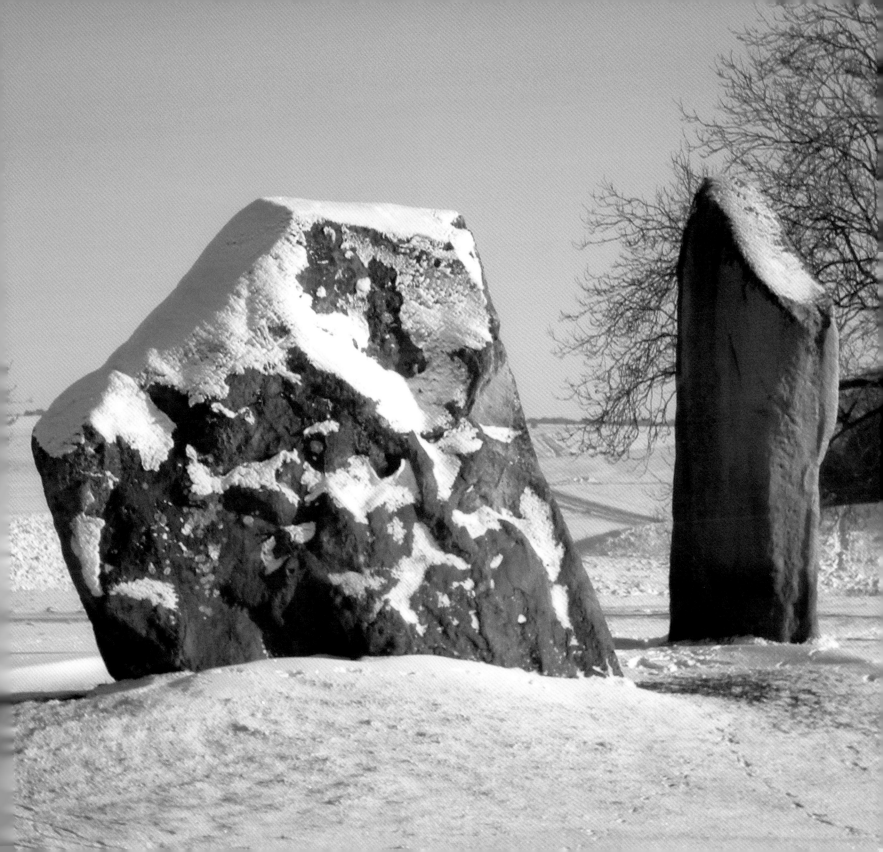

SOUTH-EAST QUADRANT

Today there is little to see of the outer ring in the south-east quadrant – only the two huge portal stones of the southern entrance and two much smaller stones near the eastern entrance, one fallen and the other a broken stump. Yet there are many more stones below the ground, presumably toppled and buried in the fourteenth century. A 2003 geophysical survey detected at least eleven buried stones in the outer circle and there may be more.

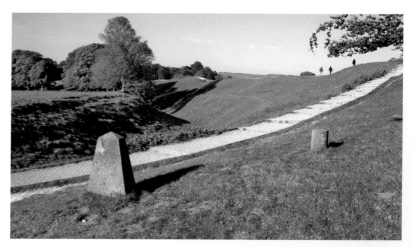

Markers for stone 1a and post hole.

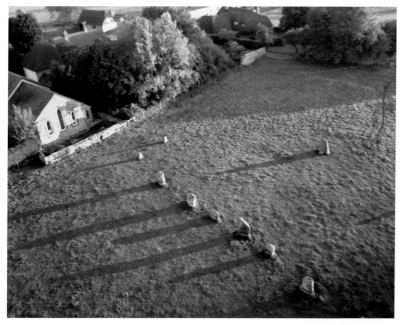

The Z-stones.

This was the third and last quadrant to be excavated by Keiller. Work began in 1939 and even though it was brought to an abrupt and premature end by the outbreak of war at the end of August, a great deal was accomplished. Trees and bushes were cleared from the southern entrance and the ditch was found to be 15ft wider than was thought. Three of the southern inner ring's fallen stones were repaired and re-erected inside the ring, and the previously unknown line of small *Z-stones* was discovered. The positions of several missing stones, including the huge Obelisk, were determined and marked with concrete plinths; the stump of the destroyed Ring-stone was found in its burning pit and set up above its original stone hole. No attempt was made to excavate the outer ring. Near the southern entrance the socket of stone 1a of the West Kennet Avenue was uncovered; next to it was a single, enormous post hole. Both have small concrete markers (*above*). The post hole may be Avebury's oldest feature, since it closely resembles three Mesolithic 'totem-pole' holes found at Stonehenge, dated 8500 to 7000 BC.

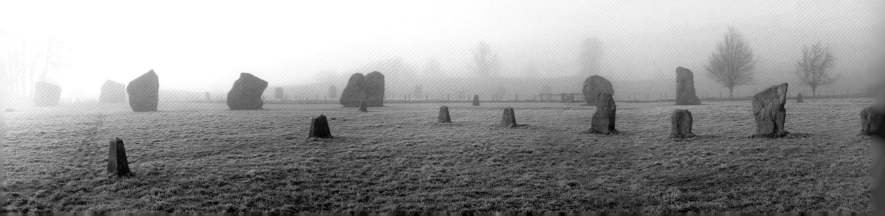

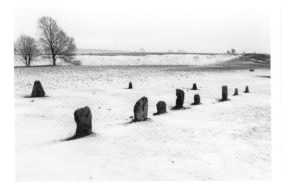

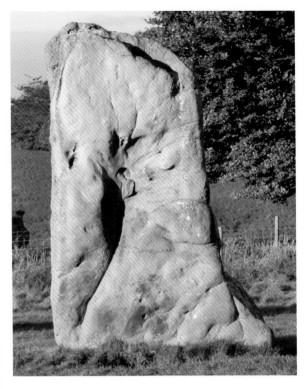

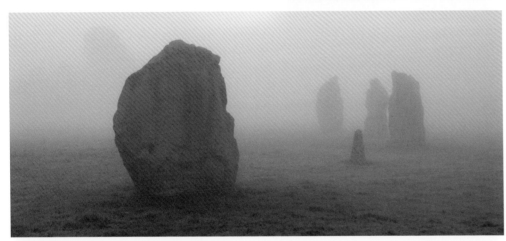

Stone 106 (*above*) has been reassembled from several broken fragments, as have many of Avebury's stones. The repairs to 106 can be seen on the back face of the stone (*below*).

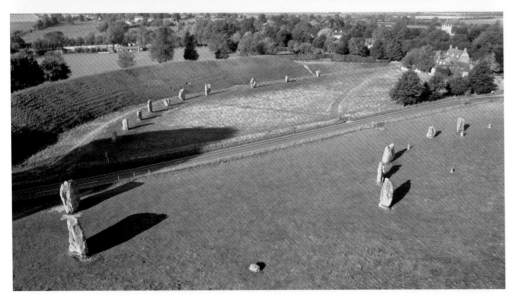

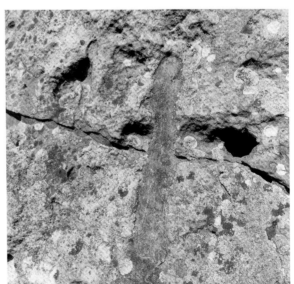

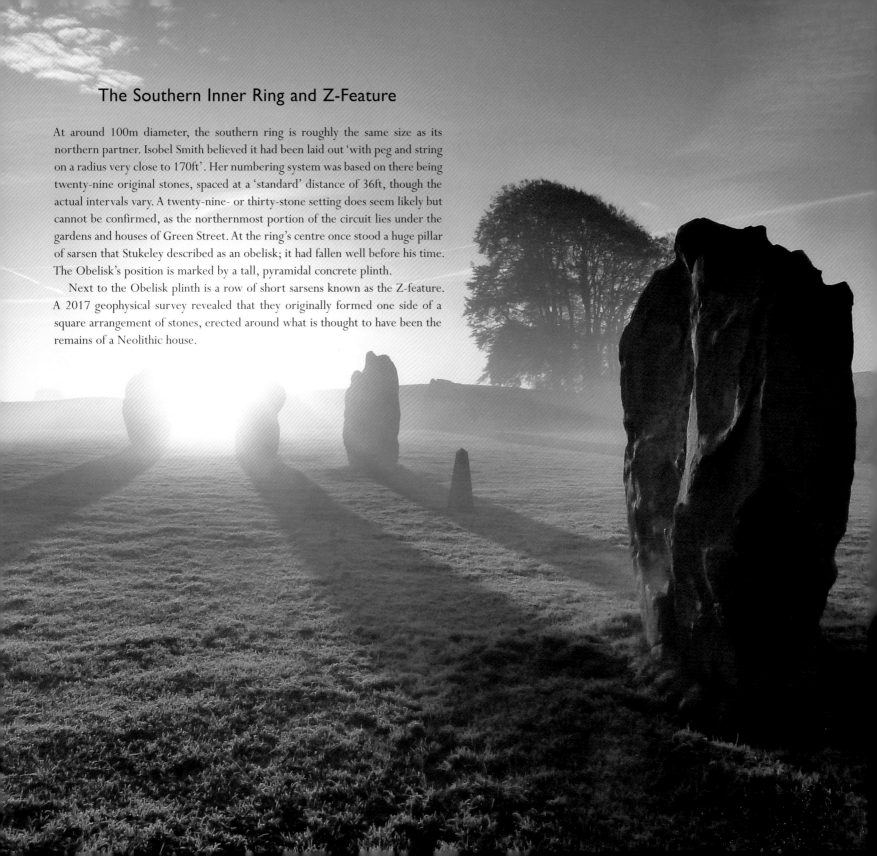

The Southern Inner Ring and Z-Feature

At around 100m diameter, the southern ring is roughly the same size as its northern partner. Isobel Smith believed it had been laid out 'with peg and string on a radius very close to 170ft'. Her numbering system was based on there being twenty-nine original stones, spaced at a 'standard' distance of 36ft, though the actual intervals vary. A twenty-nine- or thirty-stone setting does seem likely but cannot be confirmed, as the northernmost portion of the circuit lies under the gardens and houses of Green Street. At the ring's centre once stood a huge pillar of sarsen that Stukeley described as an obelisk; it had fallen well before his time. The Obelisk's position is marked by a tall, pyramidal concrete plinth.

Next to the Obelisk plinth is a row of short sarsens known as the Z-feature. A 2017 geophysical survey revealed that they originally formed one side of a square arrangement of stones, erected around what is thought to have been the remains of a Neolithic house.

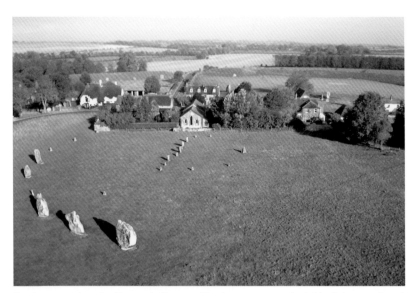

South-east quadrant, looking north. The arc of five large stones on the left is all that remains of the southern inner ring. The line of Z-stones can be seen in front of the chapel; to the right of them is the Obelisk's marker plinth, sited in the centre of the ring.

The enormous stones 98 and 1 were originally set at either side of the southern entrance before the bank was altered for a toll road. Stone 98, the 'Devil's Chair', has a recessed 'natural seat'. Curiously, so does the fallen stone 73 at the eastern entrance, and stone 1b of the Avenue. Did other missing entrance stones have seats? Are the seats entirely natural?

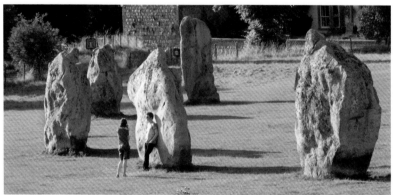

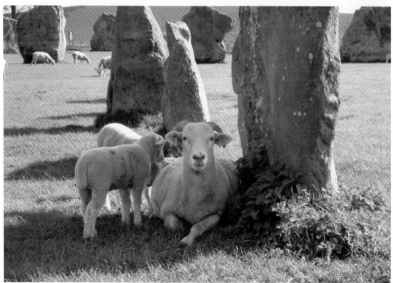

AVEBURY VILLAGE

Like most English villages, Avebury has a long and complex history. There was once a sizeable Roman settlement close to Silbury Hill. It was a stop on the major Roman road whose course is partially followed by the modern A4 road. Avebury's origins as a village are Anglo-Saxon; the settlement centralised when a *burh* was established in the tenth century. St James' church, built in the eleventh century, incorporates older features that are likely a legacy from earlier buildings. By this time Avebury had become a substantial village, though none of its houses have survived. Those we see in Avebury today date mostly from the eighteenth and nineteenth centuries, many of them built in a local style using red brick with a chequered pattern of 'glazed headers' (*see page 88*). A great deal of sarsen stone was also used in constructing the buildings that once characterised the village: much of the building stone, tragically, came from the Avebury monuments.

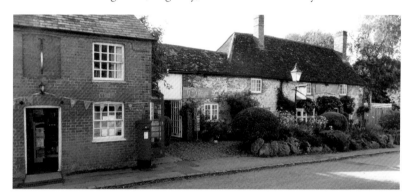

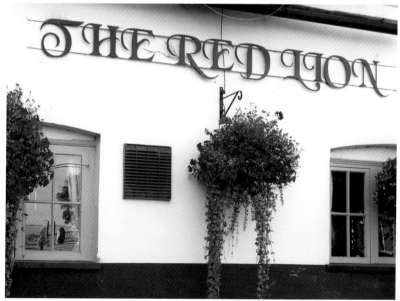

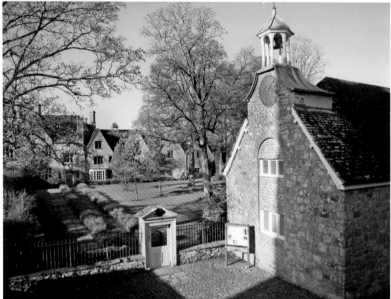

The recently restored Avebury Manor. In the foreground is the Alexander Keiller Museum, formerly the manor's stable block.

Avebury's monuments survived largely intact until the medieval period, when some stones were toppled and buried. In the early 1700s William Stukeley witnessed drastic changes to Avebury and the surrounding monuments. Sarsens were felled into 'burning pits' and heated with burning straw; cold water was poured onto the hot stones, shattering them into suitably sized pieces for building.

Broken sarsens in walls of the residents' car park. Many have a thin coating of natural 'rock varnish' (*see page 110*).

WEST KENNET AVENUE

Date of construction: probably 2600–2300 BC

From the southern entrance of the Avebury Henge, the West Kennet Avenue heads south-east towards the village of West Kennett, running roughly parallel to the long, narrow Waden Hill. The Avenue follows the flat ground at the base of the hill, but does not follow its contours exactly. On the other side of Waden Hill, to the south-west, the River Kennet runs broadly parallel to the Avenue as it also follows the lowest ground. Could this be a clue to the builders' intentions?

The Avenue's situation and route is very suggestive of a river – perhaps that is what it symbolises? It could also have been the route of a significant or ancient footpath, memorialised in stone. William Stukeley admired the 'masterly' way the Avenue harmonised with the landscape; on his visits to Avebury in the 1720s he made many panoramic drawings looking down from a vantage point on top of Waden Hill, which still offers a fine view of the Avenue's route.

When John Aubrey visited Avebury in 1663 he drew the Avenue as being virtually complete. Aubrey's highly stylised plan shows around fifty pairs of stones extending to the Sanctuary, though it is likely there were actually around twice that number. When Stukeley first visited Avebury, just half a century later, there were only seventy-two stones left of the Avenue and more were still being destroyed. By the end of the nineteenth century only four stones were left standing.

The West Kennet Avenue as we see it today was almost entirely restored in the 1930s by Alexander Keiller. When work began in 1934 some of the stones were lying toppled. They were re-erected, along with others that had been buried during the medieval period, but many stones had been destroyed or removed for use as building material. Not surprisingly, the worst damaged areas are at the north of the Avenue close to Avebury village.

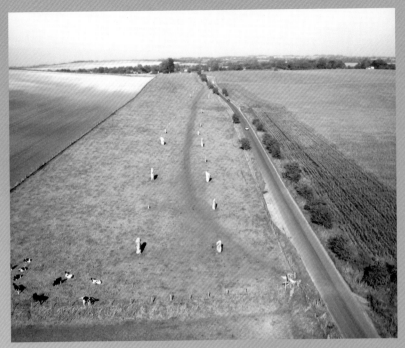

The restored Avenue, looking north.

The Avenue's direction changes several times. Although the overall design appears to be smoothly serpentine, it actually consists of a number of short, straight sections joined together. Several archaeoastronomers have claimed that the orientation of these straight sections has astronomical significance, intentionally pointing to the positions of the moon and sun at certain times of the year. The most obvious alignment is the northernmost section, from stone pairs 6 to 15. At winter solstice the sun rises midway between the two rows of stones when viewed from the south-west bank of the Avebury Henge (*below*).

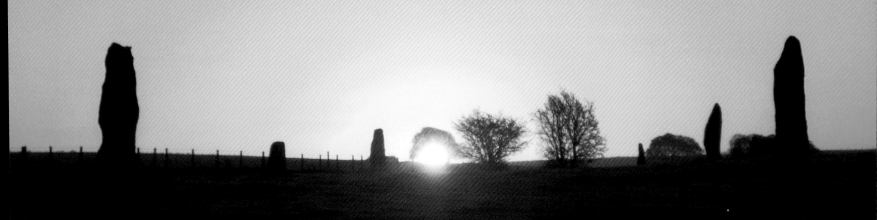

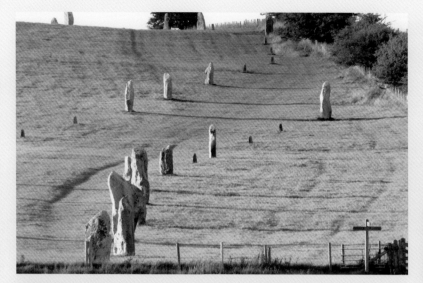

In identifying the individual stones of the Avenue, this book uses the system originated by Keiller and revised by Isobel Smith for her 1965 report. The stones are numbered in pairs from north to south, with those of the eastern side defined as 1a, 2a, etc. and those of the western side as 1b, 2b, etc.

The B4003 road runs broadly parallel to the Avenue, following the same low contours. The road does not follow the Avenue's course exactly though, and halfway along the restored line of stones it cuts through eight of the stone pairs. Stones that should be partnered are consequently separated by the road and a barbed-wire fence. Although the stones obviously came first, the impression is that the line of stones has gone astray and wandered across the road.

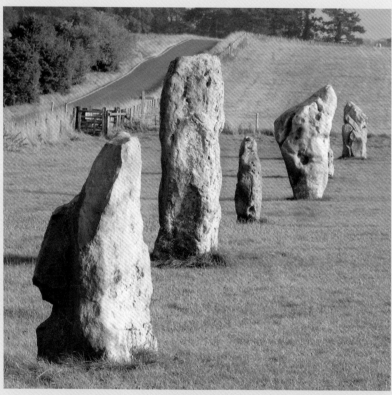

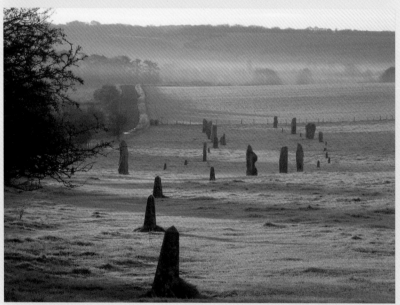

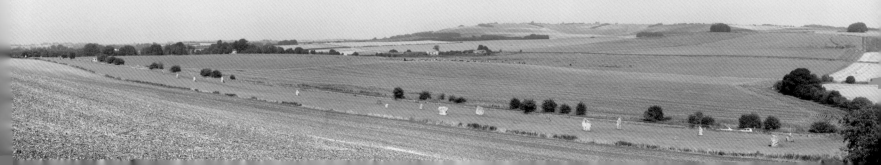

Stone 35a, 'The Shark'.

Restored northern section of the West Kennet Avenue.

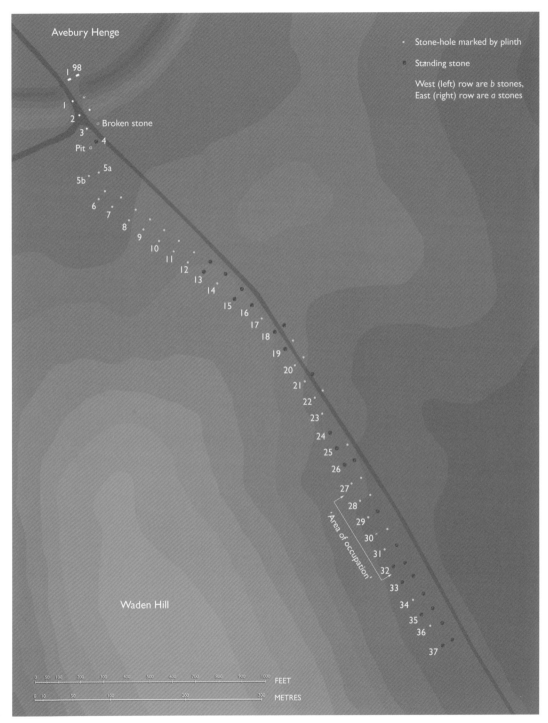

Avebury Henge

• Stone-hole marked by plinth

• Standing stone

West (left) row are *b* stones,
East (right) row are *a* stones

1 98
1
2
3 ○ Broken stone
4
Pit ○
5a
5b
6
7
8
9
10
11
12
13
14
15
16
17
18
19
20
21
22
23
24
25
26
27
28
29
30
31
32
33
34
35
36
37

'Area of occupation'

Waden Hill

0 50 100 200 300 400 500 600 700 800 900 1000 FEET

0 10 50 100 200 300 METRES

Keiller's Restoration of the Avenue

Keiller's restored section of the Avenue is about half a mile long, but not complete. When work began in 1934 the Avenue's exact route was uncertain; in the northern section only stones 33a and 33b were still standing. Starting from the farthest stone pair 37 at the southern end, the first season of work succeeded in tracing the route north as far as stone 19b of the western row and the missing stone 17a of the eastern row. The stones were found to be quite evenly spaced, so when work resumed in 1935 it was possible to estimate their likely positions by measurement. The final stretch up to the henge was made more difficult because there were allotment gardens and chicken runs in the way.

Eventually the former sites of thirty missing stones were found. Thirteen stones were found buried and an additional nine had fallen: all were re-erected. Stone 25a had been destroyed. Stones 20a and 22a had been broken up by hammer and chisel, and six stones had been destroyed by fire and water. Stone 32a had broken when it fell, so was reassembled with metal rods, which can still be seen. The re-erected stones were mounted in their original sockets, all of which had been preserved intact with their packing stones. All of the re-erected stones were stabilised with concrete foundations; stone 33a also received this treatment even though it was still standing. Concrete marker plinths were placed over the empty sockets whose stones had been destroyed.

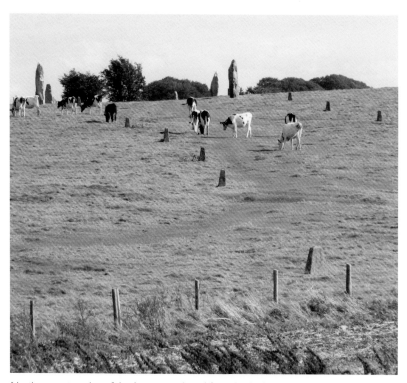

Northernmost section of the Avenue, as viewed from the Avebury Henge.

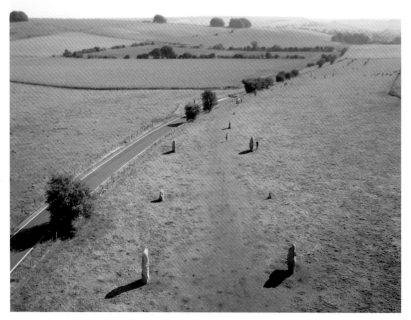

The Avenue seen looking south from stone pair 13.

Stone 33b was still standing when Keiller arrived; its base was stabilised with concrete, but the stone is still in its original position. Unlike all other stones of this section, 33b is not mounted with its long axis in line with the setting, but is skewed around 15° to the west (anticlockwise). Other stones inside the henge are similarly skewed. Was this deliberate, or did the stones slip whilst being erected?

Had Keiller's work not been halted prematurely in 1939 we might know a great deal more about the henge's southern entrance, as he intended to re-excavate and strip away the entire area of the Avenue's approach. The exact course of the Avenue where it meets the Avebury Henge is still far from clear. Keiller was unhappy with his excavations there and it is likely that a pair of stones was missed entirely.

The Avenue performs an odd twist where it connects to the henge, but the original arrangement may have been very different to how we perceive it today – not necessarily with only two parallel lines of stones. At what is usually regarded to be the Avenue's opposite end, it appears there were *three* lines of stones in the final approach to the Sanctuary and again, an odd twist in its final approach. So maybe the Avenue's approach to the southern entrance to the henge also had three lines of stones, or some other even more complex arrangement?

Keiller's 'Area of Occupation'

All along the length of the Avenue's restored section missing stones are marked by concrete plinths placed over the socket holes. The plinths are rectangular, indicating the orientation of the original stones, most of which were slab-like. However, one marker in the Avenue is different: the plinth opposite stone 30a is square. Curiously, this marker is different because it marks not where a stone once stood, but where there was **no** stone.

No evidence could be found for the existence of stone 30b, so Keiller marked the position where he thought it should have been, had it existed. It may be that there **was** a stone 30b, and that no trace exists because it was small, or had an exceptionally shallow socket, which may not have extended down into the bedrock. But it seems highly probable that stone 30b never existed at all, and that there was a deliberate gap in the Avenue at that position.

In the area between stone pairs 27 and 32, Keiller's excavation surprisingly turned up an enormous amount of debris scattered over the original ground surface. Gillings and Pollard have described this as 'effectively a midden' or rubbish dump; but as we also see in other sites, such as Windmill Hill, the material was not simply strewn around randomly, but distributed in a structured way. Ten natural hollows and two man-made pits were used for the deposition of flint artefacts, assorted pieces of sarsen and other stones (some of which originated in Germany), animal bones, charcoal and pieces of broken stone axes. The debris was dated to the Middle Neolithic.

2013 saw this part of the Avenue excavated again, when, as part of the Between the Monuments project, some of Keiller's trenches were re-opened. The dig continued in 2014 and 2015; at the time of writing the team's findings are still being evaluated.

At a Between the Monuments Open Day in 2013, Josh Pollard and Mark Gillings explain their findings to a group of local people and members of ASAHRG – the Avebury & Stonehenge Archaeological & Historical Research Group.

What Made the Scratches?

Two of the Avenue's stones, 29a and 25b, have mysterious areas of horizontal parallel scratches. Both stones are similarly shaped, quite smooth and rounded. There may be a natural explanation; it is also possible that the scratches were inadvertently man-made as the stones were moved from wherever they were sourced. Like marble and many types of building stone, buried sarsen that has never been exposed to the air is quite soft; it hardens after coming into contact with oxygen. So perhaps these two fairly small stones were dug up and simply dragged on ropes over rough, flinty ground to the Avenue, acquiring scratches in the process?

Mystery scratches on Stone 29a.

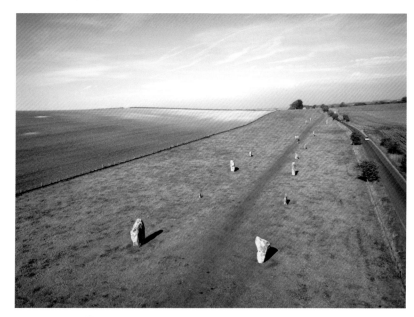

The restored Avenue, seen looking north from stone pair 35.

Sexing the Stones

Keiller and Piggott were convinced that the Avenue stones, and other standing stones inside the henge, were of two basic shapes, *Type A* and *Type B*. They thought that the shapes may have had symbolic significance, the pillar-like *Type A* stones being male and the lozenge-shaped *Type B* being female, based on their resemblance to human genitals. Although the idea was never anything more than conjecture, it persists to this day and is often regarded as fact. Several authors have claimed that *all* the stones of the West Kennet Avenue are arranged as *Type A* and *Type B*, male and female pairs, but many stones are missing. This notion is usually illustrated with stones 13a and 13b (*page 95*) which are pillar and lozenge-shaped respectively, but few other stone pairs conform. Many stones that are not pillars are set as squares, rather than lozenges. Readers may judge for themselves: all the surviving stones are shown to scale (*below*) with a superimposed grid of metre and half-metre steps.

Falkner's Circle

At the southern end of the restored Avenue is a gate leading to a small roadside parking area. On the opposite side of the road a rough track runs north-east. Around 200m along the track can be found a single sarsen stone, all that remains of Falkner's Circle. The stone can usually be seen from the Avenue, but at only 1.3m high it may be obscured by vegetation in the summer. Mr Falkner discovered the monument in 1840; he described a ruined stone circle with three remaining stones – one standing and two fallen – and nine hollows where stones had been removed. A 2002 excavation confirmed this and found the hollows to be stone-destruction pits. It is now thought that the circle may have had only ten stones, which were spaced irregularly. The circle's diameter was estimated at about 44m, close to Falkner's 120ft.

Surviving stones of western row Surviving stones of eastern row

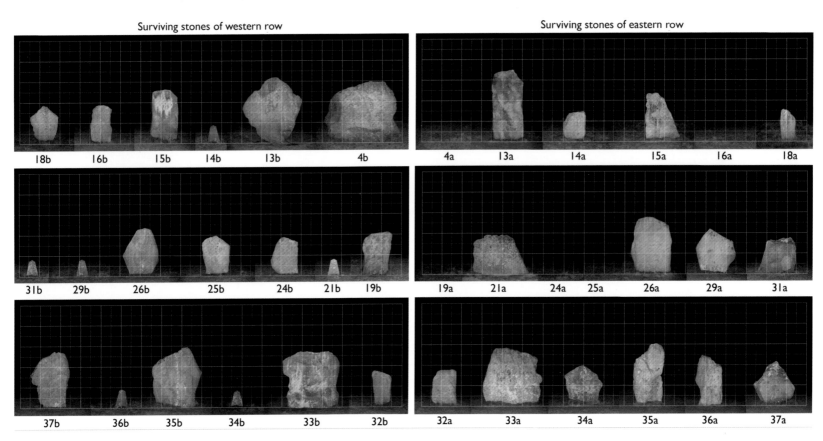

RIGHT: Surviving stones of the West Kennet Avenue, including the southern section and Falkner's Circle, shown not to scale.

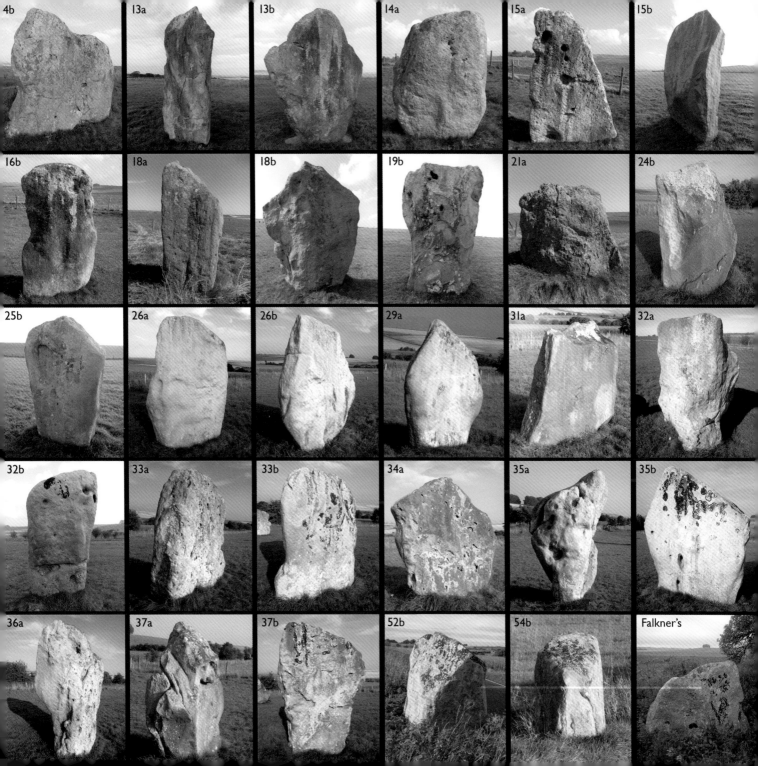

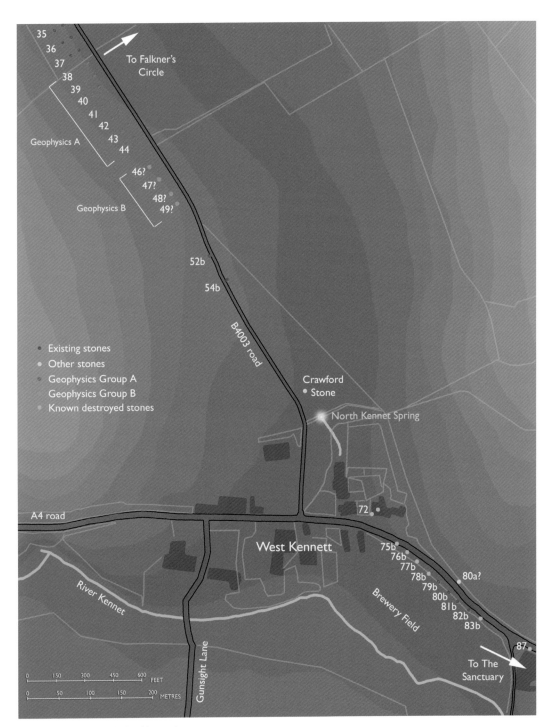

Stone 79b.

Stone 80b.

Stone 81b.

Stone 82b.

Map labels:

35
36
37
38
39
40
41
42
43
44

To Falkner's Circle

Geophysics A

46?
47?
48?
49?

Geophysics B

52b

54b

B4003 road

• Existing stones
• Other stones
• Geophysics Group A
 Geophysics Group B
• Known destroyed stones

Crawford
• Stone

North Kennet Spring

A4 road

West Kennett

River Kennet

Gunsight Lane

72

75b
76b
77b
78b
79b
80b
81b
82b
83b

80a?

Brewery Field

87

To The Sanctuary

0 150 300 450 600 FEET
0 50 100 150 200 METRES

Southern section of the West Kennet Avenue.

Further South: Beyond Keiller's Avenue

The Avenue once continued on south-east, still running roughly parallel to the present road. Though there are no markers, its route can be followed through another grassy field that is accessible. A geophysical survey in 1990 determined the position of stones in a 150m-long section *A* that continued on from Keiller's pair 37; they were able to trace the sites of stone 38a (but not its partner) and pairs 39 to 42. This section, as was expected, tracked broadly south-east, with a slight curve taking it steadily more eastward. Pair 43 shows less clearly, as there is a presumed burning pit between the two stones. Only one more stone-hole can be seen at the end of the survey area – it is probably 44b.

Continuing south into section *B* the geophysics was inconclusive but the team produced four conjectural stone positions based on their results. It has been suggested that the Avenue deliberately became a single row of stones at this point; it could equally be that it shifted course again, and that another parallel row is buried beneath the road. This would appear to be supported by Stukeley's field sketches, which all show at least some pairs of standing stones in this section.

Even further south there are two stones standing by the roadside that have never been disturbed. The road passes between them but both are considered to be *b* stones: on the Keiller/Smith plan they are 52b and 54b. Beyond these is the Crawford Stone that OGS Crawford recorded as being buried in the winter of 1921/22. When the stone was excavated in 2003 no socket was found: it may simply be a natural sarsen. The Avenue is presumed to have continued on through West Kennett.

The remains of a further four (possibly five) stones may be seen by crossing the A4 road and walking south-east along the hedge-line of what is known as the Brewery Field. The stones are not easy to find and visitors are advised to search in the winter, as summer foliage may completely obscure them. The four are all considered *b* stones; their *a* partners are presumed to have been sited along the opposite side of the road. It is possible that at least one of these has partially survived: two sizeable pieces of sarsen half-hidden in the hedge may be the remains of stone 80a. The road is dangerous, with no pavement, and trying to reach the stone is not advised. Instead, view it across the road from the safety of stone 80b.

Note that on the map of this section a spring is shown not far from the buried Crawford Stone. Identified as North Kennet Spring (map, left), it may have played a crucial role in the form and function of the Avenue.

There is very little physical evidence of the West Kennet Avenue beyond Keiller's restored section, save a few burning pits and sockets. Most of the stones drawn by Stukeley in this area are conjectural. Similarly, between the Brewery Field and the Sanctuary is thought to have been a continuous double row of stones, but Stukeley's drawings show that they were almost entirely destroyed even by the 1720s.

Did the Avenue Run Continuously to the Sanctuary?

The earliest recorded plan of the West Kennet Avenue was made around 1660 by John Aubrey; it shows an avenue running due south from the henge and stopping short at West Kennett. From there, at right angles, another avenue runs due east to the Sanctuary. There is a distinct gap between the two avenues. Aubrey noted that the eastward run crossed a river; from his plan it clearly was not the Kennet. It is possible that he saw a river that no longer exists but is still shown on the current OS map.

On the north side of the A4 is a yard attached to West Kennett Farm. The OS map shows a tiny stretch of river running south-east across this yard; on older maps it is marked 'drain'. The river is shown to start at what was once almost certainly a spring; it ends abruptly where it has probably been channelled underground, to flow south under the A4 and into the River Kennet. The farmyard has always been notoriously wet; local residents recall that the water once flowed south into the Kennet. The yard is still often wet today, though there is no stream, as the spring has likely been capped. If Aubrey really did see a river crossing the Avenue's eastward course, its probable source would be this, which for convenience I have named the North Kennet Spring.

The North Kennet Spring, assuming it flowed then, would have been a significant element of Avebury's prehistoric waterscape. It is highly unlikely that the spring would *not* have flowed, considering its position in a shallow valley sloping south to the River Kennet. The valley is a former drainage channel – an ancient watercourse, now dry, that must have existed throughout successive ice ages, when rain and snow-melt were shaping the hills and valleys from permafrosted chalk. Water naturally flowed south down the valley and into the river. Part of the ancient watercourse just north of the spring shows clearly on Google Earth as a dark stripe, curving across a bare field of chalky soil (*below*).

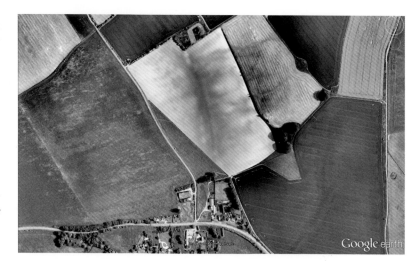

Exactly how little physical evidence there is for a continuous run from the Avebury Henge to the Sanctuary may be seen from the map (*right*) which shows that at least half of the Avenue's supposed course is conspicuously absent. Aubrey and Stukeley's evidence also suggests that the Avenue was not continuous, and that there may always have been a gap at West Kennett. At the centre of that gap is the North Kennet Spring.

The River Kennet's modern course is not natural and has been heavily managed. Moving slowly across flat areas of low ground with a gentle gradient, it would naturally have formed large areas of marshland, perhaps hundreds of metres wide. Weaving through this would be many narrow, braided channels that changed and moved according to seasonal fluctuations in the water supply. In times of high rainfall they may have formed one great, wide river as witnessed in recent flooding; in drier times the braids would recede, forming pools as they shrank back to trickling streams.

The course of the Avenue, if it was continuous, would pass directly through where the North Kennet Spring is shown to rise on the OS map. If the water table was higher in prehistory the spring may have risen further north, which would have made the area even wetter. Could this explain why the Avenue appears to have a missing section? Perhaps, rather than a continuous avenue running from the henge and terminating at the Sanctuary, there were two separate avenues, one from each monument, that both terminated at the North Kennet Spring.

Stukeley's vivid and imaginative 1740 description of ceremonial routes used for religious processions at Stonehenge resulted in a general assumption that all avenues must have been used for this purpose. Yet archaeological surveys of Stonehenge and Avebury have concluded that few people, if any, walked the actual avenues. Since 'hollow ways' develop so easily in chalk, hollowing of the avenues would be expected if many people were processing over time, yet none was found. Stukeley even described Stonehenge's avenue as being slightly raised 'a little above the level of the downs'.

Features described as 'avenues' have been found at other monuments around Britain, particularly henges. The avenues frequently run downhill to terminate at rivers, but not all are like Avebury and Stonehenge. Marden and Durrington, for example, have far shorter avenues that *do* appear to have been meant for human traffic, since they were metalled with gravel and stones, and have been compressed. Perhaps our understanding has been hampered by the terminology and not all 'avenues' had the same function?

If avenues such as those at Avebury and Stonehenge were not meant to be walked, what was their function? Avenues resemble rivers, in that they generally 'flow' downhill to meet an actual river, sometimes accompanied by springs and marshland. Rivers and avenues frequently form an east–south confluence – seemingly a significant factor in the siting of monuments. In its south-east course from the Avebury

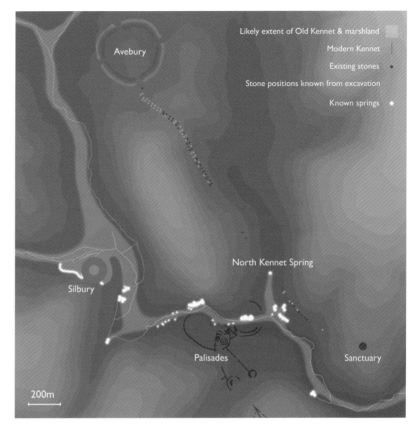

Henge, the West Kennet Avenue elegantly 'flows' around the contours of Waden Hill. Its route is essentially riverine, even though its gradual descent is interrupted by two shallow ridges. Symbolic rivers can presumably flow uphill occasionally.

In European mythology there is a long tradition linking rivers to the Otherworld, or Underworld. The Indo-European myths were already ancient when first recorded around 900 BC – perhaps they contain remnants of beliefs held by the Neolithic monument builders? A common theme is of journeying to the Otherworld by travelling along, or crossing, a river. In Greek mythology Hades is portrayed as a marsh watered by a confluence of five rivers, of which the best known is the River Styx.

In a monument where funerary rites were performed, an avenue may have functioned as a 'river of souls' like the River Styx – a route for the souls of the dead to travel to the Otherworld, as symbolised by a marsh. Marshland is 'liminal' in that it is between wet and dry; it is not quite water and not quite land. Liminal places such as marshes, boundaries and crossroads have a deep association with the Otherworld. Being liminal, they are places where two worlds meet – the worlds of the living and the dead.

THE LONGSTONES AND BECKHAMPTON AVENUE

Avenue's construction: probably between 2250 and 2000 BC

Avebury once had another avenue, similar to the one we can see today. A double line of standing stones ran from the western entrance of the henge, probably along the present course of the High Street. It crossed the River Kennet, then veered to the south-west across what are now arable fields towards Beckhampton, almost a mile away.

Adam.

Eve.

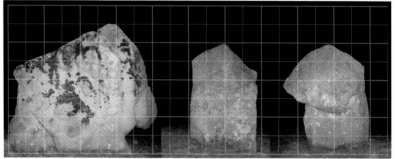

Adam and two views of Eve, with a grid of metre and half-metre steps.

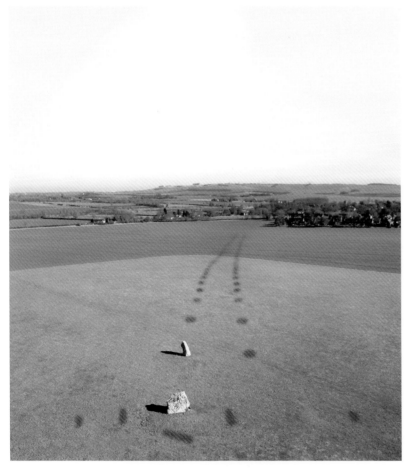

The Longstones and the projected course of the Beckhampton Avenue, seen looking north-east to Avebury. Adam is in the foreground; behind it is Eve.

The Beckhampton Avenue is now all but destroyed with only two of its stones standing, although others are known to be buried. The two remaining stones, known as the Longstones or Adam and Eve, are sited at the end of the Avenue. They now stand in the middle of a field just north-west of the Beckhampton Roundabout and may be glimpsed whilst driving to Avebury from the A4 road. The Longstones field is accessible and it is easily possible to walk there from Avebury (*see map overleaf*).

William Stukeley's sketches, drawn in the field, show that by 1724 the Beckhampton Avenue was in a ruinous state: its last few remaining stones were being removed as building material and Adam and Eve were the only two stones left standing. A double row of hollows where stones had once stood ran from Avebury to the Longstones; eventually the hollows silted up and by the nineteenth century their last traces were gone.

Between 1997 and 2003 the Longstones Project, a joint-universities pro-gramme of excavation and survey, was concentrated on an area north-west of Beckhampton, centred on the Longstones. The archaeologists found stones of the Avenue that had been toppled and buried, also an earthwork — an oval bank and ditch named the *Longstones Enclosure* that may have been one of the earliest features of the Avebury Complex.

The Longstones Enclosure

The Longstones Project is best known for its discovery of buried Avenue stones but equally important was the excavation of the *Longstones Enclosure*. First noticed from the air as a cropmark, the enclosure is a flattened oval, roughly 110 × 140m across, that is not normally visible. On its eastern side, where the Avenue ran off to Avebury, is an entrance 45m across. The Avenue stone Eve is just inside the enclosure; Adam is just outside of it.

The enclosure was found to be a ditch, dug as a series of conjoined long pits with causeways between them. There were few finds, but enough to establish a probable date of 2820–2660 BC, slightly earlier than the earthwork of the Avebury Henge. The earthwork had been deliberately levelled and its ditch back-filled, seemingly after quite a short period of use – another example of monument 'decommissioning'. Why this should have been done is not clear. Perhaps the Longstones Enclosure was considered to have been supplanted by the building of the much larger Avebury earthwork?

The area near the Longstones was apparently regarded as special, long before the enclosure was constructed, since there were two long barrows close by. The *South Street long barrow* most likely dates from 3490–3020 BC, and the *Longstones long barrow* from before 3370–2910 BC, so both were already ancient when the Longstones Enclosure was constructed. Why this area should be regarded as special is a mystery, as today it has no unusual features. A connection to water might be expected, but none is apparent. The nearest springs are more than 500m from the Longstones, on ground that is about 10m lower. It is always possible that there may have been springs on the high ground, but not likely.

Could it be that the Longstones area had a natural drift of sarsens that was particularly impressive or unusual? The huge quantity of stones required for the double row of an avenue must have come from somewhere and there is a good case for monument stones being sourced locally. From the Longstones site, following the course of the Beckhampton Avenue, the ground steadily falls away to the north-east in a shallow drainage line to the river. This is just the type of landscape where sarsens may be expected: it is quite feasible that the avenue's course followed a natural drift.

- Public roads
- Public footpaths
- Presumed route of avenue
- Known former stone positions
- Existing stones

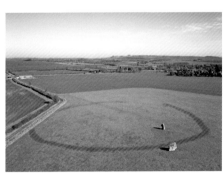

The Longstones seen looking north-east, with the Enclosure added.

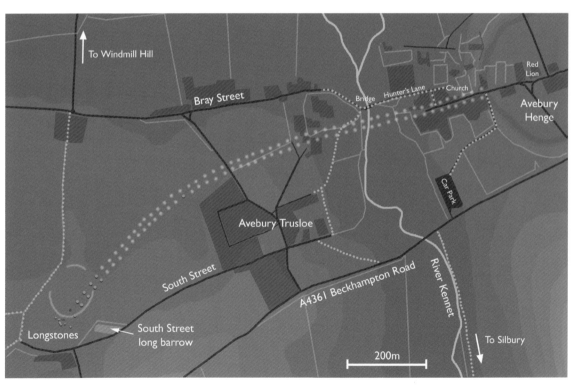

The Beckhampton Avenue's projected course from the Longstones Enclosure to the Avebury Henge.

Rediscovery of the Beckhampton Avenue

In 1999 archaeologists of the Longstones Project excavated part of the Longstones area near Adam and Eve. There they found three stones buried intact and traces of others that had been removed, likely in the early 1700s. The three buried stones were all quite different and one had polishing marks. At the eastern end of the field by Avebury Trusloe the site of another missing stone was found (*see map opposite*). Five pairs of Avenue stone positions were excavated, three pairs inside the Enclosure and two pairs beyond it. Of those ten stones only Eve is still standing.

This seems to confirm that a double row of stones, spaced similarly to those of the West Kennet Avenue, once ran from Avebury to the Longstones. The river crossing is still a mystery – did the pairs of stones continue through the Kennet?

The Longstones Cove

Eve was one of a pair of Avenue stones; Adam was part of the box-like *Longstones Cove* that marked the end of the Avenue. The Cove was built in two phases (*right*). First, three stones L11, L12 and L13 were set in a line perpendicular to the course of the Avenue. Each stone was turned so that its long axis matched that of the Avenue and the centre stone was set exactly between the two rows of the Avenue. It is possible though, that the three stones were already in position when the Avenue was attached.

At some later date the three-stone setting was altered. The middle stone (L11) was left in position and a new stone erected opposite it. The other two original stones were probably taken away and used elsewhere. The angled sides of the Cove were formed by the addition of two huge slabs, one of which was Adam. Interestingly, the original line of stones and the long axis of the Cove were both aligned to about 130° – the direction of winter solstice sunrise from the Longstones site.

Adam today appears as a slightly tilted rectangle but it was originally mounted on one of its corners as a lozenge, or diamond. It fell in 1911 and the following year was re-erected and set in concrete by Maud Cunnington. Because the stone's weight of around 60 tons was underestimated, it slipped sideways and slumped forward in the re-mounting process, so is now permanently fixed in the wrong position. Stukeley's field sketch from 1724 shows Adam's opposite partner in the Cove (which was then already toppled) to be around the same size as Adam and also set as a lozenge. The other two stones are the same size (about 4m × 3.5m) but set on edge as squares.

The reconstructed Beckhampton Cove, as depicted by Stukeley in 1724. In the foreground is the one stone retained from the initial three-stone setting; Adam is on the right.

Acoustics of the Longstones Cove

Sarsen stone reflects sound extremely well, so it might be expected that a structure such as the Beckhampton Cove would produce interesting acoustical effects, perhaps like the tuned resonances of the West Kennet long barrow's chambers.

In 2009 Stephen Allan, Richard Pearson and myself experimented with a simple, full-sized model of the Cove that Stephen built on a sports field. Four 8ft × 4ft sheets of chipboard were arranged exactly as the original Cove stones. Each sheet was only about half the width of a stone but this was sufficient to test whether any effects could be detected.

We discovered that the Cove does indeed produce a striking acoustic effect, though not as expected. Sounds, such as speech, made within the structure reflect from the two splayed sides and are projected out along its long axis. To a listener outside the Cove this produces the bizarre effect of the end stone L11 appearing to 'speak' as the sound is projected around it. The Cove could potentially be used as an oracle.

The effect was impressive with only a sheet of chipboard blocking the speaker inside the Cove from view – with a huge sarsen stone it would be astounding. The reflection also worked in reverse: a listener inside the Cove could clearly hear sounds from outside, even when their source was hidden by the end stone, L11.

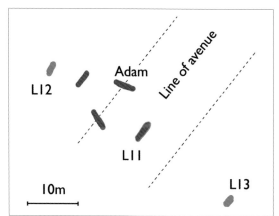

LEFT: Plan showing the Cove's two phases of construction. Blue – Phase 1, Red – Phase 2. Note that stone L11 was used, in the same position, for both phases. See also the aerial photograph with overlay of the avenue on page 101.

BELOW: Stephen Allan inside the Cove model, preparing to burst a balloon for an impulse sound frequency measurement.

103

WHERE DID THE STONES COME FROM?

It is commonly believed that the sarsen stones used to build Avebury's monuments were transported from the Marlborough Downs, several miles away. This idea has persisted for centuries. Professor Richard Atkinson proposed in 1956 that the Stonehenge sarsens originated from the Marlborough Downs, because it was then the largest existing drift; the Avebury stones were assumed to have come from the same source. Early writers such as Aubrey and Stukeley, though, remarked on the dense concentrations of sarsen across the *entire* Avebury landscape, not just where they are found today. Countless sarsens have been removed over recent centuries.

Atkinson presented no evidence to support his theory and, as yet, there is none. Nonetheless, Atkinson's claim has been repeated regularly for half a century, as if it were factual. The question may one day be resolved by geochemical fingerprinting, but since current techniques are destructive they cannot be used in the World Heritage Site. However, a great deal can be learned by simply examining and comparing the stones.

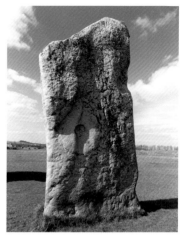

Cove Stone I.

Differences in Sarsen Stone

Not all sarsen stone is the same: there are striking differences even between adjacent stones set within the Avebury Henge. The two stones of the Avebury Cove, for instance, have quite different types of holes; their texture and shapes are also markedly different. Most tellingly, when examined with a magnifying glass one is pink, the other blue (*right*). The colours are produced by different minerals in the sand that the stones are made of, so it is unlikely that both stones could have been taken from the same natural sarsen drift. When *all* the Avebury stones are examined, it becomes clear that at least six distinct 'batches' of sarsen were used in constructing the henge and avenues.

One source could have been already inside the henge; others may have been found in the immediate area around Avebury. Since sarsen was formed on drainage lines there are several likely areas to the north-west, where the ground slopes down to the River Winterbourne and the Oslip.

In identifying the different batches, one important factor is the thickness of the stones. Almost all Avebury stones are *tabular* or slab-like because they were formed from a layer of sand spread over some original ground surface such as the bottom of an ancient sea or lake. At some later time the sand absorbed dissolved silica that eventually hardened it, and the layer broke into smaller

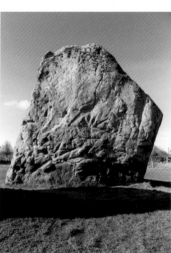

Cove Stone II.

pieces. If the ground surface was level, we could reasonably expect the sand layer to be of a broadly consistent thickness, as will the resultant pieces of each batch. Most of the stones used in Avebury's monuments are between about 0.4 and 0.8m thick; the largest are 1m thick.

We can usually determine which way up a stone was as it formed. The underside may be sheer and flat, but many undersides have an uneven, rough or jagged appearance – an impression of the surface beneath the stone as it formed, as if cast in a mould. Topsides are generally smoother and more rounded, naturally weathered by wind and rain before they were hardened by silica. Stone 46 (*directly opposite*) is a good example – its topside is shown left, its underside right.

Occasional hollows in the ground below the original layer of sand have produced corresponding lumps and bulges on the underside of some stones.

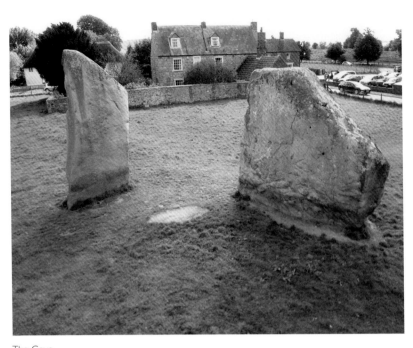

The Cove.

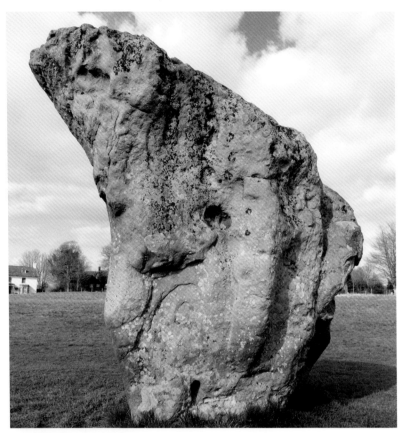

Holes formed by plants and tree roots tend to be mostly on the topside of the slabs but are sometimes also found on the underside. The sand from which the stones are formed may contain chips of flint or quartz in different sizes. Some topsides are particularly smooth and rounded, showing the characteristic erosion of running water: they were likely shaped in rivers. By recording the attributes of each stone we can see grouping patterns – further indication that the stones came from several different 'batches' of sarsen.

46

46

Stone 14 was shaped by running water, perhaps in a river.

Avebury's Primary Stones

Was there once a natural drift of unusually large sarsens in the centre of Avebury? Cove Stone II, largest of the pair of Cove stones and weighing an estimated 100 tons, may not have been moved very far, simply because of its vast size. Cove Stone II is made of pink-grey sand with orange patches. Protruding from the fine sand grains are occasional larger pieces of rounded rose quartz. The underside of the stone is jaggedly uneven; its topside is smoother, but without the polished appearance of river formation. It has small holes made by plants but not the much larger rootholes of trees; uniquely, its topside is covered with criss-cross indentations that may have been made by fallen branches resting on the layer of sand before it hardened into sarsen. Most significantly, the slab is 1m thick, the maximum size found in Avebury.

Within the henge are another nine stones of the same thickness that share all of the above attributes except the fallen branch impressions. All are pink and tend to similarly square shapes. This suggests that all ten stones were formed from a common layer of sand a metre thick, which then broke into smaller pieces and formed a sarsen drift, likely in the centre of what is now the Avebury Henge.

The ten huge 'Primary Stones' are distributed around the henge, five of them used as entrance stones (*see plan opposite*). Perhaps the missing entrance stones were also Primary Stones?

The Obelisk, once at the centre of the Southern Inner Ring, was described by Stukeley as a round pillar 6.4m long. Its diameter though, was a claimed 2.7m – almost three times the thickness of any other stones in Avebury. The great size of the Obelisk suggests that it, too, may not have been moved far from where it was formed. Perhaps the Obelisk was also a Primary Stone from the same central source, but formed in a hollow in the original ground surface?

There may once have been more Primary Stones. If all were formed naturally, near what is now the centre of the henge, the drift of gigantic stones may be one reason why Avebury was initially regarded as a special place. Maybe the Primary Stones, lying in their natural state, were regarded to hold some special power – perhaps they embodied spirits? This may later have prompted the construction of the shallow Primary Earthwork – an initial bank and ditch encircling and containing the stones.

At some later date the earthwork was enlarged to massive proportions. Possibly after this, the standing stones were erected. If there was indeed a supply of large Primary Stones on site, they appear to have been used up in marking the four entrances of the henge and the centres of the two inner rings. Even twice the number of Primary Stones that survive today would not be enough to complete the entire monument, so more stones would be needed, brought into the henge from other sarsen drifts – they also may not have been far away.

Eddy holes.

Imported Henge Stones

Inside the Avebury Henge there is a definite pattern of distribution: related stones from different 'batches' of sarsen are set together in groups. This is unlikely to be for aesthetic reasons based solely on the stones' colours. Perhaps they are grouped because they were brought into the henge from different outside sources, and moved the least possible distance?

Set close together in the north-west quadrant are six orange stones. Seven blue-coloured stones are set in a contiguous row in the south-west quadrant; two more are set near to them in the Southern Inner Circle. All are water-smoothed, unlike the five blue stones in the north-east quadrant.

There are twelve more pink stones. All are too thin to be considered as Primary Stones except possibly the large stone 77 near the eastern entrance; fallen and partially buried, there is no way to confirm its thickness. Nine of the twelve, unlike the Primary Stones, have been smoothed by running water in their formation; seven of them are set close together in the south-west quadrant.

The only Henge stones with *eddy holes* are grouped at the south of the henge, which suggests that they were likely imported from the same source as the stones of the West Kennet Avenue.

RIGHT: Plan of the henge, showing different types of sarsen stone.

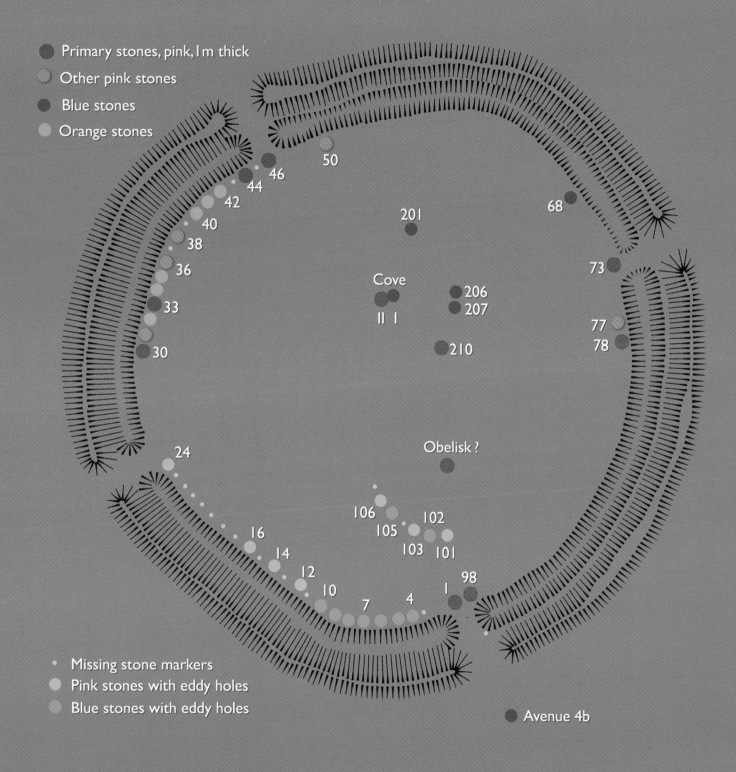

Primary stones, pink, 1m thick

Other pink stones

Blue stones

Orange stones

50

201

68

Cove

206

207

73

11 1

77

78

210

Obelisk ?

24

106

102

105

16

103 101

14

98

12

1

10

7

4

Missing stone markers

Pink stones with eddy holes

Blue stones with eddy holes

Avenue 4b

46

44

42

40

38

36

33

30

West Kennet Avenue Stones

Many Avenue stones have holes of different types. What I have termed *eddy holes* were formed by running water flowing over the sarsen stones before they hardened. Plants such as reeds growing up from the original sand layer created eddies; the swirling water then scoured distinctive funnel-shaped hollows around the plant stems (*page 106*). Occasionally, the hollows have a series of steps, suggesting fluctuating water levels; sarsen stones with eddy holes could only have been shaped by a river, or at least some seasonal or occasional watercourse with a substantial flow.

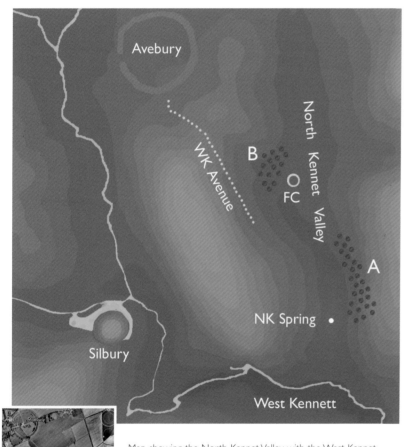

Map showing the North Kennet Valley, with the West Kennet Avenue, Falkner's Circle and the North Kennet Spring. The red dots indicate possible areas of sarsen extraction, where stones may have been sourced for constructing the Avenue. Those areas appear on Google Earth as dappled marks in fields of bare, chalky soil. Area A has a number of actual depressions that become visible when the field has a crop of maize. See photographs opposite.

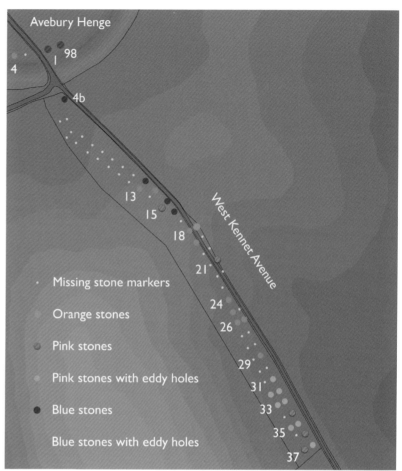

The restored Avenue is divided into three straight sections. It is thought to have been built in stages, so the grouping of stone types is particularly significant. In the bottom section all eleven existing stones are pink. Stones 52B and 54B, sited on the roadside considerably further south, are also pink.

The restored section of the West Kennet Avenue has twenty-seven stones, of which sixteen have eddy holes. At least a further four stones show signs of smoothing by running water. This indicates that most, if not all, of the Avenue's stones came from a riverine source. The stones must at some time have been on an incline for water to have flowed over them with sufficient force to produce eddy holes.

A likely nearby location is an un-named valley a little to the east of the Avenue and running parallel to it — a natural drainage line and *paleochannel* running south towards the River Kennet (*see plan, left*). I have named it, for convenience, the *North Kennet Valley*. If this was the source of the Avenue stones there may once have been several drifts along its length, as the stones are of different colours. Falkner's Circle was sited in the middle of that valley.

Sarsen Extraction Pits?

What may be evidence for one source of Avenue stones was discovered in the summer of 2013 by local photographer and National Trust guide Mike Robinson. Looking south-east from the end of the restored Avenue, he noticed a series of hollows in a field of maize (*top right*). In the foreground, left to right, are Avenue stones *26a*, *25b* and *26b*.

The field is at the southern end of the North Kennet Valley, close to the North Kennet Spring. On the area map (*previous page*) it is marked *A*. Could the hollows be extraction pits where a former sarsen drift has been removed? In Mike's photograph the ripe maize crop is about 2m tall and the hollows can be seen clearly; they are about a foot deep and their distribution does resemble a sarsen drift.

Mike Robinson had already taken a matching shot in the early spring (*second image, right*). Against the white of the bare, chalky soil, green clumps of weeds can be seen marking many of the hollows.

In the panorama at the bottom of the page the three large trees on the right are those in Mike's second photograph; the trees are beeches, planted on top of Bronze Age round barrows. The panorama shows the same dark hollows in the maize crop, but also indicates that there are many more hollows extending to the north-west (left of picture) that are distributed over almost the entire field. On Google Earth they appear as light, dappled marks surrounding the dark, curving paleochannel of the North Kennet Valley (*see previous page*).

It is possible that the mysterious hollows and soil marks were indeed caused by stone removal; or are there, perhaps, still sarsens buried beneath the soil, impeding crop growth? However, even if stones were removed from the hollows this need not have occurred in prehistory, since so much sarsen stone has been used to build villages such as East Kennett. Stukeley's drawings show no natural sarsens or fresh pits anywhere in the valley, suggesting that if there was any activity there it was not recent. There has not yet been any investigation of the pits.

ABOVE: Photographs by Mike Robinson.

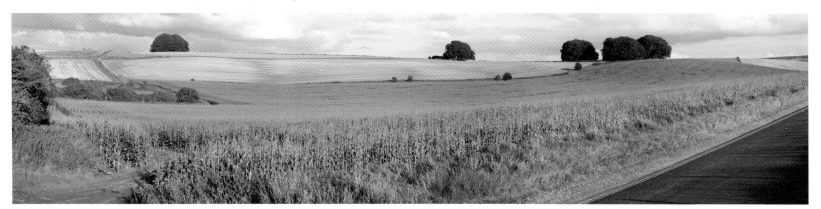

Z-feature of the Avebury Henge

Near the centre of the Southern Inner Ring is a row of six stones that are no more than 1.5m high, far smaller than any others in Avebury. They were discovered buried by Keiller, who named them the Z-feature. All have the rounded appearance of water formation. The northernmost two stones are somewhat rougher than the rest and are made of pink sand; both have small eddy holes of different types. The other four stones are completely unlike any others in the henge or the Avenue. Highly polished by water, they are a metallic chocolate brown colour, more resembling iron than stone.

The brown colour is a thin coating known as *rock varnish* – a deposit of clay, iron and manganese only a micron or so thick, bonded to rock surfaces by the action of bacteria. Wind-blown in desert regions, it can take many thousands of years to accumulate. However, in splash zones close to running water it may form rapidly. Four Z-stones are coated with rock varnish on almost all sides, so a watery origin seems certain. They may have been turned repeatedly by a river as the varnish accumulated.

There must once have been a good supply of rock-varnished stones, as hundreds of broken pieces can be seen built into walls in and around Avebury (*see page 89*). The broken stones demonstrate just how thin the layer of rock varnish is, and that beneath the dark varnish is ordinary light-coloured sarsen stone.

Rock-varnished stones near the Avebury Henge may all have been too small for use in monuments – their rounded appearance suggests that they were river boulders, smoothed to a fine polish by years of battering and rolling. The fact that so many were used in Avebury's buildings suggests a plentiful source nearby. A likely location would, again, be the North Kennet Valley. Small rock-varnished boulders are still found there, especially as field clearances in the hedge-lines near Falkner's Circle. Perhaps the four rock-varnished Z-stones were selected because they were unusually large?

Stones v and vi.

Stones vii and viii.

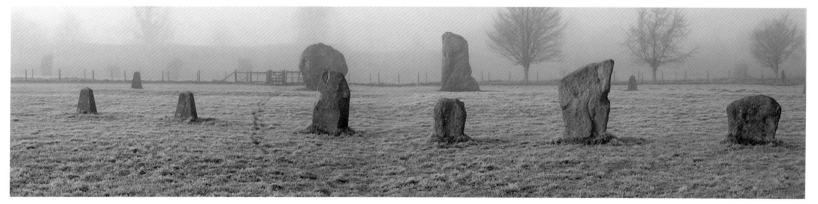

The Z-feature. From right to left are stones v, vi, vii and viii.

The Z-feature. In the foreground is Stone viii, in the background is the Nonconformist chapel, which has many rock-varnished sarsens in its walls.

Field-clearance sarsens coated with rock varnish, found in a hedge near Falkner's Circle.

Stones of the West Kennet Long Barrow

The greatest concentration of rock-varnished sarsen in the Avebury area is found inside the West Kennet long barrow. A great many of the huge slabs used in the internal structure of the monument are coated with rock varnish to varying degrees. Not all are an even chocolate brown: some are coated more thinly, or in patches. Interestingly, the polished areas of the stones used as polissoirs are *also* coated with rock varnish, suggesting that they were in a river when used for polishing axes, and that the varnish continued to accumulate after this period of use.

There is a definite pattern to how the rock-varnished stones were used: the darkest, most densely coated ones are concentrated at the western end of the passage and in the west chamber. Stone 22 (*below, left*) is exceptionally dark and smooth; at the time of writing this is enhanced by a roof leak that keeps the stone wet for much of the time. Some of these stones have a slippery, globular appearance that resembles viscera or flesh. This is most evident in stone 19, at the left of the entrance to the W chamber. At the top of this mostly dark-coloured stone is a *simulacrum* – a light-coloured, fleshy protuberance like a human ear (*below, right*).

The four side chambers use less of the rock-varnished stones, favouring instead an unusually white type of stone quite unlike anything found in the henge or Avenue. The huge roofing slabs covering the NW and SW chambers are both quite flat and smooth, formed of yellow sand with a patchy, white coating that looks powdery but is bonded to the stone and is probably chalk. The slabs of the NE and SE chambers both have a highly unusual surface – a complex, detailed pattern of bas-relief that looks almost carved (*page 112*).

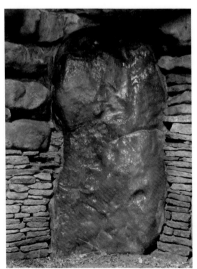

Stone 22.

The 'ear' on stone 19.

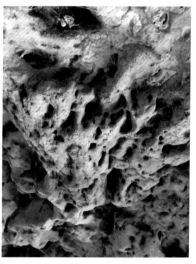

NE chamber roof detail.

SE chamber roof detail.

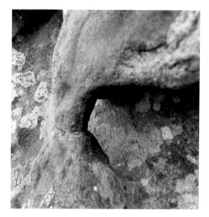

Stone 6.

In contrast, most of the stones used externally are of a more familiar variety of sarsen, not entirely unlike ones used in the Avebury Henge and Avenue. A thick covering of lichen makes determining their colour difficult but some are certainly pink – notably the enormous 'blocking stone' no. 45. Some though, have a partial covering of rock varnish. Stone 43, set immediately left of the blocking stone in the facade, has a lumpy protuberance along its top edge with odd, raised features resembling dripped wax; they are a light caramel colour, although the rest of the stone is grey (*below*). Stone 6, set behind it, has similar raised, coloured areas rather like the 'ear' feature on stone 19.

The long barrow's stones may not all come from the same source, but those with rock-varnish must once have been in or close to a river. There are several suitable valleys close to the barrow: the stones could have come from any of them, or from the River Kennet. The nearest source of sarsen, however, is a substantial drift that was once close to the eastern end of the barrow extending far away to the south. The drift is now vanished entirely, but fortunately it was recorded by A.C. Smith in the 1880s. The sarsen drift, shown in the centre of the map (*below*) is concentrated in a drainage line valley, now dry; the river that once flowed through this valley may have helped coat the long barrow's sarsens with rock varnish.

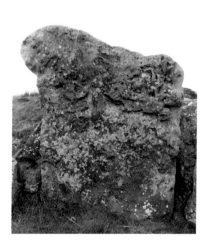
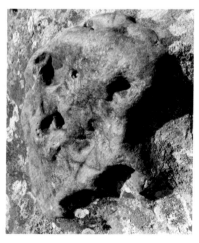

Stone 43.

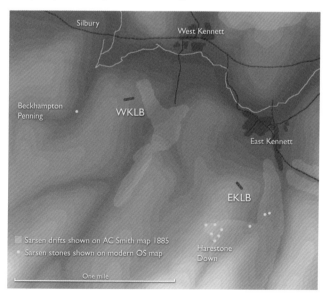

Sarsen drifts recorded by A.C. Smith.

Walking the course of the River Kennet when it is dry reveals that there are still many sarsens littering the riverbed and lining the banks. Some have been placed there to reduce erosion, but between East and West Kennett there are stones up to 2m long, too large to move (*right*).

Longstones and Beckhampton Avenue

Adam is a large, square stone set originally on one of its corners as part of a rectilinear Cove. Nearby is *Eve* – only survivor of the *Beckhampton Avenue* (*see page* 101). Eve is an unusual shape, pillar-like with an awkwardly top-heavy bulge. Both stones are densely coated with lichen.

From what can be seen of it, Adam is pink with areas of darker pink; some areas are paler, almost white. Eve is quite different: mostly a pale caramel, it has at least one area of a darker plum colour. Eve has a very high silica content with a partially fractured, sheer surface that is smooth and marble-like. Adam, like most of the henge stones, is rough to the touch. The two stones are completely unalike so probably came from separate drifts.

On the area map (*right*) the contour lines are in 5m steps. The lowest ground, at 150m, is shown darkest. In other locations where sarsen is found, the greatest concentration is typically those areas 5m to 10m above the lowest ground. The Beckhampton Avenue runs through exactly such an area.

Other likely locations would be all of the areas on the 155m contour, either side of the two rivers, and at the southern base of Windmill Hill. At Yatesbury, 3 miles west of Avebury and just beyond the left side of the area map, great quantities of large sarsens may be found as field clearances. In the fields north of Windmill Hill, stones over 2m long have been dug up; there is a good deal of sarsen too, in all the villages north of Avebury along the River Winterbourne.

So although we cannot be certain where the Beckhampton Avenue's stones originated from, it seems highly likely that they were taken from several natural drifts, now largely depleted, that were close by. Following the River Oslip's course east from Yatesbury there are sarsens in the fields and hedgerows – many more may yet be buried. A wide-ranging geophysical survey might identify those areas still richest in sarsen stone.

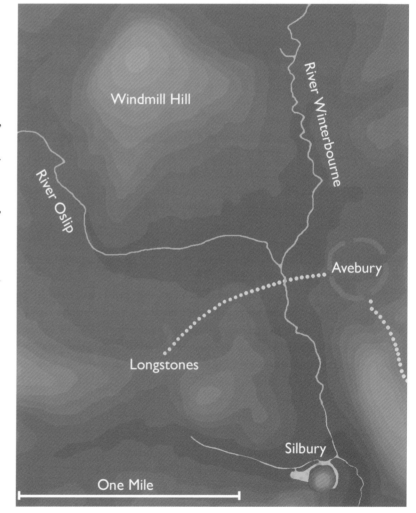

THE SANCTUARY

Date of construction: around 2500 BC

About a mile east of Silbury, where the Ridgeway crosses the A4 road, is the Sanctuary. From its position high on Overton Hill there are spectacular views, but visitors often find the actual monument just as confusing as Woodhenge (near Stonehenge), which it closely resembles. Both were once *timber circles* composed of a mass of wooden posts arranged in concentric rings; the Sanctuary also contained two stone rings.

It is thought that the Sanctuary was originally a timber structure, though it is possible that timbers and stones stood simultaneously. Or perhaps before the last traces of timber rotted away, the double-concentric stone circle was constructed in its place. The diameter of the inner stone ring matched that of the original timber structure; the outer stone ring was twice its diameter (*see plan, page 116*). The stones have since disappeared – the last ones were removed, according to William Stukeley, in the winter of 1724.

John Aubrey visited the Sanctuary in 1649 and drew a plan showing the West Kennet Avenue connected to the outer of the two stone circles. Aubrey wrote that the stones were 'four or five foot high, tho' most of them are now fallen down.' Stukeley drew the Sanctuary as it was in 1723, with most of its stones toppled but still in place (*below*). It was Stukeley who first cited the name 'Sanctuary', claiming it was a name used by the local 'country people'.

Today's concrete markers show both of the Sanctuary's phases simultaneously – round for the original timber posts and rectangular for the later stones (*page 116*). At the north-east side, more stone markers project from the outer circle in three short rows. Two rows of three stones each are almost parallel: this is where the West Kennet Avenue is thought to have once connected to the circle. The northernmost row only contains two stones and points to Avebury's northern entrance.

Maud Cunnington excavated the Sanctuary in 1930 with her husband Ben and a small team of workmen. A few years earlier, the Cunningtons had excavated Woodhenge. As well as the stone positions, the previously unsuspected wooden post holes were discovered. This was a surprise, as the team were only looking for two concentric stone circles. Excavation of the post and stone holes resulted in a few finds of pottery, flint and stone; there was also the *Beaker Burial* of a youth in mid-teens.

Stukeley's 1723 depiction of the Sanctuary in ruins.

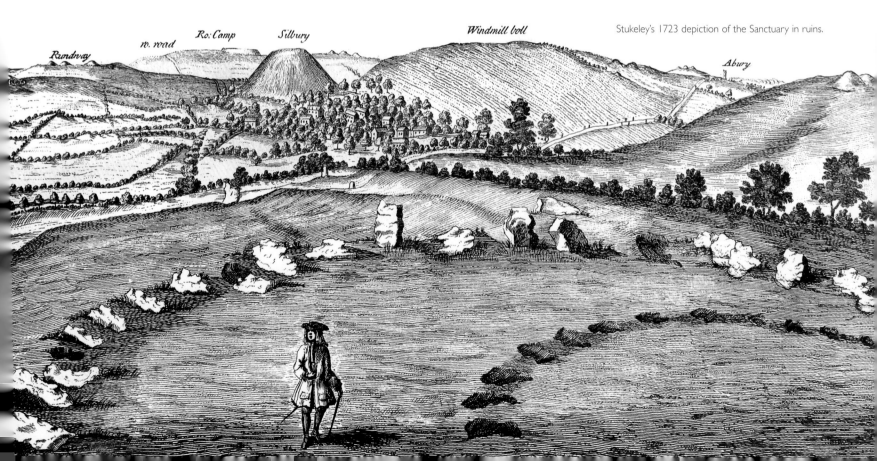

The Sanctuary was not large. Its outer stone circle was 40m in diameter, the cluster of posts only 20m. For a long time it was thought that the Sanctuary may have once been a circular building, its roof supported by the posts. The notion of a building has since fallen from favour, partly because many more timber circles have been discovered since 1930: from their great size, some clearly could not have been buildings. (The Great Circle of Stanton Drew, for instance, measured 113m in diameter and probably contained nine concentric rings of posts.)

The seven concentric rings were given names and labelled A to G, starting from the outermost, the large stone circle. Their likely heights above ground were estimated from the depth of the postholes: the tallest were about 15ft (4.6m), roughly half the height of the nearby Palisades. If the posts held lintels, each post would gain extra support from its neighbour, so could be taller. Ring B, named the *Fence-ring*, had two entrance posts around 10ft high; the rest of its posts were about 5ft 6in – the height of a man. This would seem to support Cunnington's view that it was simply a fence to keep animals out of the main structure.

Facsimile of Maud Cunnington's 1931 excavation plan of the Sanctuary.

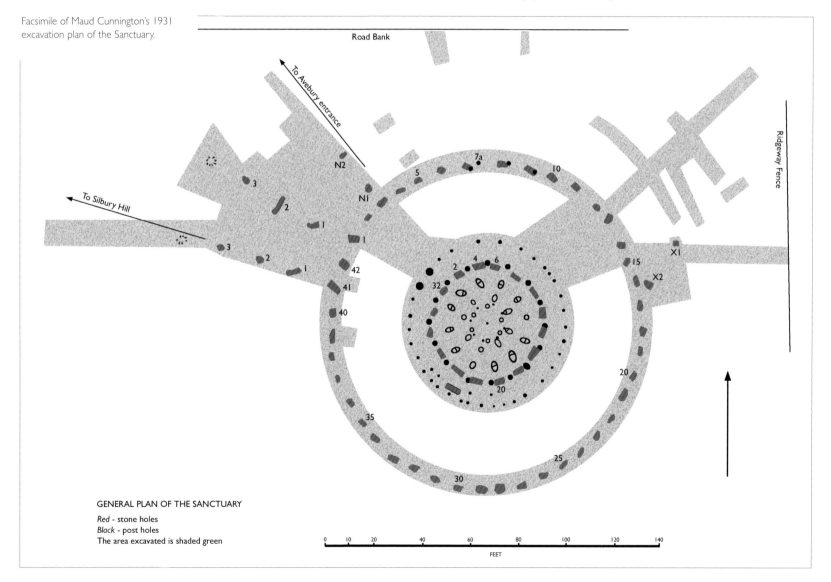

GENERAL PLAN OF THE SANCTUARY

Red - stone holes
Black - post holes
The area excavated is shaded green

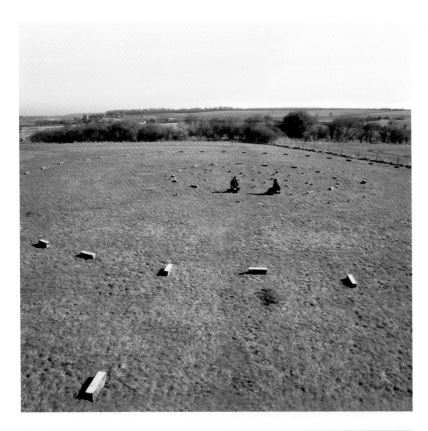

Cunnington measured the Sanctuary's posts as each about a foot in diameter; they sat in postholes about 2ft wide and up to 5ft deep. After the poles were lowered into position the space around them was filled with packing material and rammed solid for stability; this was done so well that the archaeologists had considerable trouble differentiating between the packing material and the natural chalk that surrounded it.

Geometry

There is geometry in the layout of the Sanctuary that is not immediately obvious. Rather than a series of concentric circles, it could be considered as a series of overlaid regular polygons, with six, eight, twelve and sixteen sides. The polygons are symmetrically arranged on an axis running roughly NW/SE through the centre post and between the two large 'entrance posts' of B, the Fence-ring. This central axis through the Sanctuary, marked X on the plan (*below*) is on a bearing of 123.5°. To anyone with a basic understanding of geometry, laying out the Sanctuary's ground-plan could easily be done with a rope and a couple of pegs.

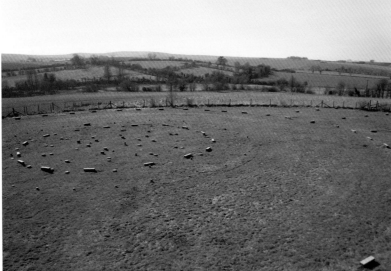

The Sanctuary today, with concrete markers.

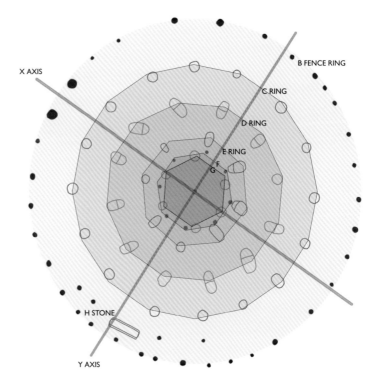

117

What Happened to the Sanctuary's Stones?

The stone circle's destruction began, according to Stukeley, in 1723 when Farmer Green took some stones away to West Kennett. The remaining stones were removed the following year by Farmer Griffin, another local man. It is quite possible that some of the stones may now be in East Kennett, built into the walls of Orchard Farmhouse. The house, built mainly of sarsen, dates from the sixteenth, seventeenth and eighteenth centuries. Surrounding the property is a wall into which at least twenty large sarsens have been set. Several of the stones show chisel marks and at least one has been broken into pieces, then reassembled.

It is not known whether the Sanctuary's posts held lintels. Stonehenge was built of worked sarsen stone using jointing techniques suggestive of those used in woodwork; the Sanctuary may have been constructed similarly. Or perhaps the posts were freestanding, carved and decorated like Native American totem poles? They could have been left in a natural state, maybe with their branches left on. However, there is evidence that surprisingly graceful and sophisticated woodworking techniques were possible at the time, including mortice and tenon joints secured by pegs. Note how without lintels the structure appears as a jumble of posts, even if the rings are individually colour-coded.

CGI by Martin Smith.

What was the Sanctuary Used For?

Possibly at the end of the Sanctuary's life, as its posts rotted, the structure was regarded as important enough to be 'lithicised' into permanence. Standing stones were erected between the posts of the outermost ring. Since this was only 20m across, the memorial was made more impressive by the erection of another concentric stone circle of twice that size. This clearly involved a great deal of effort, so why was the Sanctuary thought to be so important? Why were timber circles built in the first place? Let us explore some possibilities.

Yew tree expert Allen Meredith has proposed that timber circles might symbolise yew groves, which grow slowly, in a radial pattern, outwards from a single yew tree (*see page 32*). Or, could timber circles have been memorials to *actual* venerable yews that died before becoming a grove? Interestingly, a tree hole was found beneath the bank of Woodhenge: it contained large quantities of Early Neolithic pottery and was capped with chalk.

The concept of 'commemoration' often features in archaeological interpretation. Since monument-building was a communal activity, it may be that timber circles were a collective remembrance of some important event or person, possibly with a connection to the monument's location. Today, we often plant a tree as a memorial to a departed loved one, perhaps in a similar spirit of commemoration.

We generally envisage the Sanctuary as an open structure, but with wattle panels fixed between its poles it would have assumed a quite different character. The panels would ensure that certain areas were blocked from view, perhaps also limiting physical access to all except a privileged few. It has even been suggested that the Sanctuary could have been a *labyrinth*.

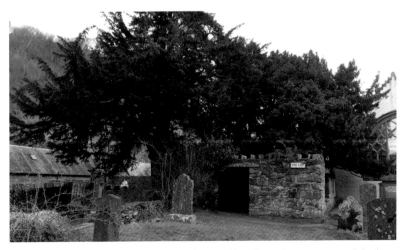

The Fortingall Yew in Scotland is at least 3,000 years old, yet it continues to grow and slowly spread outwards.

A labyrinth has only one path to its centre, which is made longer by adding twists and turns. With the addition of panels the Sanctuary *could* be made to work as a labyrinth. The plan (*above*) shows one possible arrangement of panels to form a spiral path to the Sanctuary's centre. Passing through this labyrinth could be regarded as a symbolic journey, perhaps a rite of passage.

It is also possible that timber circles may have had some astronomical or calendrical use. Their circular form suggests *horizon astronomy* – the use of markers to record the rising and setting positions of heavenly bodies. It may be significant that the lithicised Sanctuary had what seems to have been a *recumbent stone*, as a reference to astronomy. The Sanctuary's rarely mentioned *H stone* was aligned to the midsummer moonset, evoking stone circles in Scotland (see the Exploring Avebury website).

From the way that some of their other monuments are aligned, it seems the Avebury people had an interest in the winter solstice, which is quite understandable. For a community that stored and rationed its food through the lean winter months, it would be invaluable to know when the mid-point of winter had come. The Sanctuary could feasibly have been used to determine the arrival of winter solstice.

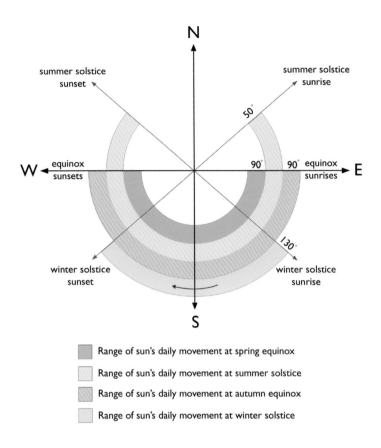

summer solstice sunset

summer solstice sunrise

N

50°

W | equinox sunsets

90° | 90° equinox sunrises | E

130°

winter solstice sunset

winter solstice sunrise

S

Range of sun's daily movement at spring equinox

Range of sun's daily movement at summer solstice

Range of sun's daily movement at autumn equinox

Range of sun's daily movement at winter solstice

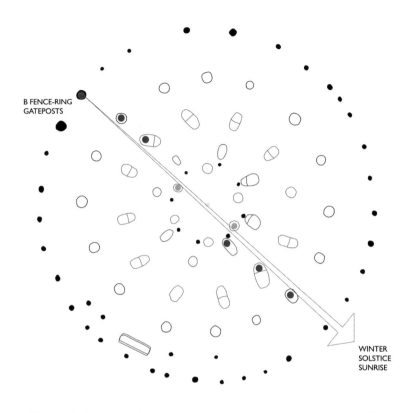

B FENCE-RING GATEPOSTS

WINTER SOLSTICE SUNRISE

The sun rises exactly in the east on only two days each year: these are the spring and autumn equinoxes. As winter approaches, the sun rises a little further south each day until winter solstice, when it rises in the south-east at its furthest position south; there it stays for twenty-two days. The sun then begins to rise a little further north each day until reaching its northern maximum at summer solstice, when it rises in the north-east. After staying there for eighteen days it begins to rise a little further south each day. The cycle repeats endlessly, as shown in the diagram below.

Noting when the sun has reached its solstice positions forms the basis of a solar calendar. But recording the sun's position does not require a structure anywhere near as complex as the Sanctuary – all that is needed is a fixed viewing place and one distant pole to mark the sun's position. If another pole is added, slightly to one side of the first, the sun may be framed between the poles and its position known even more precisely. If that position marks a solstice there is a period of several weeks when it can be confirmed, which gives some allowance for bad weather.

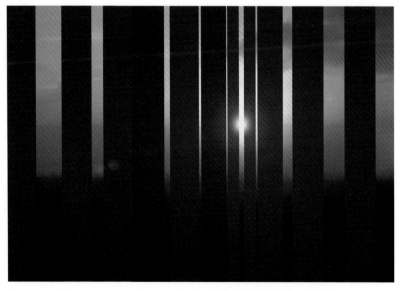

Simulation of the winter solstice sunrise, as seen through the posts of the Sanctuary.

Could it be that some of the Sanctuary's poles were used in this way? Perhaps the maze of unnecessary extra poles only served to add grandeur and mystery to what was really a simple device? To outsiders, determining the arrival of solstice-time using the Sanctuary may have appeared to be a complicated business; perhaps to those in the know, it was simply a matter of understanding which poles to use for the sighting.

From the Sanctuary the winter solstice sun rises at 132.5°. If an observer was to stand with their back to the northernmost entrance post of the Fence-ring and look south-east through the Sanctuary to 132.5°, then the rising sun at winter solstice would be seen through the gaps in the poles (*page 121*). This viewing window could be surprisingly narrow: for accuracy, it should be as narrow as possible.

Perhaps other alignments to the sun, moon or stars may also have been visible through the structure at different times of the year, if one knew exactly where to stand, and where to look?

Sunrise from the Sanctuary on 13 January, three weeks after the solstice.

SILBURY HILL

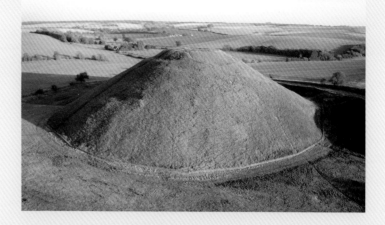

Date of construction: between 2450 and 2350 BC

Almost a mile south of the Avebury Henge is Silbury Hill, an immense artificial mound built mostly of chalk rubble, now naturally covered with turf. Surrounding the mound is the Silbury Ditch. Cut deeply into the chalk bedrock, the ditch is quite circular on its eastern and northern sides, but to the west it extends to become almost rectangular. On the south side two causeways run from the roadside footpath to the mound, with only a short section of ditch between them. Silbury is built on the end of a spur reaching north-east from Thorn Hill; part of the spur can still be seen, just beyond the ditch.

When the water table is high, usually in the winter, the ditch fills with water. Silbury Hill is intimately connected with water. To the east of Silbury the River Kennet flows south along the base of Waden Hill but it currently plays no part in filling Silbury's ditch; the ditch's water is supplied by the Beckhampton Stream flowing from several areas of springs to the west, and springs that flow from the edges of the ditch itself.

Silbury's dimensions

Known as 'the largest artificial mound in Europe', Silbury is actually the world's largest prehistoric chalk mound. Its immense scale is hard to comprehend. The mound is so huge that Stonehenge could sit on its flat top with room to spare; its construction involved moving almost 350,000 metric tonnes of soil and chalk, enough to fill 1.3 million wheelie bins. Silbury's base has a diameter of around 150m and covers an area of more than 5 acres. Its height at the centre is 31m above the original ground surface. The mound appears even taller as it is surrounded by a ditch, originally up to 9m deep, dug to provide material for the mound. Recent computer modelling has shown that the volume of the mound closely matches that of the ditch.

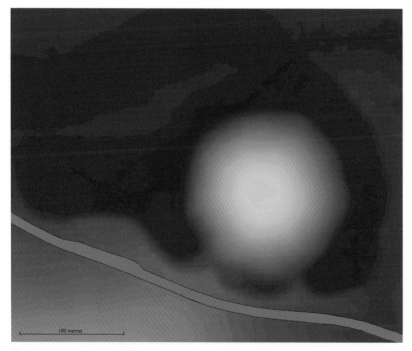

Contour plan based on a 1968 survey, showing that Silbury is not actually round, but is nine-sided, with a series of internal 'spokes'.

Sheep grazing on Silbury help keep the grass short. Until the mid-twentieth century the long, dry grass was burned off annually, leaving the hill looking like 'a giant Christmas pudding' throughout the winter.

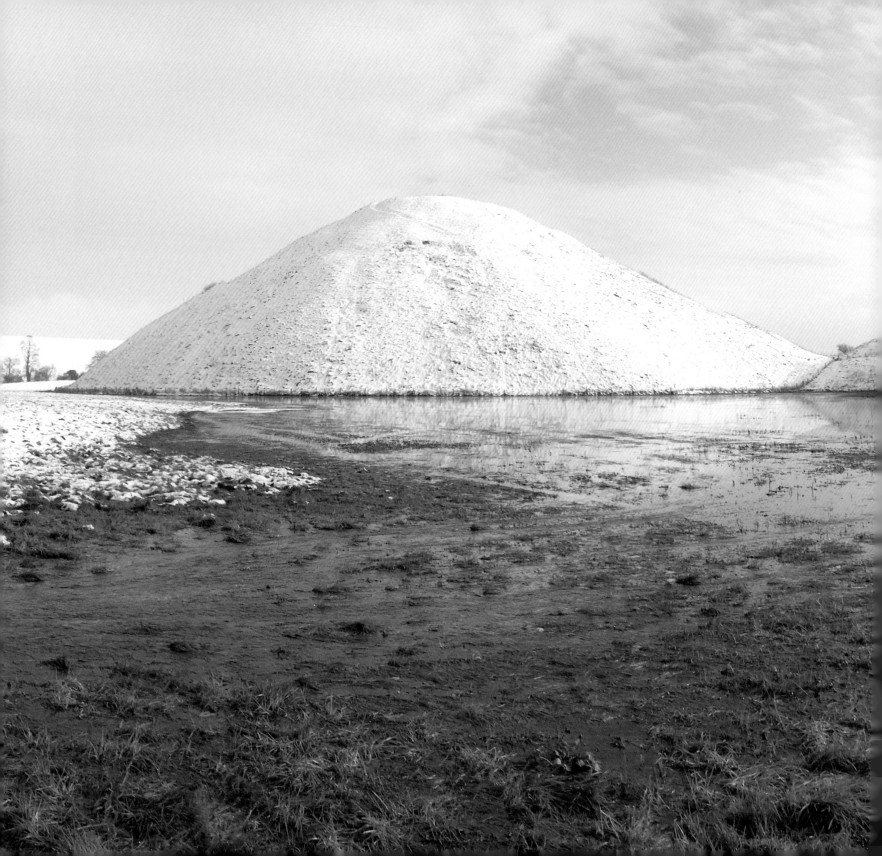

Silbury's construction required enormous communal effort, yet we can only guess at its original purpose. It was long assumed to be military, or later, the burial mound of some great king; but despite many excavations, no trace of a burial has been found inside. In fact, nothing at all has been found that gives any indication of Silbury's purpose, though it is generally thought to have had some religious meaning or function.

Perhaps Silbury represents the *axis mundi* – the centre, or navel, of the world? It may be the embodiment of a creation myth, perhaps like the 'earth-diver myth' of native North Americans, in which all the world is water until some animal dives to the bottom of the sea and returns with a mouthful of mud to create the first land. Most of the world's creation myths begin with the forming of waters from chaos; this is often followed by a sexual union of the gods of earth and sky, from which all life descends. The building of a huge mound, watered by springs and rivers, could be seen as a material expression of this concept – a creation myth monumentalised in chalk; a meeting of earth and sky, surrounded by the swirling and bubbling primordial waters of creation.

Silbury Before the Mound

When water levels are high, springs flow into Silbury's ditch from all along its southern and western sides. Rainwater soaks into Thorn Hill, south-west of Silbury, then flows north-east below the ground. The water emerges where it does today only because Silbury's ditch was cut into the chalk bedrock, interrupting the natural flow. If the enormous ditch was not there, the springwater would presumably continue on through the porous chalk, to emerge at the base of Thorn Hill in the meadow beyond Silbury. There it would merge with an eastward flow from springs at Beckhampton and the southward flow of the River Kennet. Since prehistoric people seem to have revered the east/south confluence of rivers, and also springs, this may have made the Silbury site an important place long before there was any mound.

The map (*overleaf*) gives an impression of how the area may have appeared before Silbury's ditch was cut, with the centre of Silbury indicated by a red dot. The modern River Kennet has been forced into a narrow, artificial channel.

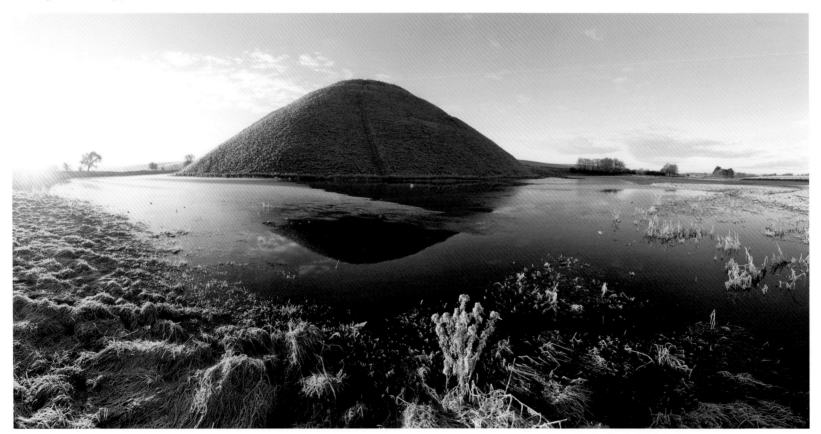

Flowing as it does over flat ground with a shallow gradient, it would naturally form meanders and braids with wide areas of marshland between and around the channels. Today, the Silbury Springs flow copiously into the western ditch, with a lesser flow into the eastern ditch. No springs have been recorded on the north-east side of the mound where they might be expected, but piling so much material on top of the water's underground course may likely have stemmed its natural flow, forcing it out to the two sides, where springs now run (*see page 27*).

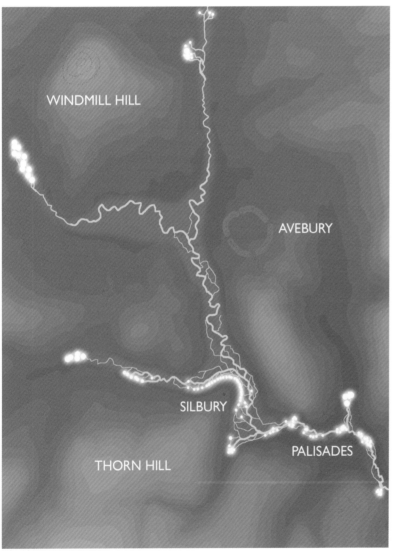

How the Silbury area may have appeared before the mound was built.

Building the Mound

Silbury has suffered from much excavation over the centuries, since it was long assumed to contain some great secret. Several tunnels were dug into the mound's centre, notably in 1776, 1849 and 1968. Inadequately back-filled, the resulting voids caused a partial collapse of the mound after heavy rains in 2000. Silbury was finally stabilised in 2007–08, with all of its tunnels filled with chalk. Working alongside the engineers who carried out the repair work was a team of archaeologists; the enormous quantity of data they gathered has led to a new understanding of how Silbury was constructed. It was previously assumed that the mound had been 'designed' to be a certain shape and size, then constructed to a fixed plan. The latest evidence, however, suggests that there was no plan: the mound *evolved*.

The original ground surface on which Silbury was built is chalk bedrock, overlain with clay-with-flints; the soil would be expected to be 20 to 30cm (up to a foot) thick. Instead, the chalk beneath the mound was covered with just a few millimetres of smooth, grey, silty clay, and was virtually free of stones. This indicates preparation of the site: it seems the topsoil had been stripped away and the subsoil compressed by human and possibly animal feet. If the site was already special, the ground may have taken many years to compress. Had the missing stones been picked out of the clay by hand? In the centre was a hearth – a small scorched area with some charcoal, two burnt pig teeth and a few burnt hazelnut shells.

On top of this thin layer of clay was a pile of gravel almost 1m high and 10m in diameter. Why was gravel used? It may be that gravel had some ritual significance; it may also be because springwater was flowing up out of the ground.

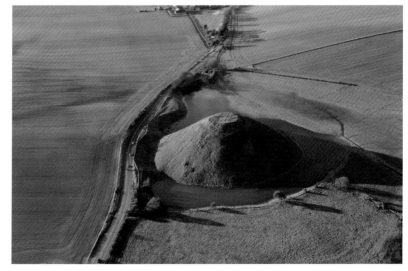

Silbury in flood. (Aerial photographs by Philippe Ullens)

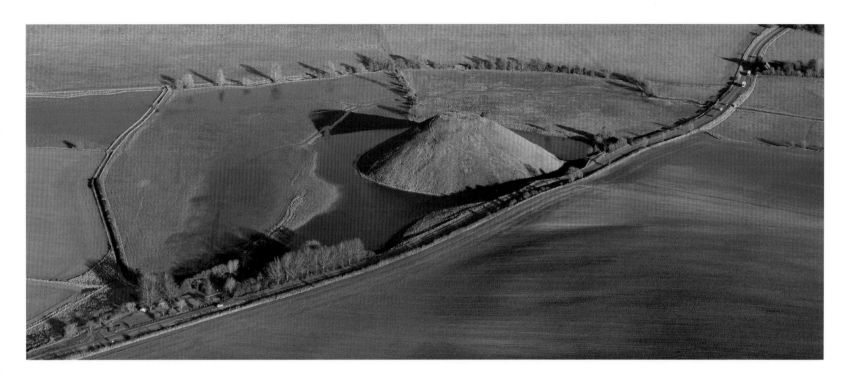

When the Silbury Springs flowed in 2013 they turned some flat areas of ground to a jelly-like consistency as underground springwater flowed directly up to the surface. It is likely that the Silbury site was similarly populated with springs. If so, then covering the saturated ground with gravel would be a practical first step if the area was to be used for any kind of activity.

At some unknown later time the site was enlarged, with a ring of stakes placed around the gravel mound to mark a new perimeter. A waist-high mound of soil, mud and turf was formed. Nearby were two smaller mud mounds, each less than half a metre high – one was like a model of Silbury with a ditch around it. The two mounds that were found just happened to be in an open tunnel: there may well have been others.

The mound was made bigger by piling on more soil; most of it was of a different type, brought in from outside the immediate area. With this were basket-loads of clay, chalk and gravel, and yet more turf. The turves were now from many different locations: it has been suggested that people were travelling from afar to visit Silbury, adding a piece, literally, of their home turf. This complex layer cake of material was seeded throughout with round sarsen boulders. Inside the tunnel, archaeologists saw the many layers in cross section, as interweaving stripes of varying thickness and colour. At this stage the mound was an estimated 35m across and 5 or 6m high.

A mighty ditch was dug into the chalk encircling the mound: about 100m in diameter, it was an impressive 6m wide and 6.5m deep. Around two thirds of its present size, the ditch was likely a later feature but it may have been there since work began. Within the ditch, concentric banks, each a few metres apart, surrounded the central organic mound, suggesting that one original bank grew outwards over time. All these features are now buried beneath the mound.

From this point on, it appears that all the material added to the mound was chalk dug from around the mound, creating the ditch. This raises several questions. What was the reason for cutting the ditch? Was the intention to surround the mound with water, or was this an accidental result of excavating material for the mound? Most experts agree that the water table was higher at the time of Silbury's construction, but was this all year round or just in the winter, as it is now? It is hard to imagine that any excavation was possible if the chalk bedrock was underwater, as wet chalk is extremely slippery and the workers would have used antler picks, which are also slippery. The rivers may still have been flowing when the work was done, as they could be dammed or diverted; however, it would be well nigh impossible to stop the springs flowing north-east from Thorn Hill. So it seems highly likely that the Silbury Springs were seasonal, just as they are today, and that they usually dried up in the summer. (*See also* Avebury's Waterscape *pages 21–32*.)

The Chalk Mound

Silbury is sometimes compared with the pyramids of Egypt: although of a similar age, they have little else in common. Even Menkaure's Pyramid, smallest of the three pyramids of Giza, is twice as tall as Silbury. The Giza pyramids have sides angled quite steeply at a little over 50°; Silbury's sides are considerably flatter at around 30°. Stone-block construction methods allowed the Egyptians to build their pyramids at a precise chosen angle; Silbury was built mainly of chalk rubble, so its angle could not be chosen.

All granular materials, such as sand, gravel or soil, each have a characteristic *angle of repose* resulting from the friction between their particles. Chalk rubble, when made into a pile, naturally settles at an angle of about 30°. A mound of chalk piled any steeper than 30° will eventually revert, through the action of wind and rain, to its natural angle of repose. It has been claimed that the 30° slope of Silbury's sides was a deliberate 'design feature' to prolong the mound's life; although the builders may well have seen the wisdom in building at 30°, they had little choice in the matter.

After Silbury's initial building stages using several different materials, all were eventually incorporated into one mound about 5 or 6m high and 35m across. From there on, by the addition of successive layers of chalk only, Silbury grew to its present size as a white, chalk mound. Could it be that Silbury continued to grow because of a desire to maintain the whiteness and preserve its presence?

Britain has other more recent chalk monuments, in the form of 'hill figures' such as the famous White Horses of Wiltshire. Every few years the figures must be 'scoured' to preserve their whiteness: this involves more than just removing invasive weeds. All hill figures are on steep hillsides to allow them to be seen from a distance, so winter rain tends to wash any loose chalk downhill. White Horses can turn an unpleasant puce colour in times of high rainfall, as chalk loses its whiteness when saturated. The solution is to apply a top dressing of fresh, white chalk.

Silbury historian Brian Edwards suggests that this may account for Silbury's many successive layers of chalk: a need to whiten and renew the mound resulted in its great size. There are instances around the world of holy places being regularly purified with whitewash; the Bible refers to 'whited sepulchres, which indeed appear beautiful outward, but are within full of dead men's bones, and of all uncleanness' (*Matthew 23:27*).

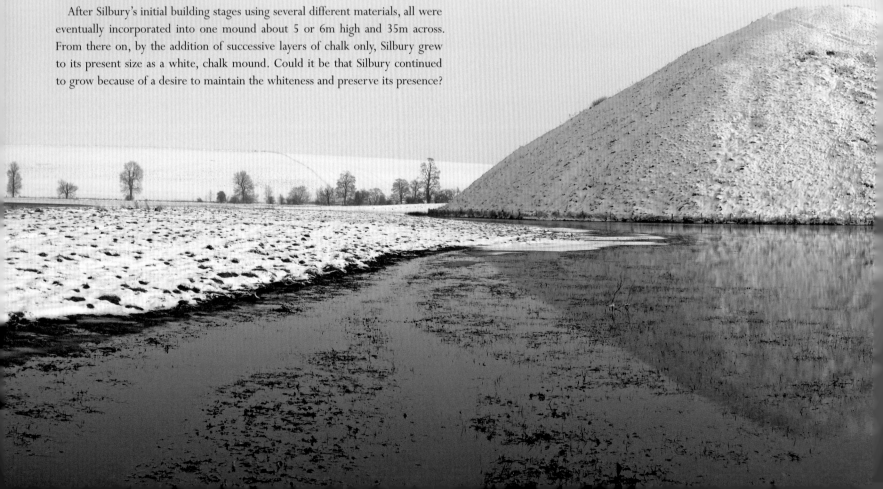

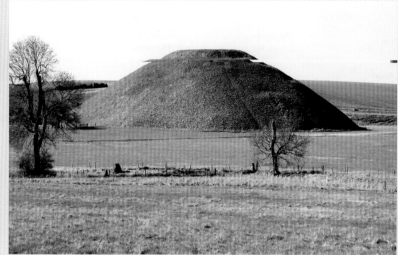

The sides of a pile of chalk rubble will naturally settle at the same angle as Silbury's.

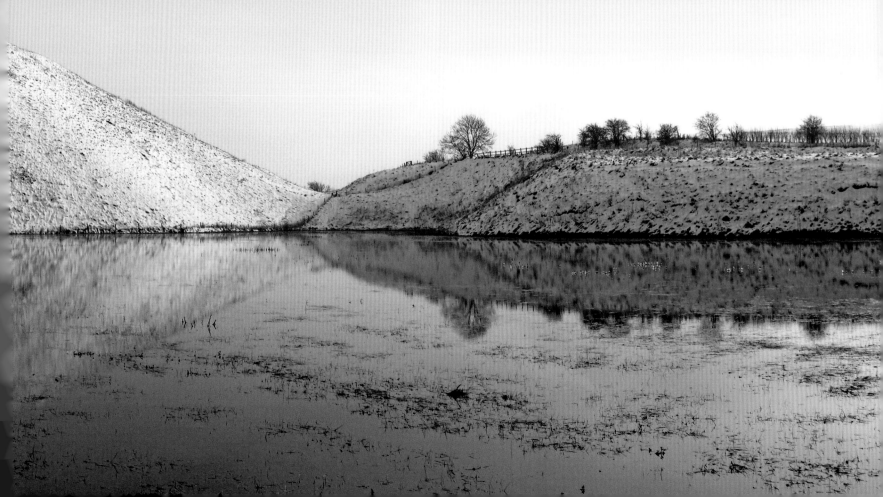

Pictured here is the Cherhill White Horse being scoured in May 2007 by adults and children of the local community. Loose chalk was transported to the top of the hill; from there it was bagged and carried down onto the horse by a human chain, to be spread out evenly with rakes. Was a scene like this once a regular event at Silbury? Interestingly, the Cherhill White Horse is on a hillside that slopes at around 30°, the same as Silbury. The scouring team were only just able to stand upright on the horse as they worked – if the hill was any steeper they would have needed climbing ropes.

After its uncertain beginnings, with several small mounds and ditches, Silbury eventually became one single mound, about the size of the Marlborough Mound (*below*). From that point on, layer after layer of material was added, mostly chalk. Around 250 of these layers have been recorded, suggesting a regular, possibly annual, ritual or festival that involved covering the mound with fresh chalk dug from the surrounding ditch. Not all the layers are of pure chalk, so was it the whiteness of the material that mattered, or the fact that it was excavated from the ditch? If springs and water were what drew attention to the area originally, it is possible that any material dug from around the mound may have been revered, white or not.

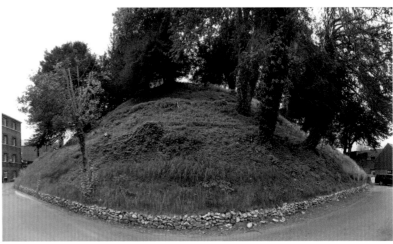

Also known as 'Merlin's Mount', the Marlborough Mound is now surrounded by buildings in the grounds of Marlborough College. Rising above the school buildings that closely surround it, the mound is more than 18m high with a diameter of 83m at the base. Its dimensions are approximately half those of Silbury Hill, which it closely resembles. Only 5 miles apart, both monuments are known to date from the Late Neolithic, around 2500 BC. Over many centuries the Marlborough Mound has been appropriated by a succession of owners, each exploiting it in different ways. As a 'motte' it was once part of the medieval Marlborough Castle; in the early 1600s it was turned into a garden feature by the Seymour family and a spiral path was cut to its summit. Stukeley noted that the mound was surrounded by a ditch in which springs could be seen to rise; another spring rose at Barton Farm, just north of the mound. Both are long gone and have been built over, but even today there are springs flowing into the River Kennet near Treacle Bolly, just a short distance from the mound.

Scouring the Cherhill White Horse.

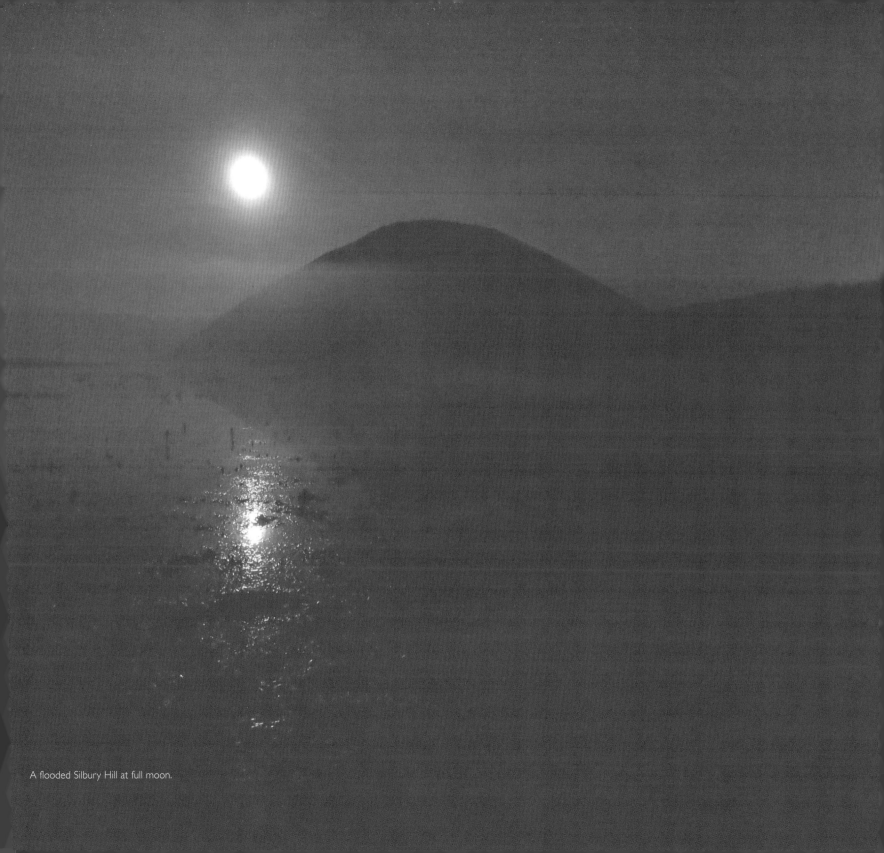

A flooded Silbury Hill at full moon.

Significantly, Silbury's final, outer layers are quite different, suggesting that the builders attempted to make a final casement – a white coating that was more permanent. Maybe they eventually tired of regularly dressing the mound? Perhaps after so many layers Silbury simply became too large, and adding any more chalk was no longer practical or necessary? For whatever reasons, Silbury's outermost coating is made of horizontal layers of loose crushed chalk, held in place by shallow revetment walls that encircle the mound. Skilfully built from chalk rubble boulders, the walls are angled in towards the mound, making them extremely stable. The loosely formed rubble walls have voids allowing rainwater to drain away freely, which may be one reason why Silbury has survived for so long.

Why people felt driven to create huge earthen mounds is still a mystery and we can only guess at what the mounds' true purpose may have been. There is, though, a definite connection to moving water, as all known examples were built close to rivers and springs.

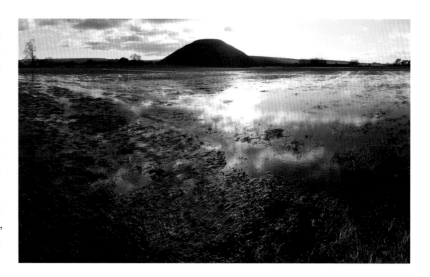

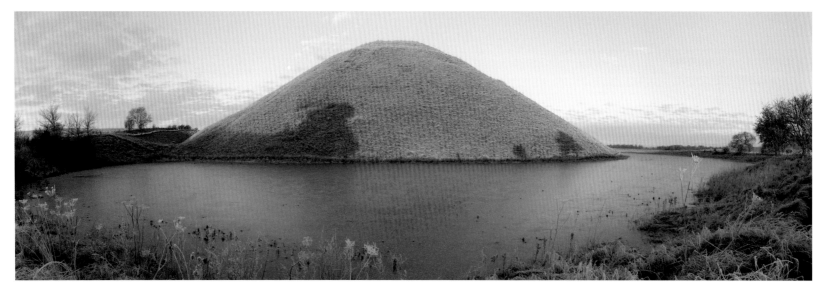

Plant remains inside Silbury

Inside Silbury was a wealth of seeds, pollen, plant and insect remains from the landscape surrounding the mound during its construction: a time-capsule from the Late Neolithic. The climate then is thought to have been slightly warmer and wetter than today, so it is perhaps surprising that virtually every plant and tree species found inside Silbury can still be found growing within a few miles of the mound. Shown are Yew, Woundwort, Cleavers, Hazelnuts, Scabious, Meadowsweet, Self-heal, Elderberries, Speedwell, Cow Parsley, Thistle, Great Plantain, Tall Oat-grass, Lesser Stitchwort, Sloes, Forget-me-not, Hawthorn, Buttercup, Bramble, Stinging Nettle, Cocksfoot Grass, Ground Ivy, Red Campion, Ribbed Plantain, Rose

WEST KENNET
PALISADED ENCLOSURES

Date of construction: in the decades around 3300 BC
Later settlement between 2500 and 2000 BC

South of the A4 road at West Kennet there was once a vast complex of timber structures, ranging across an area almost half a mile square - nearly twice the size of the Avebury Henge. Today the enclosures exist only as a ghost, appearing occassionally as faint cropmarks on aerial photographs. A map of the cropmarks has been compiled from pictures taken over many years but it may still be incomplete. Now mostly arable farmland, the area is quite accessible and exploring it on foot with a map is the best way to fully appreciate just how huge the Palisades were. *Gunsight Lane* runs south into the Palisades area from the A4 at West Kennet, and a useful network of public footpaths connects to East Kennet. On the area map (*opposite*) footpaths are shown as green dotted lines.

A new assessment of carbon dates in 2017 determined that the Palisades were built around 3300 BC, some 800 years earlier than previously thought. At the north of the site by the river two enormous, conjoined enclosures were constructed from oak trunk posts set into the ground; the posts were closely-set, forming a continuous wall of almost solid timber. To the southeast were several smaller circles and concentric rings, some connected by radial lines. The posts were set into ditches more than 2m deep, yet the top of the palisade walls may have towered six or eight metres above the ground; around the same height as the electricity poles that cross the site today. Several thousand of these posts were used in the construction, representing what amounts to an entire forest of mature oak trees. With trunks around 80cm (2.6 ft) in diameter, the oaks would have taken at least 120 years to grow.

Enclosure 1 straddled the River Kennet. On the plan it appears to have had two concentric circles of posts with diameters of about 220 and 280m but this is not certain. It is likely that both of the concentric arcs existed simultaneously as palisades, since new evidence indicates that the inner circuit predates the outer circuit by only a few years. Concentric arcs can only be seen south of the river; the northern part is obscured by farm buildings and only one short single arc has so far been detected, most likely a continuation of the southern inner one. If there was an outer arc to the north, it would have extended just beyond the present A4 road. The area close to the River Kennet has been flooded regularly, erasing anything that would be likely to show up as cropmarks but even so, it cannot be assumed that all of the enclosures' outlines were originally continuous – there may have been deliberate gaps.

To the west was *Enclosure 2*, a single oval shaped ring with its long axis aligned roughly east-west and sited just south of the river. If a continuous oval it would have measured around 340m by 220m. (The stone circle inside the Avebury Henge also has a diameter of about 340m). On the crop-mark plan the entire northern side of this enclosure is absent; it may have been erased by flooding, but it is likely that there was no palisade there and that the river served to mark this section of the enclosure. This would not be so unusual, since the gigantic henge at hearby Marden is now known to have had a missing section of earthwork and instead, utilised the River Avon for one of its sides. West Kennet Enclosure 2 was apparently constructed just a few years before Enclosure 1 and both existed simultaneously. After less than a century of use the timber structures were deliberately burned to the ground, though whether this was an act of religious sacrifice or the result of conflict is unknown.

Pieces of Grooved Ware pottery and pig bones were found by excavators at the bottom of the postholes. Originally seen as ritual deposits dating from the Palisades' construction period, they are now known to date from much later. Between 2500 and 2000 BC, the area became a 'Grooved Ware settlement' – probably home to the builders of Silbury. Some features have recently been interpreted as the chalk floors of Neolithic houses, like those found at Marden anf Durrington Walls, near Stonehenge. Large-scale feasting apparently went on at the West Kennet settlement, since domestic pig bones were found in every posthole that has been excavated. Rather than being deposited, it now seems that the bones simply fell down the holes left by the long burned-out posts. At Durrington, pig bones were similarly found in vast quantities; flint arrowheads were also found, some embedded in the bones. It appears that the pigs were shot, for sport or in some bloody ritual. Were pigs also shot at West Kennet?

Looking northward into the area of the Palisades from the lane east of Structure C. The walls of the Palisades are thought to have been around the same height as the electricity pole in the picture.

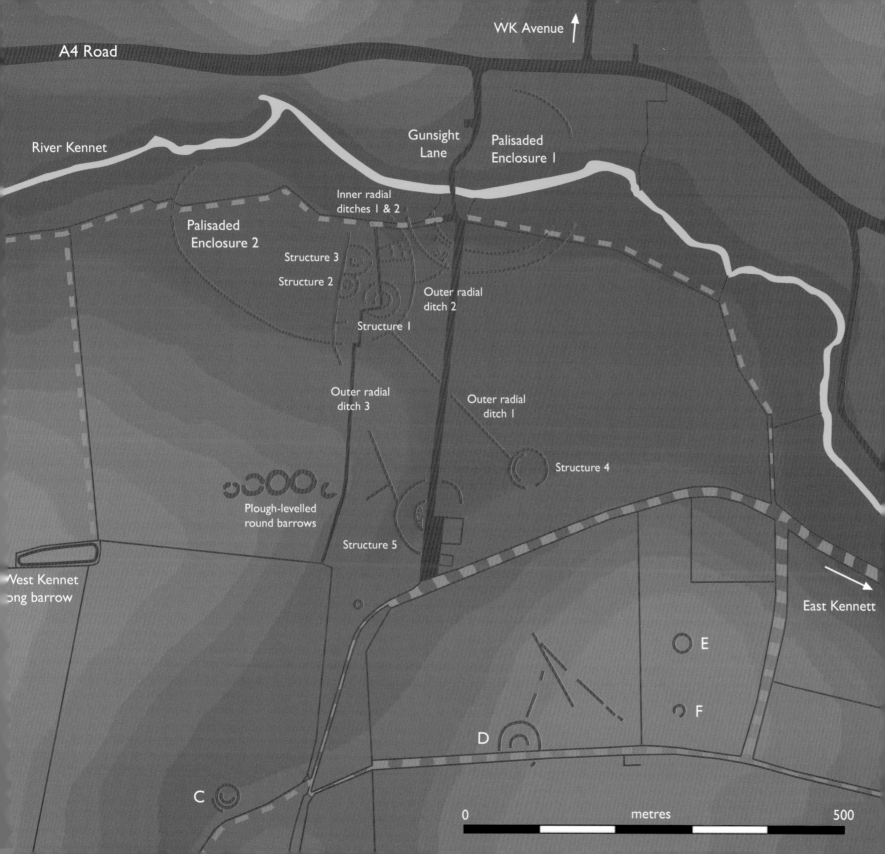

A4 Road

WK Avenue

River Kennet

Gunsight
Lane

Palisaded
Enclosure 1

Inner radial
ditches 1 & 2

Palisaded
Enclosure 2

Structure 3

Structure 2

Outer radial
ditch 2

Structure 1

Outer radial
ditch 3

Outer radial
ditch 1

Structure 4

Plough-levelled
round barrows

West Kennet
Long barrow

Structure 5

East Kennett

E

F

D

C

0 metres 500

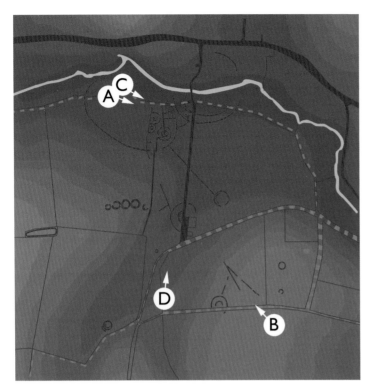

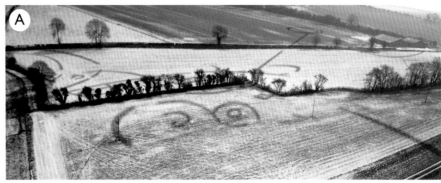

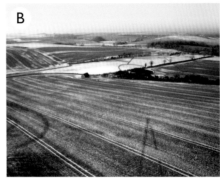

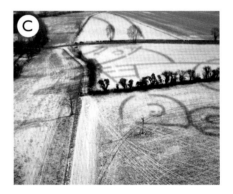

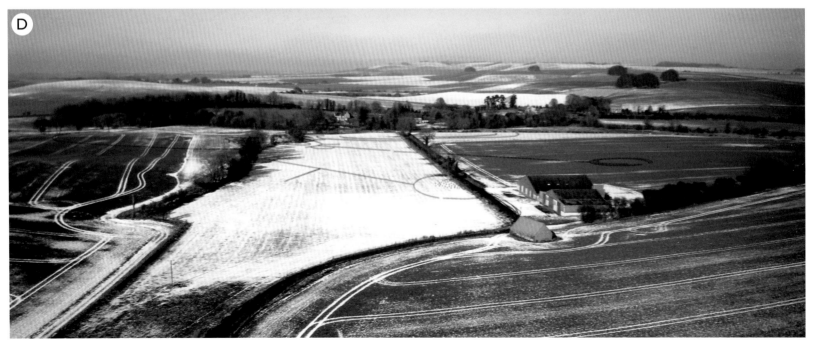

The Palisades and Water

The West Kennet Palisades are intimately connected to water: the area is densely populated with springs and in prehistory there may have been more. Enclosure 1 encircles a major spring, so was it built purposely to contain the spring's power?

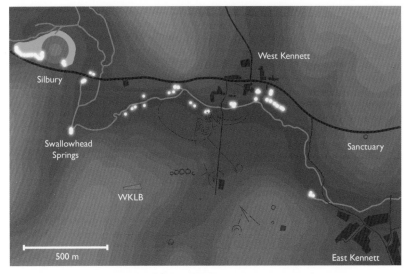

The Palisades area today, showing the Kennet's modern course and known springs.

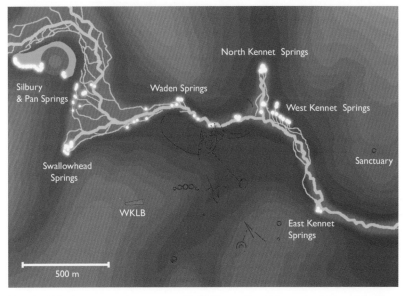

How the Palisades area may have appeared in 2200 BC, with a higher water table and the River Kennet in its natural state before management.

Enclosure 2 contains springs on its northern side, notably the Waden Springs which still flow copiously, even though they have been largely buried under a large mound of soil and rubble. Perhaps the Waden Springs were originally an integral element of Enclosure 2? Limited excavation has determined that the Palisades' posts were erected in dry ground, suggesting that this was summer work. If the un-managed River Kennet flowed permanently then, it would still fluctuate with seasons. A wide-spreading sheet of water in winter, it would shrink back in the summer months to a number of braided streams, which could be temporarily diverted away from construction sites.

The West Kennet Palisades are not entirely unique: there are other British sites with great similarities, sited on low, often waterlogged ground, near rivers and springs. Often there are nearby flat-topped, earthen mounds, surrounded by water, of which Silbury is by far the largest example. The Hindwell palisaded enclosures in mid-Wales postdate West Kennet by nearly a thousand years, yet the shape of its two enclosures, encircling springs, is almost identical: it seems clear that Hindwell was modelled on West Kennet. The Exploring Avebury website has a great deal more information about the Palisades.

Water from springs that rise at the centre of Palisaded Enclosure 1 flows into the River Kennet. There are several springs across a wide area of overgrown scrubland in the grounds of West Kennett Farm, a property owned by the National Trust. One powerful spring rises beneath a pool close to the river; ripples and bubbles break its surface.

OTHER PLACES TO VISIT

Within 5 miles of Avebury there are many more prehistoric monuments and other interesting places to visit: readers are urged to go out into the landscape and explore it for themselves. The 10-mile square area map on page 10 shows the approximate positions of some recommended sites; all are featured on the OS map, which also shows rights of way. The Exploring Avebury website has more information, including the positions of the area's twenty-seven long barrows, many of them now destroyed.

Devil's Den (*opposite*) can only be reached on foot, since all roads near it are private. The nearest parking is in Clatford village, to the south.

West Woods, best known for its extraordinary show of spring bluebells, also has a sizeable drift of sarsen stones scattered amongst the trees (*right*). This is likely how the Avebury area appeared in the Mesolithic, before its forests were cleared.

Walking along the northern edge of the Vale of Pewsey is particularly recommended for its stunning views and wealth of sites. There is parking near *Knap Hill*, a Neolithic causewayed enclosure. Walking east along the ridge leads to *Gopher Wood*, a beautiful ancient woodland mentioned in the *Anglo-Saxon Chronicle*. West from the car park is *Adam's Grave*, probably Britain's most spectacularly sited long barrow. On a clear day the spire of Salisbury Cathedral, 22 miles away, may be seen from the barrow.

Further west is the *Alton Barnes White Horse*; from there the ground rises to *Milk Hill*, the highest point in Wiltshire, and *Tan Hill*, site of an ancient horse fair. Following a track to lower ground leads to *Rybury*, another Neolithic causewayed enclosure. Running north of the ridge and parallel to it is the *Wansdyke*, a massive bank and ditch dating from the fifth or sixth century. The Wansdyke runs west from Savernake Forest near Marlborough, in places incorporating a Roman road. Traces of it may be found almost all the way to Bristol.

Sarsen stones in West Woods near Lockeridge.

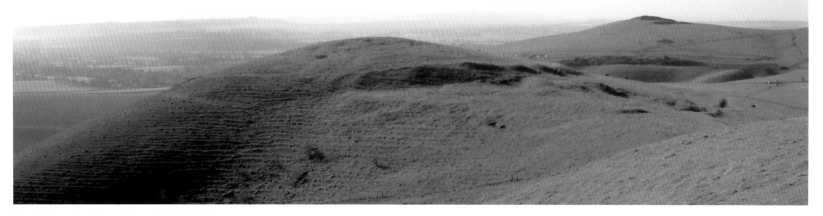

Knap Hill, seen looking west; beyond is Adam's Grave.

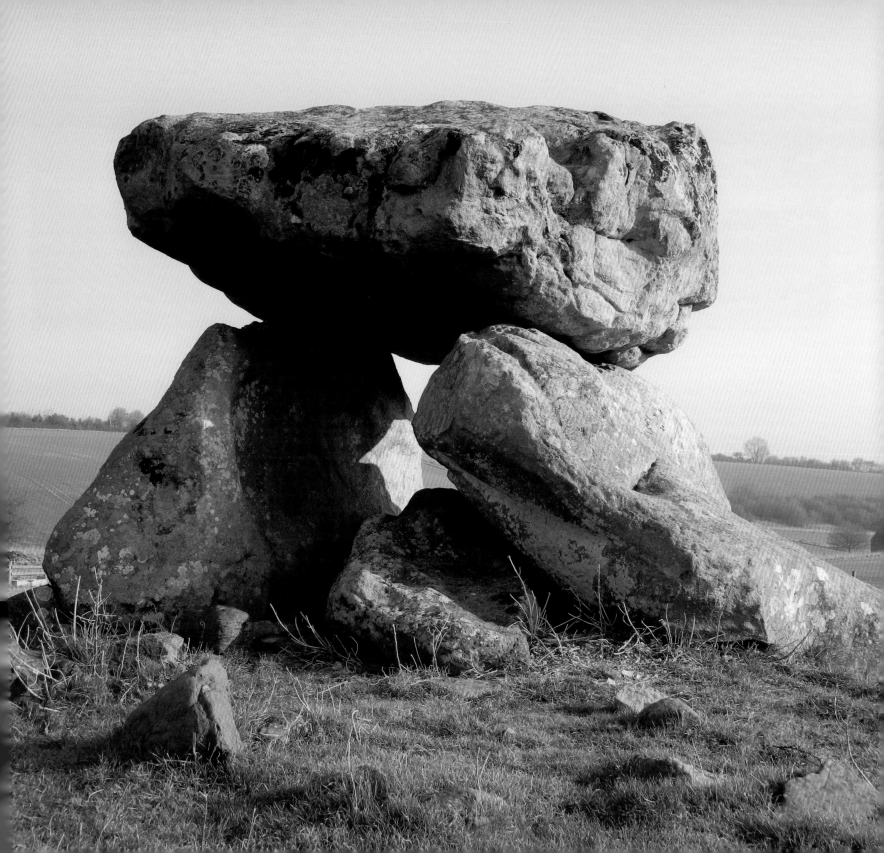

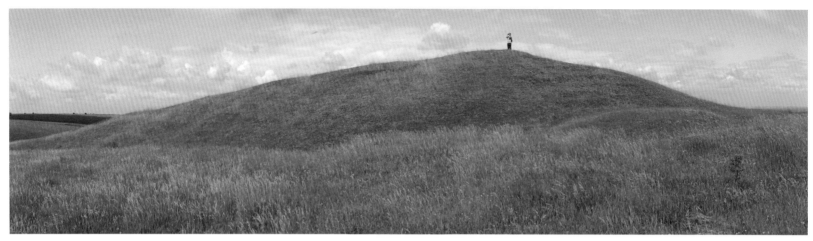

Adam's Grave.

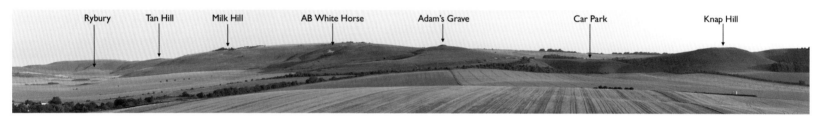

Rybury Tan Hill Milk Hill AB White Horse Adam's Grave Car Park Knap Hill

Northern edge of the Vale of Pewsey, seen looking north-west from Woodborough Hill.

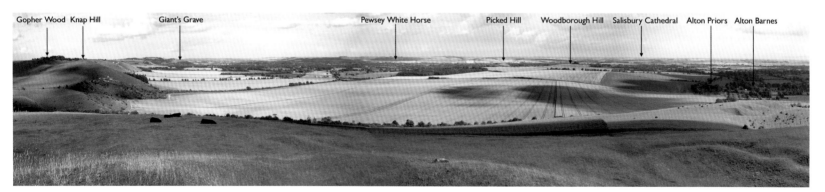

Gopher Wood Knap Hill Giant's Grave Pewsey White Horse Picked Hill Woodborough Hill Salisbury Cathedral Alton Priors Alton Barnes

View from Adam's Grave looking south-east across the Vale of Pewsey.

THE EXPLORING AVEBURY WEBSITE

Exploring Avebury: The Essential Guide was originally conceived as a twenty-first-century equivalent to the *Guide to the British and Roman Antiquities of the North Wiltshire Downs in a Hundred Square Miles round Abury*, published in 1884 by the Revd A.C. Smith, Rector of Yatesbury.

Like Smith, I spent many years exploring Wiltshire on horseback, and once rode the length of the Ridgeway from Goring-on-Thames to the Vale of Pewsey. This book was written whilst living in Yatesbury, a tiny village just 3 miles west of Avebury.

I began my research by poring through dozens of archaeological books and reports, and soon became caught up in my own fieldwork. After the planned one-year writing project had gone on for five years, it became apparent that even several books the size of Smith's could not contain all the material I had amassed. Smith's book is enormous: it weighs 2.5kg (5½lb) and in 1885 cost two guineas – probably the equivalent of around £500 today! My solution was to print a small, affordable book, and make the extra material available on a website.

The Exploring Avebury website (www.exploringavebury.com) is a great resource for anyone interested in Avebury, and archaeology in general. There you will find additional material for each chapter of the book, including extra text with notes, references and web links. There are also bonus chapters on William Stukeley and other aspects of Avebury, as well as videos of some unique features, such as the acoustics of the West Kennet long barrow.

One of A.C. Smith's hand-drawn maps of Avebury.

Those who are unable to visit Avebury can still explore the area from home. The website has tutorials on using Google Earth and Ordnance Survey maps; there are gpx files to download, showing the positions of the monuments and individual stones on Google Earth. For those who must experience Avebury for themselves, some files may also be used in a GPS device for locating features in the landscape.

There are gazetteers of all the springs I have located, and of the many long barrows of the Avebury area. A.C. Smith's beautiful hand-drawn colour maps are included, showing all the monuments and earthworks that existed around Avebury in the mid-nineteenth century; sadly, many are now lost. Of particular interest to geologists, there is a large archive of photographs showing sarsen stone features of the natural drifts and monuments.

The website is updated as new discoveries are made.

The Revd A.C. Smith's former home in Yatesbury.

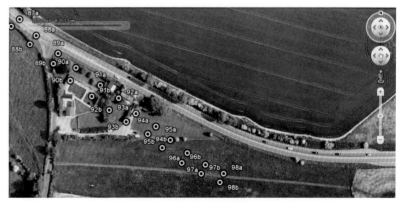
West Kennet Avenue stone positions shown on Google Earth.

INDEX

Page numbers in bold refer to an illustration.